The Complete
Animation
Course

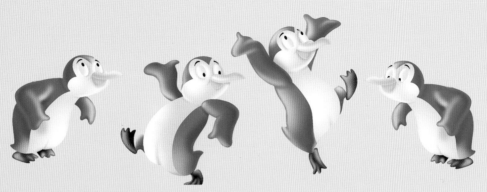

The Complete
Animation
Course

The principles, practice and techniques of successful animation

Chris Patmore

Thames & Hudson

First published in the United Kingdom in 2003 by Thames & Hudson Ltd, 181A High Holborn, London WC1V 7QX

www.thamesandhudson.com

British Library Cataloguing-in-Publication Data
A catalogue record for this book is available from the British Library

ISBN-13: 978-0-500-28437-7

ISBN-10: 0-500-28437-7

Printed and bound in China

Contents

◀ 3D computer-generated animation is everywhere now, and with the increased power and affordability of consumer computers it is possible for anyone to create a top-quality animation on their desktop, such as Rustboy by Brian Taylor (see page 142).

INTRODUCTION

Animation is the art of capturing a series of individual movements, whether on film or in digital form, and replaying them in rapid succession to give the illusion of movement. It can be achieved using images drawn on a cel, paper or other medium; with clay figures or paper puppets; or using computer-generated images. There are some fundamental skills, though, that are common to all animation styles, and the fact that you have picked up this book means that you may already have shown some talent for this wonderful art form and want to take the next step. In writing this book I have therefore made some assumptions about you, the reader. These are (a) you are not a professional animator; (b) you have some creative and artistic talent; (c) you have access to a personal computer or lots of pencils and paper; (d) you have immense patience; and finally (e) you have a story to tell.

THE AIM OF THIS BOOK

The Complete Animation Course is designed to explain something about all the different aspects and types of animation, to act as a catalyst to stimulate you to try different things, and, hopefully, to make a career out of your talent. As the saying goes, find something you like to do and you'll never have to do a hard day's work in your life. In my work, first as photographer and graphic designer, and now as a journalist specialising in creative digital technology, I have been fortunate in staying true to that maxim – and to find in animation an art form that uses all these disciplines at once. I am currently developing a web site for animators and comic artists (details at the back of this book), which I hope will be a useful source of tips and contacts for you.

It would be impossible to cover everything you need to know about animation in a single book. What I have tried to do is make this book as practical and inspirational as possible in the space available. I hope you will follow *Complete Animation Course* up with some of the recommended reading but, more importantly, I hope it will encourage you to start making your first animation because experience is always the best teacher.

Chris Patmore

▲ With the success of Aardman's Wallace and Gromit and Chicken Run, 3D stop-motion puppet animation is experiencing a revival, with many colleges such as Glamorgan Centre for Art & Design Technology in Wales, UK (where this work was done), offering courses dedicated to stop motion and other animation disciplines.

How to use this book

Richly illustrated with production stills, frame grabs and artworks, and using a fun coursebook format, *The Complete Animation Course* explains the art of animation and brings it vividly to life. The book begins with a general overview of the equipment you will need to produce animation, and is subsequently divided into six chapters. The final section offers advice on how to bring all the elements of an animation together. This page provides a general breakdown of the book's structure.

CHAPTER INTRODUCTION
This book is divided into six chapters, each devoted to a main category of animation. The chapter introduction provides an overview of the topic under discussion.

MAIN TEXT: *Written in a clear and engaging style, the text explains the chapter subject and provides relevant examples of animation works.*

CHAPTER UNITS
Each chapter is divided into double-page units composed of instructional text, practical examples and/or step-by-steps and computer frame grabs.

ANNOTATED GUIDES: *Step-by-step guides demonstrate the creation of a specific part, or an overview of an animation process.*

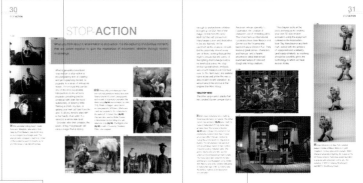

CONTEMPORARY EXAMPLES: *The book is stunningly illustrated with carefully selected stills from a wide range of animation works and styles. Each image is accompanied by a detailed caption.*

OVER TO YOU PANEL: *This panel provides tips and hints on how to make the most of the information provided in the unit.*

NAME OF ANIMATION: *The opening panel displays the name of the animation and/or animation company that forms the subject of the case study. It also summarizes the animation techniques involved.*

FRAME GRABS: *Frame grabs of computer software packages, together with detailed captions, explain how to use the programs best suited for a particular animation effect or style.*

CASE STUDY *Each chapter ends with an inspirational case study of an animation work, or a set of works by an animation company. This is designed to demonstrate the practical information discussed in the chapter.*

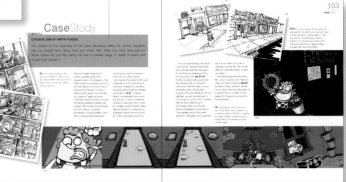

EquipmentOverview

A NEW AGE

Whether we like it or not, we are living in a digital age. For a lot of artists this has meant the opportunity to create works that would not have been possible before.

The boundaries between consumer and professional equipment are blurring, so much so that for very little outlay it is possible to produce a professional-quality animation that people could only have dreamed about a little more than a decade ago. Working with film is not really a viable option for most people and despite the more tangible qualities of celluloid, the disadvantages of film outweigh its advantages. No matter which style of animation you want to do, the way forward is definitely digital. So what will you need?

• A computer
• An image-capture device (digital still or digital video [DV] camera and/or a scanner)
• Something to hold the camera (tripod or camera stand)
• Lights
• Graphics tablet

That's it. Software and media-specific equipment are covered in the relevant chapters.

THE COMPUTER AND PERIPHERALS

Which computer to buy? You have two choices, really: one that runs Mac OS or one that runs Windows. There are other operating systems such as Linux, Unix or Irix, but the consumer choices are Macintosh or Windows (which will both run Linux if you really want to). The debate about which is better is never-ending and will not be entered into here. Macs are generally the preferred choice. Nearly all the popular creative software was originally developed for this platform. This book is biased towards Macs as that's what the author is familiar with. For Windows-based systems, there's an endless supply of hardware variations, and many programs for animators that are not available on other platforms, which could influence your decision if you're just starting out. Most of the top 3D software is available on both platforms, so in the end the choice is yours. Just get the right tool for the job according to what you can afford.

The issue of processor speeds tends to suffer from too much marketing hype. Unless you intend to make the next *Final Fantasy* or *Toy Story* on your desktop, most current desktop (and laptop)

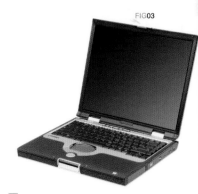

FIG02

FIG01

▲ *The Apple iMac, with its built-in CD and DVD writer and integrated video editing software, comes with everything you need to finish and distribute your animations. It is very quiet and looks very stylish with its LCD flat screen.*

▲ *This Hewlett Packard computer is one of the hundreds of different machines built to run the ubiquitous Microsoft Windows operating system. LCD monitors are becoming more commonplace, but a standard CRT monitor will give you much better colour definition.*

FIG03

▲ *Laptop portables are just as capable as desktops for most animation tasks. These come in a variety of sizes and configurations from 12 inches up to Apple's 17-inch widescreen PowerBook, with DVD burner. However, portability does come with a premium price .*

computers **(figs 01–03)** have more than enough power to do whatever you want without spending a fortune on professional-level machines. The important thing to have is plenty of RAM and hard drive memory, a decent monitor with a resolution of at least 1024 x 768 pixels, and a CD writer as your minimum. From there on you are constrained only by your budget and your love of technology. If you

FIG04

9

EQUIPMENT OVERVIEW

▲ Wacom is the main producer of graphics tablets throughout the world, and most graphics software supports its range. This is its affordable, entry-level Graphire tablet, which is more than suitable for most drawing tasks.

FIG07

◀ The minimum computer monitor resolution for most animations is 1024 x 768 pixels.

FIG09

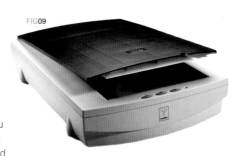

▲ A scanner is another must-have piece of equipment. For our purposes any of the entry-level scanners, such as this one from Umax, or any of the other manufacturers – Microtek, Epson, Canon or HP – will be more than adequate. Your choice will be governed by price and software bundle.

FIG05

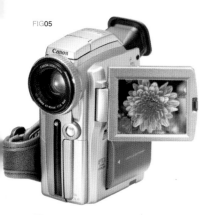

▲ Digital Video (DV) cameras, such as this model from Canon, pack a lot of features into a very small package. They will easily handle all your animation needs and plug directly into your computer for editing.

have chosen to work in 3D stop-motion, you will need a camera. However, before you put your hand in your pocket, or someone else's, to buy one, you should ask yourself how committed you are. If you are going to buy a lot of expensive gear, will you get your money's worth from it? Will you make ten minutes of the film, then lose interest and stick it all in a cupboard? If you must have a top-of-the-range DV camera, look first in the small ads, printed or online, because you can find plenty of equipment that's been sitting in someone else's cupboard and get it at a bargain price. If you buy a DV camera you will have to make sure that your computer has, or will accept, a FireWire (IEEE1394) connection.

A DV camera **(fig 05)** is not always necessary, and you may be much better off starting with a digital still camera, although there is not a lot of difference in price.

Again, always go for the best you can afford, but resign yourself to the fact that something better and cheaper will come out the following week; this also applies to computers and scanners.

A scanner **(fig 09)** is easily affordable and is your best option for cel animation. The quality-to-price ratio has changed dramatically over the years, and now even the cheapest scanner scans at a resolution that before was available only on expensive professional scanners. Not long ago scanners came bundled with software; now it's the other way around. Browse in the computer shops and mail-order catalogues if you are buying a new computer, because they are often bundled with scanners and digital cameras.

Tripods, camera stands and lighting are covered later in the book (page 32). The important thing is to get a computer and the right image-capture device before

you start. You can choose software as and when you need it. You will almost certainly need a word processor, Adobe Photoshop (or something similar) and Apple QuickTime, but these will usually be included with your hardware package. Specific software is covered in the relevant chapters. Let's get started.

FIG06

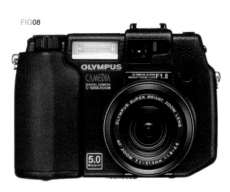

◀ Current large-screen, high-powered laptops, like this Apple PowerBook running Final Cut Pro editing software, let you work on your animation anywhere.

FIG08

◀ Digital still cameras can be used for shooting stop-action animation. The resolution offered by this Olympus model is more than you'll ever need; but if you have an interest in other forms of still photography, it is an excellent multipurpose tool. Make sure you have finished shooting your animation scene before you use it on a shoot somewhere else.

THE**STORY**

Before you put the first pencil outline of your lead character onto your sketch pad, you have to have one – a lead character, that is. And in order to be animated, he (or she, or it) has to do something.

FIG01

The character has to perform some sort of action. This action, even if it is just one step, could be the first step of a journey, and that journey will have a tale. It could be a very short journey, such as a foot coming down on a banana skin or a piece of chewing gum, but a story has been relayed to us – not a very original one, but a story nonetheless.

To make an animation, you have to have a story. Well, that's not entirely true. You can make an animation without a story, but you won't find too many people watching it. You can make an animation of a bouncing ball, and some people may even find that fascinating, for a while. But you have more imagination than that. To qualify that statement: 'To make an animation you have to have an idea; to make an engaging animation you have to have a story.'

Everybody has a story to tell. You come home from school or work and tell your mum/dad/spouse/ friend what happened to you that day, whether it was that the coffee machine ran out of water just as you put in your last coin or that you were kidnapped by aliens and taken to a parallel universe where you were worshiped as a god. It is not always what happened to you that makes the story, but the way you tell it. A good storyteller could make the coffee machine episode interesting by embellishing and exaggerating. Animation is the perfect vehicle for this. With animation you can make the story as fantastic as you like and make it seem realistic, because that is what animation does – it brings things to life.

So you have a story, or maybe

▼ *William Shakespeare was a master storyteller, his plays enjoyed as much for their profundity and acute psychological insight as for his use of language. His work has been interpreted, adapted, copied and used as the inspiration for countless other stories for centuries.*

◄ *Stories can inspire us to perform great deeds (or not, in Don Quixote's case). They can entertain, inform and stimulate the imagination. One story can act as the catalyst for a new story, or telling the story in a different way – with animation, for example (which could almost be considered a Quixotic quest).*

FIG02

FIG03

FIG05

◀ *Before the arrival of animation and moving pictures, legends and tales illustrated by great artists, such as Walter Crane (fig 03), Arthur Rackham and Gustave Doré (fig 01), were a popular way to convey stories, much like today's comics and graphic novels.*

FIG04

▲ *Classical and traditional stories nearly always involve a quest and have some sort of moral. The Green Man of Knowledge, made by Red Kite in Edinburgh as part of the* Animated Tales of the World *series, is one such tale. The young man shown in **fig 05**, on his first journey away from home, ends up in the Land of Enchantment, where he faces three challenges from the mysterious Green Man.*

just an idea for a story, and you want to tell this story using animation. Even though you can do anything that your imagination and talent allow, your story must have a certain structure for it to work. It must have a beginning, a middle and an end. Elementary but true. This first chapter of the book deals with 'The Story': why we tell stories, how to make a story work, and how to get it into a format you can work with – the screenplay. Again, it cannot be stressed enough how important the story aspect of the animation process is. Read some of the books recommended at the end for more inspiration.

▲ *The Inuit of northern Canada have a rich tradition of storytelling that is filled with important morals and life lessons. This story, from the* Animated Tales of the World, *tells how a blind boy protects his aunt during a blizzard. During the course of the story she becomes a narwhal (a small whale) and lives happily in the sea, from where the boy is rewarded.*

FIG06

◀ *For many people stories take on a reality of their own, such is the strength of the storyteller's spell. Animators can add an extra dimension to that magic with their moving pictures. In the Chinese tale* The Magic Paintbrush, *made by Christmas Films in Moscow, the young hero is given a paintbrush that really brings everything he paints to life – with mixed consequences.*

FIG04

FIG05

Origins of Story

THE REAL ONCE UPON A TIME

Why we tell stories has been the life's work of generations of anthropologists, sociologists, and a host of other researchers. Most don't agree with the others' findings, and they continue their search in vain, but the general consensus is that it is a way of exploring and discovering the human condition – what makes us tick as human beings.

FIG01

▲ *Even before man had developed a written language, he had been telling stories and, like animators, he used pictures to enhance and record those stories. These cave paintings were made by the San bushmen of what is now Zimbabwe.*

We have been telling stories from the time we started walking upright and even before we developed any recognizable verbal language. The earliest cave paintings **(fig 01)** depicted hunting adventures, no doubt exaggerated to impress fellow cave dwellers.

As civilisation evolved, the complexity of the stories grew. Stories that tried to explain the mysteries of the world around them developed into myths, legends and religions **(figs 02–06)**. Tales of heroes and their adventures were told to entertain and inspire. In many tribes and communities the storyteller was regarded as an oracle or guide and treated with the utmost respect. This oral tradition, passed from one generation to the next, required a special talent to capture

the audience so that moral codes were understood and remembered by everyone.

The leaders of all the great religions were master storytellers **(figs 07–10)**. They had to impart their message to people who lacked an understanding of these higher concepts, and so, for

FIG02

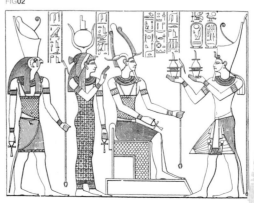

example, we had the parables of Christ, the songs of Solomon and the koans of the Zen masters.

FEW STORIES, MANY TELLERS

If we were to look at the stories that have survived through the millennia to become legends,

▼ *The ancient Egyptians were prolific storytellers, covering their walls with paintings and carved reliefs of stories about their gods and pharaohs. They used both words and pictures and developed papyrus sheets (the precursor to our modern paper) to make the recording of stories easier.*

FIG03

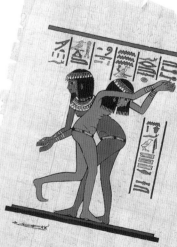

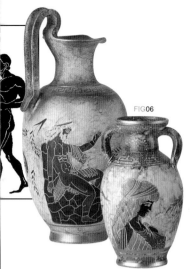

◀ *The ancient Greeks were master storytellers, and most of their tales were about their gods, and other heroes, including sporting ones. Many of their representations were drawn onto vases and urns, which, like their mythology, have survived the centuries.*

FIG06

FIG07

FIG08

myths and religious texts, we would see many similarities between them despite the huge cultural differences.

As storytellers it is up to us to take these raw materials and create not only captivating, entertaining tales, but ones that teach and enlighten our audience. We have to give them not only visual delights but also nourishment for the mind and the heart. Why were *Star Wars* (Episode IV – A New Hope) and *The Matrix* so successful? Not just because they were spectacular action pieces, but because they addressed issues deep within the human psyche that struck a chord with their viewers. They presented archetypal characters – the hero, the mentor, the shadow (the bad guy) – who where on a quest for self-knowledge.

Of course not all stories need to go to these depths, and animation in particular can be entertaining in an often frivolous way, but even *Looney Tunes* cartoons, under scrutiny, fulfill the requirements of the archetypal tale.

◀ ▲ *The great religious leaders of the world used stories and poetry to impart their messages. Jesus Christ told parables and King Solomon sang poetry and songs.*

FIG10

FIG09

▶ *The followers of religions, the monks, from Christians to Zen Buddhists, were the ones who wrote down the stories to pass on to the following generations.*

▶ *India's heritage of religious storytelling is so ancient that the stories appear to have been written by the gods themselves. The Ramayana, the story of the god king Rama, was written contemporaneously by the sage Valmiki, who received divine inspiration to tell the story before he actually met Rama in person.*

AnimationforStorytelling

FIG02

REALISING THE IMPOSSIBLE

When you have a story that you want to tell in moving pictures, and it goes beyond the realm of the human world, animation is really your first option. Even before King Kong scaled the Empire State Building, animation was used to bring fantasy worlds to life.

FIG03

With the huge range of techniques available your only real limitation is your imagination. Before the advent of animatronics (puppets or characters with robotic skeletons) and 3D Computer Generated Imagery, or CGI, (see page 116) how else were animals going to act? Or multiheaded mythical creatures or sword-fighting skeletons? Not with actors in suits. The only option was, and still is, animation. Ray Harryhausen mastered this in the film *Jason and the Argonauts* **(fig 01)**. Digital animation is developing to such a level that it is used where once actors in prosthetic suits could be employed to great effect, as can be seen in the most recent *Star Wars* films.

One of the great advantages of animation in storytelling is control. The animator is the creator whose creatures and characters will look and act exactly as he or she wants them to. No tantrums or outrageous demands from these actors, despite what Pixar would have us believe in the out-takes from their films. This is where Pixar is so successful, because the creators there make us believe their characters are alive and as real as we are **(fig 04)**.

SUSPENSION OF DISBELIEF

What animators should aim for when telling a story is 'suspension of disbelief'. The story has to be good but the telling has to be better. The audience has to forget that it is watching thousands of painstakingly hand-drawn and coloured still images, lumps of clay, wire and foam models, or terabytes of rendered polygons. Sure, when we watch Sully collapse into the snow in *Monsters,*

▲ *The oral tradition of the storyteller has been usurped by film and television, but thanks to animation's visual nature old folk tales have been given a new lease of life. The story of King Solomon and the Bee* **(fig 02)** *was created to appeal to young children by Pichi Poy in Jaffa, as part of the Animated Tales of the World series (see page 44). The Brothers Grimm story* The Enchanted Lion **(fig 03)** *was created by Trnky Studio in Prague, internationally famous for its wooden puppet animations.*

FIG01

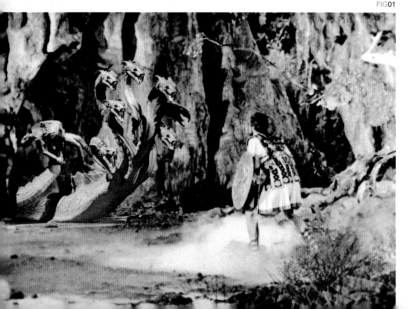

◀ *Ancient mythology and fables were brought to life by stop-motion animation master Ray Harryhausen. Long before the advent of computers, Harryhausen's artistry amazed filmgoers around the world, and despite the advances in technology, modern audiences are still captivated by the magic of his work.*

Inc., we marvel at the technology that produced that blizzard and all that moving fur, but we are still caught up in the emotion of his exile. No matter how many times we've seen Sylvester swallow Tweety, we all wish he'd digest that yellow bird, or that Wile E. Coyote could just once barbecue that smug Road Runner.

Animation makes the impossible possible, not only with characters but also with camera angles. The opening 'zoom' shot in Disney's *The Rescuers Down Under* or the sequence of Cody on the eagle's back from the same film would be impossible in 'real life'. We can put the characters and the camera anywhere we want and have them do whatever we want. We can change the light, and the weather, and make mountains out of molehills. We can achieve things

that cannot be done just with the written word.

Like it or not, we live in a visual world, and with many children being raised on television cartoons, animators have a great responsibility as storytellers to produce works of both artistic and instructional value. We need to learn the crafts of storytelling and animation so that young imaginations can be stimulated and informed.

FIG05

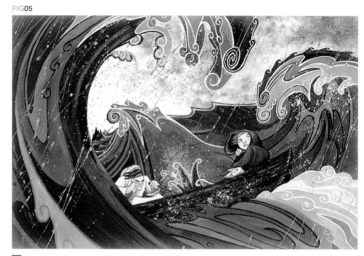

▼ *With a combination of great stories, well-developed characters, funny dialogue delivered by top actors/comedians and stunning CGI animation, Pixar Studios has produced not only significant, groundbreaking animations but great films that go beyond the animation genre. Monsters, Inc. is so engaging and well made that it is very easy to forget you are watching a computer-generated image.*

▲ *The myriad artistic interpretations that can be given to a story make animation a unique medium for telling stories. The Cartoon Saloon used a mixture of simple, austere drawings and decorative images to convey the story of the Irish monks who made the Book of Kells.*

OVER TO YOU

OTY/01

Watch your favourite animations and make a list of the things that captured your imagination. Use it as a reference when starting to work on your own film.

OTY/02

When developing your film, take into consideration your choice of story and the type and style of animation you will use. Will they work together? Does your animation style best convey the feeling of the story? The success of a story is in its telling, and the visual impact is a vital part of that telling.

FIG04

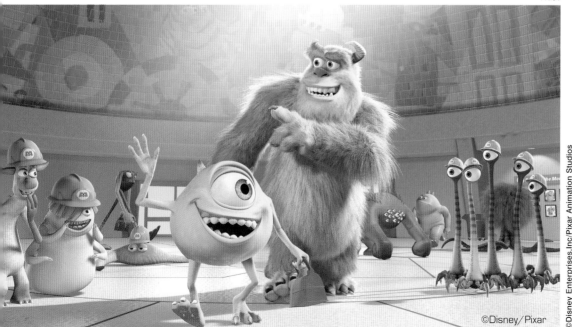

©Disney/Pixar

Character**Development**

ARCHETYPES OR STEREOTYPES

All stories are character-driven. It doesn't matter what form this takes; if there is no character, there is no one to tell the story about. In animation anything can become a character – from animals (Mickey Mouse) to toys (Pinocchio and Toy Story) to mountains (Fantasia).

FIG02

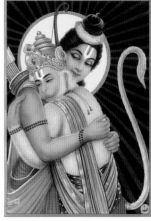

Hanumana, the Hindu monkey god, can be seen as the archetypal herald. In the story of Rama it is always Hanumana who announces the hero's action. He is the one that carries the messages for Rama, just as Hermes and Mercury did. Hanumana was also a trickster, causing chaos for his adversaries with his sense of mischief.

This is characterisation and animation – bringing to life nonhuman and inanimate objects. They are exclusive to our chosen medium. Character development is something that covers all realms of storytelling, whether in the form of a novel, play or film. Whatever format we choose to tell our story in, our characters have to be believable, no matter what they look like. This is even more important when creating nonhuman characters. So how do we make them realistic and engaging?

All the great writers agree on one thing: archetypes, not stereotypes. Archetypes are universal characters, whereas stereotypes are localised, with cultural conditionings that keep them tied to their specific area. Archetypes are heroes and villains whose personality traits are recognisable in any culture and go beyond the external forms. There are seven basic archetypes, classified by Joseph Campbell in his book *The Hero with a Thousand Faces*: hero, mentor, threshold guardian, herald, shapeshifter, shadow and trickster. Read the book to gain a proper understanding of these archetypes as it is too complex a subject to cover here. An example of the archetypal hero is Jason in *Jason and the Argonauts*; the mentor, Gandalf in *The Lord of the Rings*; the shapeshifter, or the one who is not what he or she seems, Agent Kent Mansley in *The Iron Giant*; the shadow, the Emperor from *Star Wars*. These various character types have specific roles to play, and their appearance is dictated by the way your story unfolds.

Taking the archetypes as the basis for our protagonists, we also need to give them personalities. We have to give them a history, and out of that history we can assign the necessary traits and moods. Even though your characters are on screen for maybe only minutes, you have to create a whole life for each of them and know the details intimately, such as how and why they would react in a situation. You have to know how they came to be there in the first place, and this has to be conveyed to the audience without wasting screen time. If you have to create 24 images for every second your character is on screen, you want to convey your message as quickly as possible and get on with the action.

The genie in Disney's *Aladdin* is a composite of many of the archetypal characteristics. He is a shapeshifter, a trickster, a herald and even a mentor to Aladdin – and all this with Robin Williams' unique sense of humour.

FIG01

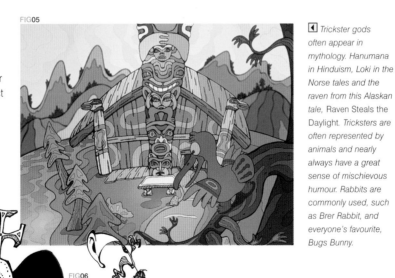

FIG03

FIG04

One other key aspect of character development is getting the right voice. Could you ever imagine Sylvester or Bugs Bunny with a different voice? Would the way you perceive them change? Getting the right voice can also affect the way your character behaves and influence the film's final outcome, as Robin Williams did in *Aladdin* **(fig 01)**.

OBSERVATION

Observation is the key to developing realistic characters. Start by observing yourself – how and why you react in a particular way in certain situations. What is it from your past that causes you to act in a certain way? People-watching is another important pastime for animators. Shopping centres, parks or sports games, or better still a street café, are perfect places to go armed with index cards or a notebook, to watch people acting and reacting. And because they are strangers you can let your imagination invent histories for them. This is one of the more pleasurable activities of the creative process, and just as important as sitting at your drawing board or computer.

▲ *King Arthur and Merlin is one of the best known hero and mentor relationships, retold many times on the screen in both animation and live action. Of course, the relationship between Obi-Wan Kenobi and his two generations of Skywalker apprentices is probably better known to more recent generations.*

▲ *The original Cyclops, not the one from X-Men, could be considered a threshold guardian. He was not a true enemy but an adversary who tested the hero's courage to continue with his quest. This is the role threshold guardians play.*

FIG05

◄ *Trickster gods often appear in mythology. Hanumana in Hinduism, Loki in the Norse tales and the raven from this Alaskan tale,* Raven Steals the Daylight. *Tricksters are often represented by animals and nearly always have a great sense of mischievous humour. Rabbits are commonly used, such as Brer Rabbit, and everyone's favourite, Bugs Bunny.*

FIG06

◄ *The shadow archetype is the dark side of our personalities. It is the Gollum that wants to kill Frodo, it's the werewolves, the Mr Hydes, the Green Goblins and the Darth Vaders. It's Hermann Hesse's* Steppenwolf. *It is the deranged cannibal* **(fig 06)** *from Cartoon Saloon's* Underground. *The shadow is the villain and the negative force that has to be overcome by the hero, whether it is external or internal.*

OVER TO YOU

OTY/01

When you watch a film or read a story, see if you can identify the archetypes in the characters. It is not uncommon for characters to display more than one of the attributes. Jot them down so you can build up a clearer picture of what they are and how they work in the story.

OTY/02

The indispensable tool for any animator is the index card. Jot down ideas about your character's life and personality traits, make sketches of expressions to match the written descriptions, and slowly you will develop a fully rounded character. Do this for all your characters until you have a pile of cards that will become reference points as you write your screenplay and make your animation.

Research

MAKING THE INCREDIBLE CREDIBLE

Research is necessary to add credibility to our story. When developing characters we study people, including ourselves. If, for example, you are making a film about rabbits, such as *Watership Down*, you will have to study rabbits, and then integrate what you find with the persona you have created.

FIG02

Books are a useful source of information, especially when dealing with historical events and times. These can be contemporary journals or even novels of the period. All will help to build up an accurate picture in your mind.

All stories need some research, unless you are drawing completely on your own experiences. Experience is the best teacher, which is why so many writing experts say, 'Write about what you know'.

For the making of Dreamworks' *The Prince of Egypt*, the artists went to Egypt and the Middle East. They could have studied books and photographs, but there is no substitute for firsthand experience. The totality of an environment, with its smells, sounds and changing light, can leave a lasting impression. Record it on tape, film or video to help you remember, but it is being there that counts.

If you are dealing with history it is important to get the details reasonably correct to make it believable, no matter how far you stretch your imagination. Despite their modern appliances and modern thinking, the Flintstones still wore animal skins and used stone implements **(fig 01)**.

When setting a film in a foreign land it is very important to visit it. Take photos, make notes and sketches, buy souvenirs of objects that may be useful as props, or that capture the atmosphere of the place.

FIG01

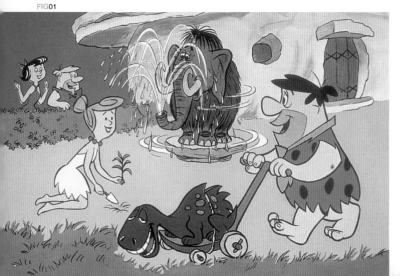

The ingenuity of The Flintstones lies in taking what may have existed at the time and adapting it to represent the conveniences of our modern life. The researchers would have had to find out what creatures there were, what they looked like, the type of vegetation there would have been, how people dressed and what they ate. It was then up to the imagination of the animators to modify the information to suit their designs.

FIG03

But what about fantasy or science fiction? These are nonexistent worlds and cannot be observed outside your imagination. Or can they? Whatever world you create it still has to have its own ecosystem and rules. If you want to create mythical or alien beasts, then look to nature, where you can find the weirdest creatures imaginable. Study their biology to make your fantasy creatures realistic **(figs 03–07)**. If you are making an animation about space travel, or a science fiction piece that really does involve science, then find out as much as you can about the subject.

SOURCES OF INFORMATION

Libraries are good but the Internet is the greatest storehouse of information. Knowing how to use a search engine properly will save you hours in front of the computer. Always be specific about what you are searching for. The best search engines allow you to enter a specific phrase or string of words and will find only that. Most engines sort their results by the most relevant and the most visited, so always start at the top and work your way down.

▲ ▶ ▼ *Studying animals in their environment will help you in the development of characters. Tim Beaumont's penguins* **(fig 04)** *are a caricature of real ones, exaggerating their behaviour and adding human characteristics. On the other hand, Atomic Cartoons' alligator* **(fig 06)** *bears very little resemblance to a real one in looks or behaviour (possibly because he was raised by humans). A study of alligators* **(fig 07)** *was still needed to confirm the attributes that kept its 'alligatorness' and those which could be reversed for comic effect.*

FIG04

FIG05

FIG06

FIG07

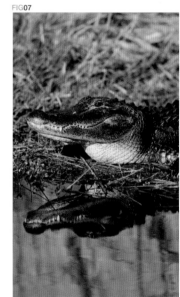

◀ *If you want strange creatures for your animation, you don't have to look any further than the nature around us. The insect world and the ocean floors are a rich source of weird-looking beasts, such as this walking bat fish. By taking ideas from nature, the behavioural patterns and ecology already exist as a basis for your new creature.*

OVER TO YOU

OTY/01

Join your local library. Most major cities have research libraries where you can go to study. Some museums also have study areas. You can also use university and college libraries, but without borrowing privileges. Tell them you only want to do some research and the chances are they will oblige. You can only ask.

OTY/02

Research is also about observation, not just information. Talking to people will give you knowledge you won't find in books, and it will help you with character development.

HollywoodFormula

WORKING WITH A THREE-ACT STRUCTURE

The title of this section has probably caused some sort of reaction in you. It does in most artists. They usually feel that their creativity and independence are under attack from the soulless studio juggernaut that is Hollywood. This section is not about selling out, but it could help you to sell.

It's not so much about formula as form. It's about understanding what works, and why.

Like it or not, the Hollywood studios produce, and have been producing, films of all genres for a long time. They may not produce the most or the best, but they do have a wealth of experience, and generally, but not always, know what works.

Your story has to have a certain structure for it to work on screen.

Once you have learned and mastered the use of that structure, you are free to experiment. A jazz musician has to learn scales, rhythm and musical craft before beginning to improvise, or else it is just noise. Picasso was a master draftsman before he experimented with his own individual style; if he hadn't been, he would have produced nothing but scribbles. And so it is for writing, and especially screenplays.

The form (or formula) is very simple: beginning, middle and end – Act One, Act Two and Act Three. In Act One you set up the story, characters, and setting. This is about one-quarter of your running time. Act Two is the confrontation; this is where most of the action takes place and takes up half your running time. Act Three is the resolution, where you answer the questions about who or why or how. It doesn't have to have a happy ending and it doesn't have to answer all the questions, but it does have to finish in such a way that the audience feels satisfied that the story has reached a conclusion. This accounts for the last quarter of the time.

BEGINNINGS AND ENDINGS

The beginnings and the endings can be the most important parts of the film, and the endings the most difficult. You have to know when you start how it is going to end. If

you know how it starts and how it ends, the middle can often take care of itself. The beginning has to hook your audience. If you don't get them in the first ten to fifteen minutes (of a feature-length film), you have probably lost them for good. If you don't have a substantial ending (and that doesn't mean an obvious or contrived one, as in many Hollywood films), then the last thing the audience sees will leave them with an unfavourable impression. How many times have you seen a film and when asked how it was, replied, 'OK, but the

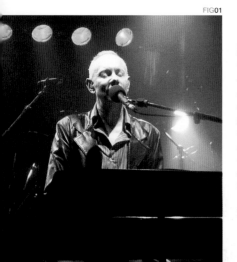

FIG01

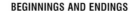
Joe Jackson is one of pop music's most versatile artists. Apart from innate talent he, more importantly, learned his craft studying music and composition at the Royal Academy of Music in London and by playing in cabarets and clubs, before becoming one of the leading figures in the punk/new wave music of the late 1970s. Since then he has diversified and recorded albums of jive and swing jazz, symphonies, film scores and his own unique style of 'pop' music. Whatever artistic endeavour you want to pursue – learn your craft.

KEY

• • • • *basic storyline template*

▬▬▬ *storyline for* The Lighthouse

CLIMAX

CENTRAL CRISES

DELAYED CRISES

PLOT POINT 1

PLOT POINT 2

ACT ONE — BEGINNING
SETUP (25% OF STORY)

ACT TWO — MIDDLE
CONFRONTATION (50% OF STORY)

ACT THREE — END
RESOLUTION (25% OF STORY)

FIG02

ending was rubbish'? You forget everything that happened before no matter how good it was.

The other device used in this three-act formula is the plot point. This is a scene or piece of action that moves you into the next act **(fig 02)**. It is an apex, like the top of a roller coaster before you are plunged, hurtling into the next act.

Once you understand these basic rules, then play with them. Make the end the beginning (as in *Memento*, or *Pulp Fiction*, where the stories cross over each other to come back to the same point), but don't make it so complicated that you lose your audience completely, because without an audience your work is nothing.

▲ *The journey from the beginning to the end of your story/screenplay is not completely linear. Depending on your story, it can have more spikes but it should follow the basic template shown in* **fig 02**. *The crisis point is the principal event of the story that has the most effect on the hero. Whether it happens in the middle or at the end of the second act is your decision as a storyteller. The climax is different, as this is where the story peaks and finally resolves itself. The illustrations above, from Mårten Jönmark's* The Lighthouse, *show how even a six-minute animation can conform, more or less, to this formula. The time division is not as precisely delineated as is possible in a longer work, but it is very close, and the action definitely follows the peaks and troughs.*

OVER TO YOU

OTY/01

To get a fuller explanation of the Hollywood formula read some, or all, of the books recommended at the back of this book, such as *The Writer's Journey* by Christopher Vogler or *Screenplay* by Syd Field.

OTY/02

Draw a copy of the chart in **fig 02**. When you watch a film note down what you think are the different plot points and act changes. If you get more than those on the chart, keep marking them down, then review them afterwards. If you have DVD, watch the film a second time with the director's commentaries to see if they offer any clues.

WritingtheScreenplay

HOW TO MAKE AN INDUSTRY-STANDARD SCRIPT

You have an idea for a story that you want to make into an animation. So where do you take it from there? Storytelling and character development has been covered earlier. By now you should have a pile of index cards with written and drawn sketches that you've carefully arranged into some semblance of order to create the final step before heading off to the drawing board – the screenplay.

The screenplay has a specific standardised format through which screenwriters express their vision. The screenplay for animation is slightly different from that of live-action film in that it requires numbering for the dialogue to match the dope sheet (see page 76). This can be entered at the production or shooting script stage, once the script is finished to the producer's satisfaction.

FIG01

The blank page is every screenwriter's nightmare, especially not knowing how to get the ideas down on paper and past the initial 'Fade in'. Despite the proliferation of computers and dedicated screenwriting software, there are still scriptwriters who prefer to use a good, old-fashioned typewriter.

(A word of warning: if you want to see the script made the way you wrote it, you will have to direct and probably produce it yourself. If other people are involved, be aware that what you wrote won't be what you eventually see.)

ONE PAGE, ONE MINUTE

Each page of a script is usually regarded as one minute of screen time. Generally it is better to under-write. If you are making a ten-minute animation, eight to nine pages should be more than enough, allowing time for visuals. Get your script down on the page. As you are working in a visual medium, a script does not require the masses of description that a

literary story does. For example, when setting the scene it may not require much more than:

EXT. FOREST — EVENING

This establishes place and time, and is followed by a description of the action or stage direction:

Two small shapes are moving slowly through the undergrowth, keeping to the shadows. They stop, leaning against a tree trunk.

Then the dialogue can start. The character's name appears first in capitals, and the speech follows on a new line. If you want to add directions for the actor, they can be inserted after the name. In live-action film screenplays these directions (called parentheticals) are kept to a minimum to allow the actor to carry out his or her craft. In animation more direction is needed.

ELVIS

(looking nervously at the frightened ZOE)

Do you think they saw us?

FIG02

The working window of Screenwriter 2000 is not dissimilar to a standard word processor, except it has preset (and editable) style sheets and shortcuts to make the job of writing and formatting a screenplay a lot easier. The numbers on the right-hand side indicate each piece of dialogue.

THE RIGHT FORMAT

Because all screenplays follow this fixed format, you can use one of the many style sheets available for most word processing packages that do the formatting for you. These can be downloaded from screenwriting web sites on the Internet. If you plan to do a lot of screenwriting, there are also dedicated screenwriting programs. For animators, Movie Magic Screenwriter is the best – it offers dialogue numbering, as well as integrated production features.

The important thing is to get your ideas across to the voice-over actors, who will have limited visuals to work from. If the actors can't express the script in the way you, the writer and the director want, then the animation will falter when you come to animating the characters.

It is possible to make films with no dialogue, but you will still need a script that describes all the scene changes plus stage and camera directions, which will be used together with the storyboards and the dope sheet to produce your finished masterpiece.

▶ *Because all scripts were originally written on typewriters, their formatting has been standardised into a very simple style. Even on computers, the Courier typeface is used with single line spacing (12pt on 12pt leading), and indents are calculated from the edges of the paper, as shown.*

SCENE HEADING: *Tells where and when the scene takes place. Set in capital letters.*

ACTION: *What is happening in the scene. This is written in the present tense.*

FIG03

PARENTHETICAL: *This is a stage direction. It is used more in animation than in live-action scripts.*

CHARACTER NAME: *Set in capital letters on a new line with a blank separating it from the previous action or character dialogue.*

DIALOGUE: *The spoken words.*

```
EXT. FOREST — EVENING

Two small shapes are moving slowly through the undergrowth,
keeping to the shadows. They stop, leaning against a tree
trunk. There is the sound of something large crashing
through the undergrowth.

                    ELVIS
           (looking nervously
            at the frightened
            ZOE)
      What was that thing?

                    ZOE
      Do you think it saw us?

                    ELVIS
      What's a dyathinkasaurus?  Aren't
      they extinct?

                    ZOE
           (looks at ELVIS
            impatiently and
            replies in a
            whispered shout)
      DO YOU THINK IT SAW US?

ELVIS tries to laugh off his mistake and looks from behind
the tree.

                    ELVIS
      I think it's gone.  We'd better go
      and tell the others before it comes
      back.

They run off together.  We follow them through the
undergrowth, still in the shadows.

EXT. FOREST — LATER

They arrive at a clearing where there are some buildings
made from twigs, leaves and moss.  All the inhabitants
gather around ELVIS and ZOE.  The community elder, JIMI,
takes them to his hut.

                    JIMI
      What happened to you two?

ELVIS and ZOE look at each other seeking the other's
approval.

                    ELVIS
      Well... We wanted to go to the edge
      of the world, just to see where it
      finished but we didn't find it
      because... because...

                    ZOE
      There was a beast there that
      entered our world.
```

▶ Presentation boards are used to sell a project and are usually far more lavish than storyboards. They focus on key frames and story events rather than every shot of an entire sequence.

The**Storyboard**

UNIT/09

TRANSLATING THE SCRIPT INTO IMAGES

After the screenplay, the most important part of the development is the storyboard. Actually, the two are inseparable. The script is the words, and the storyboard is the visuals.

FIG03

The storyboard brings the script to life in a series of simple sketches that can show how the story works in a way that is easier to understand than a script. The storyboard will show the scene and the intended camera angles, to explain to everyone, from the animators to the director and producer, how the story will unfold on screen. When the Wachowski Brothers were pitching the idea for *The Matrix* they had to get elaborate storyboards made by top comic book artists so that the studio could understand what they were trying to achieve. Those types of highly finished boards are called presentation storyboards **(fig 02)**, as opposed to the rougher production storyboards that are used as guides.

▶ *The basic concept of storyboards is to tell the story with pictures and words, incorporating direction, sound and dialogue instructions. This storyboard, by The Cartoon Saloon for its short* From Darkness, *shows each shot in the sequence with clearly marked comments about the action, sound effects and 'camera' position. The arrows are used to indicate the direction in which the different elements have to move in the final animation.*

SHOW AND TELL

In a professional studio, once the script is 'finished', a meeting is held with key production personnel such as the writer, director and lead animators. The storyboards are pinned onto a wall and the whole story is run through with dialogue to see how it plays out. This is usually followed by a lively, enthusiastic, and sometimes heated discussion on what works and what doesn't. Although it can be difficult for writers to have their work pulled apart, it is a valuable part of the creative process that allows a story to develop and fresh ideas to be thrown into the mix.

It can't be stressed enough how important the storyboard is in the making of an animation. In live-action a scene can be blocked out and rehearsed, different camera positions and lighting tried and retakes made with relative ease. Animation does not afford you this luxury. All your scenes, shots and angles have to be determined before you commit to commencing the expensive and lengthy animation process. This is doubly important in the labour- and time-intensive cel and stop-motion methods. Everything has to be decided from the outset.

FIG01

SKELETON WOMAN page 4

Arrows indicate the direction of movement

Sq 2 **Sc 90**
Action:Cut to hands winding thread around baited hook. (working noises)

Sq 2 **Sc 100**
Action:Cut to underwater shot. (S.woman P.O.V.camera move) Fish passes by, up and away. boat revolves slowly (uw sound)

Sq 2 **Sc 110**
Action:cut to fish jumping

(Splish)

Sound effects

Sq 2 **Sc 120**
Action: Man looks up excitedly looks down at his work again

Sq 2 **Sc 130**
Action:Cut to hands pulling string, tightening knot.

Sq 2 **Sc 140**
Action:cut to u.water shot looking up at boat, fish passes by. Camera wavers mimicing p.c.v.

Action describes the movement that will need to be animated

Sound effects are written in the first column with other notes

Camera directions are marked by arrows and annotations as to the type of shot

No.	NOTE
01	—WATERFALLS ON BACKGROUND — WATER SOUND ALSO (LIKE A BONSAI GARDEN
02a	02a & 02b = SAME SHOT SPLIT IN TWO DURING EDITING
03	
02b	SW PLAYING THE BRAVE, WISE & OLD MASTER (CHANCE OF A LIFETIME
04	
Date	

▶ *Another approach to storyboard layout is the three-column version, as used by Simon Valderama in creating the animated trailer for the game 'Genocide': one column for notes and directions, one for the images, and one for the dialogue. This is a very good systematic method that works well in conjunction with the dope sheet (see page 76).*

FIG02

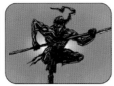

The executioner grabs Nile...

...and in that moment of desperation, Nile waves his hands wildly. Continuing his story he describes a hero...

'and then...suddenly a hero comes to the rescue and his name is – his name is...'

'...Sinbad...!'

And as he shouts the word a hero APPEARS FROM NOWHERE ABOVE HIS HEAD.

He quickly knocks out the executioner...

Nile says 'Did I just do that?' and the Toucan says; 'That's the power of storytelling kid...

...the power to bring your stories to LIFE!'

Liel's dialogue continues even though the camera is on SW. The length of the shot is dictated by the amount of dialogue

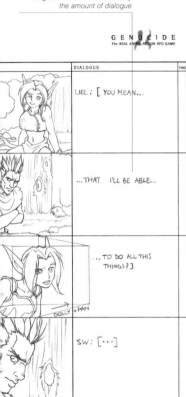

PICKING A FORMAT

How you make your storyboards is up to you. Some people prefer to divide a large sheet into many small screen–ratio-sized boxes. Others prefer to use the index cards mentioned earlier. The advantage of this system is that you can keep notes on the back and they are easier to pin on a wall, plus if you already bought them for helping with the story and screenplay, they are on hand. Whichever way you choose, keep the drawings simple, with one for each shot or key frame. You may want to add visual markers for camera movements such as pans, tracks or zooms **(fig 01)**.

Once there is a general agreement on the content of the script and storyboards, you can move on to the next stage of the preproduction.

FIG04

01 *The voice-over begins with an establishing shot of the tyrant.*

▶ *Here is an example of a tracking shot where the screen size has been added as a white box afterwards. The artist has used a simple method to show the camera zooms and movements. Some of Alfred Hitchcock's storyboards are also famous for this.*

02 *The camera begins a slow descent and zooms in gently to establish the location city.*

03 *The camera appears to tilt – this is done by gradually changing the perspective of the background drawing.*

04 *The camera tracks across the surface of another tent giving us a smooth transition into an establishing shot of the tyrant's subjects.*

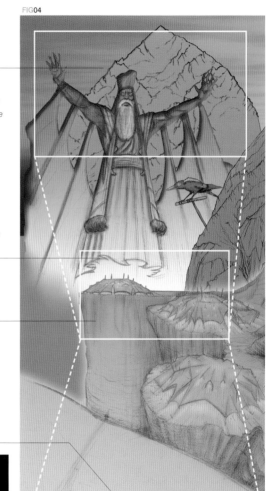

OVER TO YOU

OTY/01
Once your script is finished, make simple storyboards of the first few pages to see how they work together. If you have a DVD player most animated films (especially the 'Special Edition' releases) include multi-angle storyboard comparisons with the finished movie.

OTY/02
When making your storyboards, the quality of your drawings does not have to match that of your final ones. The important thing is to show the action and framing of the shot. As you will be making a lot of these drawings it is better to do them quickly.

OTY/03
If you don't have your own script, try storyboarding a novel or short story, or a sequence from one of your favourite films.

Storyboard Animatics

MAKING A STORYREEL

You've argued and agonised with the other members of the production team and finally have a definitive storyboard. It seems to work when run through as cards on the wall, but that's not how it was meant to be seen. You want to see it on the screen, in real time. A process known as animatics, or a storyreel, is used for this.

This is a simple technique of capturing the storyboard onto video. All you need is a video camera, a tripod, or camera stand (see page 32), and a simple light source. If you don't have access to a video camera you can use a digital still camera or a scanner and compile it together using the methods outlined in the stop-action chapter.

Whether you choose to use a camera stand or to pin your storyboard cards to the wall, make sure that the cards are in the same place each time for registration. The camera stand will have a grid already drawn on its base, but you will have to draw some marker points on the wall if you use this method.

Now you are ready to commit your storyboards to tape. Film each card for as long as you envisage the scene lasting. Your video camera should have a time counter that measures seconds and minutes. How you add the dialogue will depend partly on the equipment available. If you are working with just a single video

FIG01

 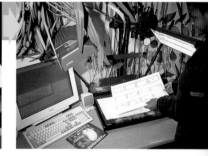

Draw your storyboards. Here they are drawn in frames on a large sheet of paper.

Once you have completed your storyboard sheets it's time to start filming.

A DV camera mounted on a commercial copy stand is used to shoot the animatic. The camera is connected directly to a computer.

FIG02

Set the time for each image on the timeline here. This is set for 12 seconds.

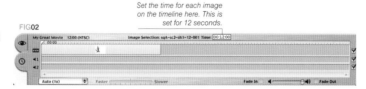

◄ Scanned storyboard frames can be sequenced in programs like iMovie, setting the timeline to match the onscreen time.

camera, get someone to do the voice-over as you film. It won't be perfect but this is only a test for pacing. If you already have computers for editing, record the sound separately and add it later.

Once you have filmed everything, with the dialogue, you will have an approximation of the finished film. Gather your production team

together, and even some friends who aren't involved but whose opinions you value, and study it for pacing. Is a shot too long or too short? Do the transitions between shots and scenes work? Do the camera angles work? Are there too many cuts? Is the overall length right? These are all questions to ask yourself.

The animatic is the final acid test before you commit to production, so make sure it's right. You might be able to resolve some things at the final editing stage, but if you are working with a limited budget it is much better to get it right at this stage, because each frame is going to cost you. This is marginally less crucial when

The storyboard sheet is placed on the copy stand's baseboard. Each frame is positioned below the camera and correctly aligned in the software's viewing window before capturing the right number of frames. The x-sheet is used as a guide. The sound is added afterwards.

FIG05

◄ *Fixing storyboard cards to a wall gives a clear, overall look at the film-to-be. To make a quick storyreel, a handheld DV camera can be used to film each panel while someone reads the dialogue. Whether your storyboard is colour (**fig 03**) or black and white (**fig 04**) is not important at this stage as you are only testing the pacing and dialogue before you commence the long job of making the final animation.*

working in CGI because you can double-check before final rendering, but for the labour-intensive animations, getting it right the first time is essential.

When you are completely satisfied, you are ready to take your animation to the next stage. If you are working in puppet-based stop-motion, you are truly entering the last stages of the production cycle. If you are going for cel or CGI then you still have some intermediate stages before making the final commitment, but get it right now and you will reduce your workload and heartache considerably.

▶ *Taking the highly finished storyboard sketches, produced for pitching their concept for a promotional campaign, Loop Filmworks cut the images together to make a stunning, low-cost ad for HBO's season of The Godfather films. In this case the storyreel became the real story.*

OVER TO YOU

OTY/01
If you don't have access to a camera, use a scanner, numbering each scanned frame sequentially. Composite them using any timeline-based software such as Flash, AfterEffects, Premiere or iMovie (**fig 02**).

OTY/02
If you haven't made a proper voice-over track for your movie, you can record one directly into your computer. A lot of 'consumer' computers come with built-in or bundled microphones that are quite suitable for the purpose of the storyreel.

OTY/03
Be aware that making your animatic on the computer may limit it to being viewed only on a computer. This is not a problem, just something to bear in mind if you want to watch it with other people to get their feedback.

Case**Study**

THE LIGHTHOUSE BY MÅRTEN JÖNMARK

We have already established the importance of the storyboard as a visual aid to the script and as a guide for the animator. In this case study for *The Lighthouse*, a short film by Swedish animator and illustrator Mårten Jönmark, we look at how he sets up the storyline and establishes the mood of this dialogue-free animation.

▶ *Although storyboard frames are traditionally created on cards that can be viewed when stuck on a wall board (hence the name), Jönmark chose to make his smaller. Working alone, it was easier for him to put twelve images on a letter (A4) size sheet of paper that could be easily printed and kept on the desktop. Using coloured images in the initial page helped to convey the mood, while the monotone images were used to advance the action, together with the written directions.*

The film tells the story of a music-loving lighthouse keeper who has problems keeping the beacon lit as a ship approaches. From the first image we see the scene and the overall style set, accompanied by clear animation and sound directions printed below the pictures. As there is no speech, the storyboards also act as the script. Because Jönmark is an illustrator, his storyboards are quite detailed, and complex drawings, some with colour, are used to show changes in scenery and camera angle. These also serve as reminders for making the final drawings **(fig 03)**.

Jönmark said, 'The coloured images in the storyboard were actual backgrounds from the film, just to see how they worked together and if I needed more of them. When I had about half of the backgrounds completed I made quick sketches of those that remained, in the spaces I had left.'

The action sequences are done with much simpler drawings and convey the pacing, with its mix of humour and drama, very clearly. This, along with the coloured drawings **(fig 02)**, was very important when it came to creating the sound track, for which Jönmark enlisted a composer.

'The composer told me it helped him a lot in understanding the nature and the environment of the film by having the coloured background images to work with.'

Having everything clarified at the storyboard stage made the final production of the animation a lot easier to manage. The pencil and charcoal drawings were scanned and coloured in Photoshop. Scenes were set up as multilayered Photoshop files that were imported into After Effects and Premiere (Adobe) for the final animation.

▼ *Storyboards in this format are easy to follow, as most of us are familiar with this style in comic books.*

FIG**01**

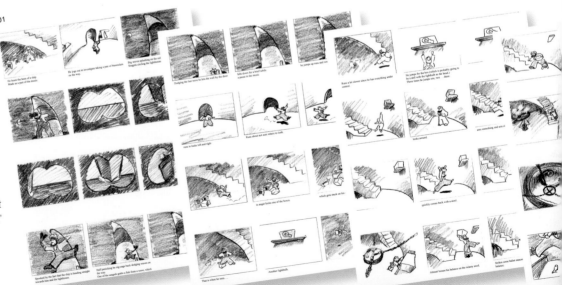

FIG02

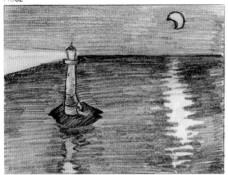

Soft music in the distance
The rotating light flickers from time to time

the music gets slightly louder...

...the closer to the lighthouse we get

the music echoing inside the lighthouse
we can see someone playing far below
slightly rotating and zooming shot

The light coming from above flickers and the
lighthouse keeper stops playing and looks up

▶ *Even though
the storyboards are
quite detailed, with
'camera' angles
and backgrounds,
the finished scenes
are noticeably
different. The
storyboard is only
meant to be a
guide, and your
efforts are better
used in creating the
finished drawings.*

FIG03

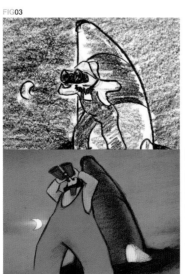

STOP-**ACTION**

FIG01

When you think about it, all animation is stop-action. It is the capturing of individual moments that are joined together to give the impression of movement, whether through models or drawings.

What is generally considered stop-motion or stop-action is the painstaking task of creating and photographing models, or puppets, in a series of minuscule moves. For novices this can be one of the more accessible introductions to the art form, because something can be produced with even the most rudimentary of drawing skills. Raiding a child's toy box, or getting your own old toys from the attic, is all you need to start with. In the hands of an artist, it is raised to a whole new level.

Decades after their creation, the works of Ray Harryhausen still carry a magic that is strong

▼ ▶ *These stills come from part of an internationally produced series,* Animated Tales of the World, *which used puppets and models in stop-action animation. The Welsh story* (**fig 04**) *was animated by Jiriho Trnky Studio in Prague, using carved wooden puppets. 3D Films in Melbourne used clay puppets for its contribution to the series of 15-minute films* (**fig 05**). *Clay was also used by Walter Tournier in Montevideo for the telling of a Latin American story* (**fig 03**). *The English story* (**fig 02**), *made in Russia by Christmas Films, uses puppets.*

FIG02

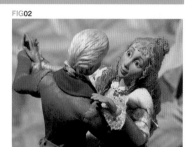

FIG03

▲ *This animated 'talking head', made from wire, fibreglass, latex and a desk lamp by Chris Nunwick, tells its life story as an immigrant in a foreign land. This strange visitor occupied a seat in a corner of the animator's room for months as he shot the movie on an Hi8 DV camera.*

FIG04

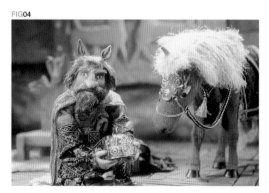

FIG05

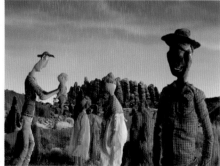

FIG08

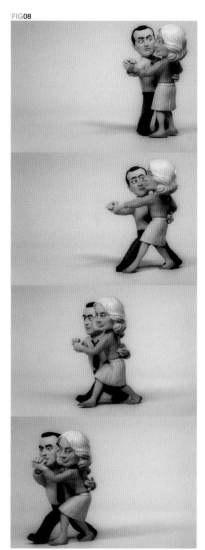

enough to enchant even children brought up on CGI. Part of the magic comes from the story itself, but the rest comes from Harryhausen's love and dedication to his art. Not only did he construct all the creatures himself, but he personally moved every one of them, working through the night to ensure that the colour of the lighting didn't change before he finished a scene. His stop-motion special effects methods were much imitated until CGI took over. In *The Terminator*, the skeletal robot at the end of the film was a stop-motion model animation, as were many of the scenes in the original *Star Wars* trilogy.

TABLETOP HERO

The other stop-motion studio that has created its own unique style is

Aardman, whose specialty is Claymation, the creation of characters out of modelling paste. Their most famous international successes have been *Wallace and Gromit* and the Dreamworks-backed feature *Chicken Run*. They featured great stories, characters and humour, and a fanatic attention to detail that turned inanimate lumps of coloured dough into living creatures.

This chapter looks at the basic techniques for creating your own 3D stop-motion animation using the equipment outlined in the introduction. Both Ray Harryhausen and Nick Park started with the simplest of equipment and a tabletop (and loads of talent), so anything should be possible, given the technology to which we have access today.

FIG06

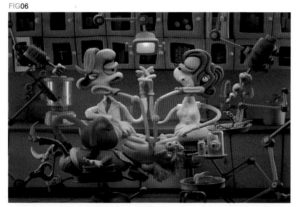

FIG07

▶ *Both these animations were made by Head Gear Animation in Canada. The rather bizarre clay animation (fig 06) was made for Corus Entertainment/YTV by Julian Grey at Head Gear. The second animation (fig 07) was a 30-second commercial for international furniture store Ikea. It used an unusual effect that was created by mixing live-action heads on stop-motion bodies. The loft apartment set was built with scaled-down copies of Ikea furniture, including working miniature lights. The actors' heads were shot first, as they acted out the anticipated animated scene. The heads were later added to the latex and ball and socket puppets using Adobe After Effects. One of the greatest difficulties in making this type of film is making sure the lighting matches in the live-action and animation.*

▲ *Loop Filmworks, in New York, created puppet models of Bruce Willis and Cybill Shepherd, the two stars of the popular 1980s television show* Moonlighting, *for a spot on the US Bravo network. Caricature model animation is popular with advertisers and is also the mainstay of MTV's* Celebrity Deathmatch *and AMC's* The Wrong Coast.

Hardware and Software

WHAT YOU NEED TO GET STARTED

The introduction outlined some of the basic equipment you will need to produce animation at home. If you have chosen to work in 3D stop-action, the equipment you will need is a camera, a tripod and some lights.

FIG01

▲ A useful accessory is a multiformat media card reader. This connects to your computer and mounts the memory card like an ordinary external disk, so you can copy your files without having to move the camera.

▼ Memory cards come in many different formats such as Compact Flash, SmartMedia, MultiMedia Card and Memory Stick. They also come in a variety of capacities – 64Mb or 128Mb are the most useful.

FIG02

The important thing is to buy the best you can afford, whether it be new or secondhand. If you think you want to diversify beyond just animation, get yourself a decent DV camera, preferably with DV in and out. This means you can download and edit your video on your computer, then record it back onto another DV cassette. Other output options are covered at the end of the book (page 154).

For stop-action a DV camera isn't always necessary. You may be much better off starting with an inexpensive digital still camera. Again, always go for the best you can afford. The advantage of a digital still camera is in the quality of the image and (depending on the model) the range of controls. Most digital cameras name shots with sequential numbers (important when importing images into animation software) when they are stored on the camera's memory card or your computer. Choose a camera with at least a 2-megapixel resolution (1792 x 1200 pixels), which should give you more than enough image quality to work with, and that also comes with a removable memory card **(fig 02)**. By upgrading this reasonably inexpensive card you can store hundreds of frames before you need to copy them to your computer. Some cameras, such as web cameras, will even allow you to save images directly to your computer, which will lessen the risk of moving the camera accidentally if you need to change the card. Whatever method you choose, remember to make at least one backup of your work at the end of each session. This is more important than you can possibly imagine.

SUPPORT GROUP

A sturdy tripod is essential **(fig 04)**. This is almost more important than the camera itself. If your camera moves slightly between shots, it is going to show in the finished product. A top-quality studio tripod with a variable head and accurate calibration, and even a spirit level, is ideal. A fluid-head tripod is needed only if you are intending to work with video for pixilation (page 42), or panning shots. The cost of a top-quality fluid-head tripod far exceeds that of a still camera tripod.

FIG03

▲ Desk lamps with photo or domestic spotlight bulbs are ideal for lighting your animation.

◄ Solid floor tripods are essential for keeping your camera in a fixed position

FIG04

LET THERE BE LIGHTS

For your lighting, again, buy the best you can afford. It is important for the lighting to remain consistent throughout the shooting period, which is where photographic lights excel. The beauty of working with digital is that it does not suffer from the vagaries of colour casting that film does. Because any colour imbalances can be corrected with software, you could experiment with a variety of domestic light sources such as desk lamps. You should, wherever possible, work with decent lighting to avoid extra work at the editing stage.

PUTTING IT TOGETHER

You will also need some software that puts all the images into a viewable sequence. Your choice is dictated by your operating system. For Windows users there is Stop Motion Pro, which helps you automate the whole process. For Mac users there is Pencil Test, an excellent and affordable shareware program, or at the top end, Apple's Final Cut Pro. Video-editing software such as Adobe Premiere and Adobe After Effects work on both platforms and are staples in the video-editing world. After Effects is definitely worth investing in for anyone working in animation or any other sort of moving image.

Once you have all the gear, it's time to set it up and start shooting.

▶ *This software can be used for putting together your stop-motion animation, shot with a digital still camera, and also for scanned pencil tests (see page 92). It is a cheap and simple to use solution for Mac users.*

FIG05

Set the final image size here. It ranges from 240 x 180 pixels up to 640 x 480 pixels in the 4:3 ratio. You can also set it to the widescreen 16:9 format. Nowadays this should be the default format you work in if you intend to be broadcast.

This automatically rotates the image as it imports it. This is for line art that has been scanned rather than images shot with a camera.

This will embed a frame counter on the final movie file.

Cadence will automatically set the number of times a frame is used. The equivalent of shooting on twos, threes or fours.

The frame rate can be set according to your final output. This comes with settings for web, film (24 ps), PAL video (25 fps) and NTSC video (29.97fps and 30fps).

This changes your files into a QuickTime movie.

FIG06

◀ *Onion-skinning lets you see through the current frame to a specified number of previous frames. This helps you ensure the smoothness of the movement as well as being able to check that the other parts of the puppet haven't moved when they shouldn't.*

▶ *Stop Motion Pro is probably the best value Windows software for stop-motion animation. With this program, a PC and a digital camera, the actual shooting of your stop-motion puppet is greatly simplified. It has many useful features to help speed up the process and make it accurate as well. The rotoscope facility lets you match your models' movements to that of a live-action video.*

FIG07

OVER TO YOU

OTY/01

Look in photographic shops and the classified ads for secondhand equipment. Finding good used tripods is rare because they hardly ever need updating. Lights should be more readily available.

OTY/02

When buying software for the first time, check to see if there is a working demo available. Shareware is usually fully functional, although there may be some limitations or time-outs if you don't pay the minimal licence fee.

OTY/03

Make sure you are completely familiar with your equipment before you start shooting.

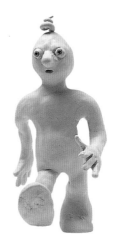

▶ *To build a simple puppet you will need about 1.25cm of balsa wood, aluminium wire, some narrow plastic tube, epoxy glue and modelling clay or paste. You will also need a scalpel or small craft knife, a steel ruler or cutting edge and a cutting mat. These are all available from hobby/craft stores and art suppliers. Aluminium wire is flexible, does not break easily and holds its position well. The balsa and tubing is used to add bulk, and also to support the movable wire skeleton.*

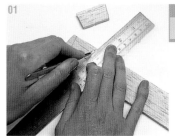

01

Cut the body and head sections from the balsa wood.

02

Use a medium/fine sandpaper to round the edges of the head shape. Plait or twist the wire strands to be used for the bendable joints.

MakingModelPuppets

UNIT/14

BUILDING A PUPPET WITH WIRE, BALSA WOOD AND CLAY

At some time you are going to want to make your own puppets to tell your story. There are many different approaches, but the most popular and accessible is to use modelling clay or paste. For the simplest of animations you can take the lump of clay and use it as it is, but it is still quite delicate and easily damaged.

▼ *These are the body and limb elements required for the figure. The head is laminated from slices of balsa wood. The wire is plaited for extra strength.*

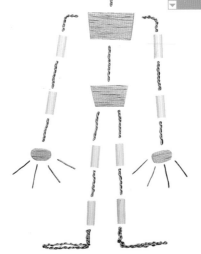

If you are making solid three-dimensional characters, you don't have enough flexibility – or rather the medium has too much flexibility – to make the puppets move convincingly. To get around this problem make a skeleton to support the clay so that the poses remain fixed during the shooting.

The simplest method is to use wire, and in this case balsa wood, to support the clay. These materials should be readily available at most hobby and craft stores. If you want something

more durable, you can use precision-made ball and socket joints that are specifically made for animation puppets. They will probably have to be ordered from specialist suppliers.

With more sophisticated designs the puppets are made from latex cast in moulds. The models are made first in clay, and a cast is made from this model. The ball and socket skeleton is then placed in the mould and the latex poured over it. The expressive parts, such as the face and hands, are

generally still made from clay for the shooting.

Another possibility you can try is to use a wooden artist's mannequin. These are easy to find and relatively cheap. Use clothes to cover the body and then use clay for the head and hands. Whatever method you use to create your puppet, remember that the face is the most important part as this is where all the expression comes from, so concentrate on getting that right above everything else.

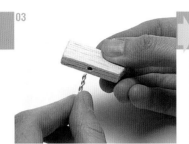

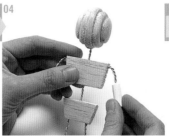

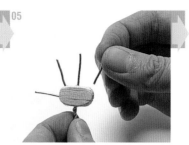

Make small holes in the balsa wood. Fill it with the epoxy glue and push the wire into it, letting it set.

Join the head, chest and pelvis. Add wire for the hip and shoulder joints. Glue the tubes for the arms and legs, with wire at the joints.

Insert wire fingers into the balsa-wood palm. Copper wire can be used for this if you prefer.

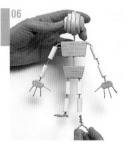

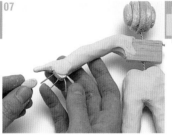

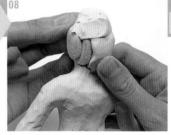

Join the hands and feet to the arms and legs, making sure that the feet are solid and large enough to support the figure.

Start covering the armature skeleton with modelling clay or paste, adding small pieces for the fingers.

Place modelling clay or paste over the wooden head shape.

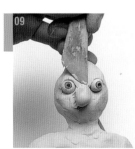

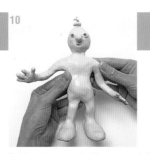

Insert eyeballs made from beads. The holes in the beads enable you to move the eyes with pins for different expressions. Create a nose and attach it to the face.

Build up the puppet with more modelling clay or paste until you achieve the shape you want.

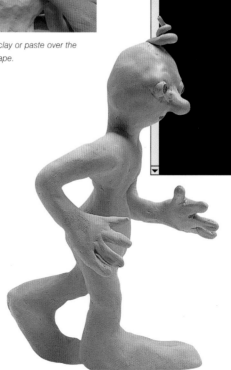

OVER TO YOU

OTY/01
Once you have built your first model, try making an exact duplicate as a backup.

OTY/02
Practise posing the model to find out how far it can move without falling over.

OTY/03
Experiment with facial expressions. These are a vital part of bringing your puppet to life.

OTY/04
Clothe your puppet with garments made from scraps of material for a more realistic effect.

SetsandBackgrounds

UNIT/15

BUILDING A MINIATURE STAGE

Apart from creating the models to be animated, you will also have to make the sets and props in which your characters are going to act. These can be as simple or complex as you wish, depending on the overall style of your production.

FIG01

If, for example, you are working in Claymation, you are more or less obliged to create everything in that medium, to maintain continuity and believability. If you are using something more esoteric, you are free to do whatever you think will fit. You may even choose to create your props from cardboard and paint the detail on them so that they are a sort of 2D–3D. They will be flat but your models (which could be clay) will still be able to move around them **(fig 01)**.

The more complicated you make your models, the more sophisticated the scenery has to be. The attention to detail given to the sets in *Chicken Run* **(fig 03)** matches those of any full-size Hollywood set – but then, they were working with Hollywood budgets.

When you build your props it is important to make them robust. They will need to be around for weeks or months, or, more

probably, longer, depending on the length and complexity of your opus. They will also need to withstand the occasional bump, as accidents are bound to happen. You should make them from materials that will not fade or warp and sag from constant exposure to lights. You should also remember that the scale of your sets must be in relation to your puppets. More important, leave enough space around the props for moving and posing the puppets and positioning the camera if you want to use tracking shots (page 40).

You will also need to think about the ground, or surface, that the

Reproducing the harshness and vastness of the Australian bush on a tabletop, for the short film Bad Baby Amy, *was executed with the consummate skills and local knowledge of the artists at 3D Films in Melbourne, Australia, even down to the perfect replica of the classic Australian car, the Holden FJ Ute.*

FIG02

Combining 2D backgrounds with 3D puppets allows you to create more stylised sets that would be very complex to create in 3D.

 Aardman's feature film, Chicken Run, with its cast of hundreds of models, featured some of the most detailed interior and exterior sets to be made for an animated film. Their exacting attention to detail brought further believability to the characters.

FIG03

FIG04

© 2000 DreamWorks, Pathe and Aardman

FIG05

 For building interior sets, dollhouse furniture can be used. This can be bought readymade, at a price, or made yourself. Dollhouse Style by Kath Delmany has some excellent tips on how to construct rooms and furniture, like those shown in **figs 05 and 06**.

FIG06

 Another in the Animated Tales of the World series (see page 44), this set for King March was built by the famous Prague animation company Jinho Trnky Studios, which specialises in wooden puppets.

FIG07

 Hobby and craft shops, particularly those that specialise in model trains and slot cars, are a great source of materials with which to build realistic outdoor sets.

puppets are going to move across. How much of it do you need to show? Do you need to put blocking markers like on theatrical stages as guides for the characters' movement? If your puppets are particularly fragile or top-heavy, you may need to incorporate cut slots in which to stand your puppets. Try to avoid surfaces that are easily marked or moved, such as sand, or surfaces that are too reflective – unless you need that effect.

As an artist and animator you are, no doubt, filled with ingenious ideas for creating models and scenery from the scraps you find around the house, but sometimes you may want a more realistic effect. If you can't find what you need from the people who supply the armatures and materials for your puppets, you can always try a hobby or craft shop, where they sell model trains and slot cars **(fig 07)**. These outlets are also a lot more common than dedicated animation equipment suppliers.

OVER TO YOU

OTY/01

Consider the style of background, sets and props you want to use. Do you want them simple, to highlight your characters, or sophisticated enough to match them? Do you need any props at all? Is there an alternative way of creating scenery? Can you shoot the puppets on a blue screen and drop them into a 2D or CGI set?

Animating**Objects**

GETTING YOUR PUPPET TO MOVE

When it comes to stop-motion animation there is really no easy way to do it. Each puppet has to be moved in precise, tiny increments, one frame at a time. And the more characters you have, the more complicated it gets. There's no layering possible here, as in 2D.

Keeping the design as basic as you can will simplify matters, but it will also make your animation seem lifeless, unless you can spice it up with sharp and/or funny dialogue, and a captivating story.

Getting your models to move around the set requires a lot of planning. For example, you will need to calculate the distance the puppet has to move, and the time you want it to take to cover that distance, and factor in the length of the puppet's pace. This will require some rudimentary arithmetic to determine the number of poses needed for the walk. Of course, it is not just a matter of moving each leg, because the whole body moves as we walk (see **fig 02**). You will have to remember this as you make your calculations to position each body part. A DVD or QuickTime movie of someone walking is worth studying frame by frame to understand the dynamics of the movement.

When you are shooting a sequence, try to finish it in one session, if possible. It is always a good idea to keep your shots as short as possible, allowing you not only to finish it quickly but make the movie more dynamic. You can also speed up the process by shooting in twos. This means taking two frames for each movement. In fact, shooting in twos is standard practice for all stop-action and 2D animation. If you are using digital stills, you simply duplicate each frame as you import it. The complexity of the movement is what determines how many frames you shoot. It is not unheard of to shoot as many as five frames, but this creates rather jerky movements. If you are shooting an intricate or detailed facial expression, or a scene with many things happening at once, you may need to shoot in ones; otherwise stick with two.

PRACTISE

The only way to perfect the technique of stop-action is to practise. Before you even start making your first scripted animation, do some rehearsals.

FIG**01**

◀ *This comes from a 60-second spot for the Astral Media MFest made by Head Gear Animation. The ball and joint armatures that act as the camera's legs are the same kind that are used for most 3D stop-action puppets, except normally they are hidden beneath latex, clay or cloth. When working with stop-action it is a good idea to keep each shot as concise as possible – this one-minute clip contains 16 separate shots.*

FIG02

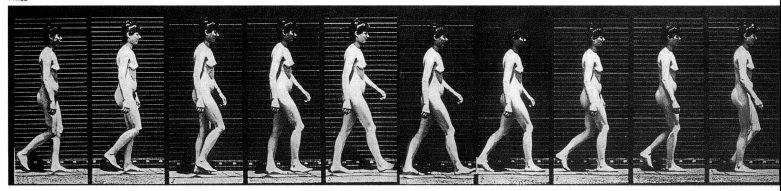

Working in digital can give you almost instant feedback, particularly if you use a dedicated program such as Stop Motion Pro. You will see how smooth each movement is (or isn't) so you can correct it with another take. If you don't want to risk damaging the puppets you have made, try using a small wooden artist's mannequin (see **fig 03**). They are inexpensive and hold poses well. In fact, there is nothing to stop you from using them as a base for your own puppet designs.

Anglo-American photographer Eadweard Muybridge produced tens of thousands of groundbreaking photographic sequences over a period of nearly two decades at the end of the 19th century. These images became, and still are, standard references for artists wanting to study human and animal movement. It was Muybridge's photographs of a racehorse that showed artists had always misrepresented the way a horse gallops, and the photos actually showed that all four of the horse's hooves leave the ground at full canter. Muybridge also designed his own projector called a zoöpraxiscope, similar to the zoetrope and praxinoscope (page 48), to show his photographic sequences.

When posing your puppet in a walk cycle, there are certain characteristics that need to be included to make it look real. Specifically, these are the heel-toe movement of the foot and the swing of the arm opposite to the leg – for example, as the left leg moves forwards the right arm swings forwards at the same time, while the left arm swings back slightly. The body and shoulders tend to sway towards the supporting leg as well. Before working with your own puppet, practise getting the movements right with an inexpensive, wooden artist's mannequin. Start by imitating the photographic sequences here, then play them back to see if you need to add some extra in-between poses to get a smooth movement.

OVER TO YOU

OTY/**01**
Buy yourself a copy of Muybridge's *The Human Figure in Motion* and/or *Animals in Motion* which are available from Dover Books at a very reasonable price. They are both invaluable resources.

OTY/**02**
Always plan and time the movements of your puppet. Working with a dope sheet (page 76) will help you to break down each sequence frame by frame.

FIG03

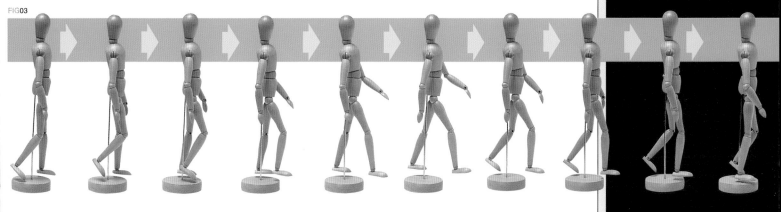

Capturing**Movement**

MOVING PUPPETS AND CAMERA

One of the big problems with tabletop animation is capturing movement effectively. in the previous pages we covered getting the models to move, which comes with a lot of practice and trial and error; unfortunately there is no other way.

A D-shaped mount is used for the neck to ensure proper registration of the head when it is replaced after adjusting the mouth.

FIG02

The problem comes when we try to make the camera move – the panning, tracking and zoom shots we are so familiar with in films.

The easiest solution is not to use these types of shots. If you think that they have to be in there, you will need a computerised mechanical rig. This will move the camera in the exact minuscule increments necessary to avoid jerkiness. Unless you have a benevolent patron or know someone who owns a studio, that

isn't going to happen. So in what way can you add dynamics to your animation?

The answer is planning and faking. The best way is to make your camera movement the action in a scene. Choose a scene where your characters are inactive, and shoot it as continuous video rather than stop-action. Panning shots across scenery are not a problem provided you are using a fluid-head tripod. Zoom shots, likewise, can be successfully executed with

▼ *Working with clay models is all about adaptation and faking it, since only the parts that show on screen are made. The puppet here exists only from the waist up, and the set is a single, flat panel. A shot like this would have no camera movement as the focus is the puppet's movement.*

A single sheet of board, painted to represent one wall of a room. No complex set building needed here.

A box of prepared visemes, ready for fixing to the puppet's face.

Movements of small, delicate areas, such as fingers, require very careful manipulation so as not to damage them.

A sheet of white card acts as a reflector to soften the shadows on the puppet.

Rather than building a complete puppet, the part that does not show can be replaced by a simple mount.

When the prepared mouth shapes are placed on the puppet's head, the seams have to be hidden by smoothing some clay over them.

▲ *Facial expressions are what bring clay, or any other puppets to life. Eyes and mouths are the most expressive. To get accurate mouth shapes for speech, a set of visemes (see page 88) is created that can be added to the head for each shot.*

FIG01

a video camera on a tripod. Tracking shots are a lot trickier. You could try doing them hand-held, but working in miniature would emphasise any irregularities of movement. Using a wide-angle lens will improve this. Using a Steadicam may help, but like any professional equipment, it is expensive. The other problem with these solutions is how to finish the tracking shot, as the camera will need to be mounted on a tripod to begin the animated sequence. One solution would be to start the

animation with a different camera angle. This would have to be planned at the storyboard stage, but if done well it can prove to be very effective.

If you are using a digital camera, you are faced with even more restrictions, but it is not impossible. For a panning shot, take a picture of the whole width of the scene at as high a resolution as your camera will allow, or take several shots and join them together with one of the many panoramic software

programs available. Now open the picture in After Effects and pan across the scene, using the software. The same technique can also be used for zooming. You could try doing tracking shots this way, but it would not capture movement through a 3D plane as effectively as 2D (see page 138). Start your next animation shot using the same method described above for a video camera.

Another option is to try different camera angles. Just as film crews have a second unit, you can try

shooting with two cameras. The cost of a second camera and tripod will be minimal compared with the time needed to reshoot a scene. You can then cut between the two different angles for added dynamism. It is a good idea to keep your shots as short as possible anyway, so that you can finish making each scene quickly.

Experimentation is the key. You won't know what works for your film until you try it. Watch out for shadows being cast by the equipment as you move around.

▶ *Make sure your puppets and props are positioned the way you want them in the set. It is important that your puppets are flexible enough to move naturally, but not too loose to maintain a pose or too stiff to reposition.*

FIG03

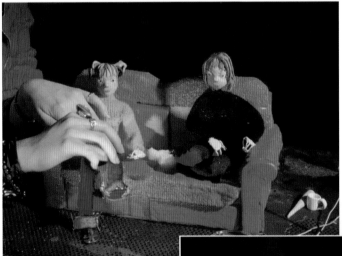

◀ *Once the puppets are in position you can start posing them. Make sure all extraneous props and tools are out of view.*

FIG04

▶ *Check your lighting and framing through the camera's viewfinder or monitor and shoot the first of countless frames you are going to need to make the sequence.*

FIG05

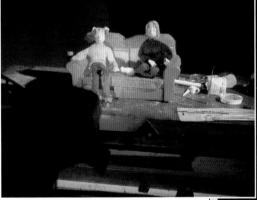

OVER TO YOU

OTY/01
Don't be too ambitious with your camera shots. Always ask yourself if the fancy camera movement is necessary to advance the story.

OTY/02
Seriously consider a two-camera shoot. Make sure you use identical cameras to get consistent colour. Two cameras will give you extra options at the editing stage and, depending on your choice of equipment, it shouldn't be very expensive either.

Time-Lapse

UNIT/18

MORE SINGLE-FRAME TECHNIQUES

Time-lapse photography takes the principle of stop-motion animation and applies it to the real world. We are probably all familiar with documentary films showing flowers opening in a few seconds or the day passing from sunrise to sunset in a minute. This technique simply involves taking one image frame at a specified interval, whether it is once a second, once a minute or once an hour, and playing it back at regular (24fps) speed.

FIG02

This technique requires the use of professional-level equipment with an interval timer function, whether it is a 35mm single lens reflex (SLR), 16mm movie camera or a digital still or video camera, unless you are prepared to sit with your watch and manually open the shutter at the exact moment. Alternatively you can create your own timer device.

Time-lapse is not a technique you will use very often, but it is an extension of the stop-motion idea and worth knowing about if you need to compress time to move quickly from one scene to another. It lends itself more easily to live-action films than to the traditional idea of animation.

PIXILATION

Another technique of stop-motion using real people is pixilation. There does not seem to be any traceable origin for the name or how it relates to the method, but it is a variation on our theme. Pixilation isn't as exacting as other forms of stop-motion in which you have to record the 24 individual frames to make up the one second of film. Part of its charm and uniqueness lies in the jerky nature of the filming, much like the early silent films that were made with hand-cranked cameras. With this technique you take very short bursts of film or video (three to twelve frames) of your actor in a pose, then have him (or her or it)

move to the next position and repeat the process. Obviously, your camera, as with all stop-motion, has to be mounted on a tripod. Pixilation does tend to be used mostly for comedy situations, although not exclusively. You can, for example, have your actor sit on the ground in the pose of a person driving a car and give the impression of him driving along a road without a vehicle.

This technique has several drawbacks that you will have to watch out for, mainly concerning the shooting environment. Because it is time-consuming, like all animation, and is most likely to

FIG01

 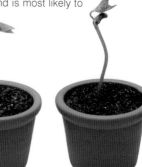

▲ ◄ Carefully timed sequences of natural phenomena can reduce days into seconds, whether it is growth or decay.

FIG03

43

be shot on location, you have to watch out for things that could move in and out of the background, whether passers-by, cars or animals. Note how light and weather conditions change throughout the day. Be especially aware of clouds changing, and the effect of the wind on vegetation, not to mention the possible strain on your actors!

This technique has been used very successfully by Darren Walsh in his *Angry Kid* animations for Aardman **(fig 03)**. He has coupled this with his own technique known as mask replacement, together with a bizarre sense of humour, to produce a truly unique series of shorts.

BULLET-TIME

Another extension of the time-lapse/stop-motion technique was employed by John Gaeta for the famous bullet-time shots in *The Matrix*. This also uses a series of still images, but unlike time-lapse, which is used to compress time, it is used to expand time so that a fraction of a second lasts for several seconds as the camera appears to move around the action. The amount of equipment needed definitely limits it to big-budget films, although it can 'easily' be emulated in a 3D CGI environment, as in the fight scene in *Shrek*.

Although these three techniques may not be perceived exclusively as animation, they use the same methodology to produce a stunning range of effects and possibilities for the animator.

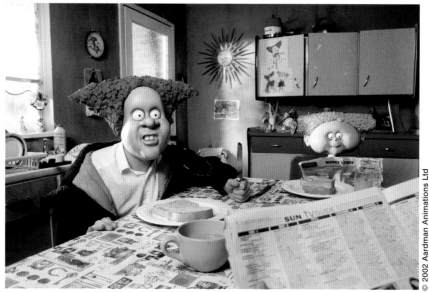

▲ *The wickedly funny* Angry Kid *short films were made by Darren Walsh for Aardman using a combination of two techniques. The character of Angry Kid is an actor wearing a mask; his little sister is a puppet. Each facial expression and mouth shape is a different mask that has to be changed for each shot. Using a live actor meant that the short (approximately one minute) films had to be shot as quickly as possible, which is where the pixilation process helped.*

INTERVAL FORMULA

Working out the interval between shots for a time-lapse sequence requires some mathematical calculations. The formula is simple, but it requires a little preplanning and investigation on your part. First you need to decide how long the finished sequence is to run (10 seconds) to compute the number of frames to be photographed. Second, you need to time the length of the action that is to be filmed (20 minutes). When you have these two figures you can calculate the interval with the following formula:

STEP 1: *Running time multiplied by frame rate* per second = total frames (10 seconds x 24fps = 240 frames)*

STEP 2: *Event time in minutes multiplied by 60 = total seconds of event (20 minutes x 60 seconds = 1,200 seconds)*

STEP 3: *Total number of seconds divided by number of frames = interval between frames/shots in seconds (1,200 ÷ 240 = 5 seconds).*

** Frame rate depends on which format you are shooting. 24fps (Film), 25fps (PAL video), 30fps (NTSC video)*

▼ *A stopwatch is a useful animator's accessory and tool for timing shots. When manually shooting time-lapse it becomes indispensable. If you are buying one, look at digital ones too, as they will have more programmable features and possibly even audio alarms.*

OVER TO YOU

OTY/01

Look for ways to combine time-lapse photography with other types of stop-motion animation. For example, place an animation puppet amongst some plants and move it in conjunction with the timed shots.

OTY/02

As an exercise, get some friends to help you shoot a short pixilation film. Remember, if it is shot in natural light, it has to be done as quickly as possible.

Case**Study**

INTERNATIONAL COLLABORATION

Animation, at the professional level, is a team effort and this spirit of collaboration is very much behind Right Angle's international award-winning animations.

FIG03

▲ *The Jiriho Trnky Studio in Prague utilised unusual carved wooden puppets for the Brothers Grimm story* The Enchanted Lion, *from Germany.*

FIG01

FIG02

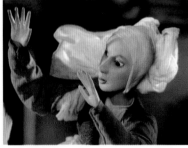

▲ *Using the works of Flemish painter Pieter Bruegel as the basis for the design of* The Tree with the Golden Apples, *Christmas Films in Moscow made the puppet animation to tell this comic love story from the Netherlands.*

This small company, run by Penelope Middelboe and Martin Lamb and based in Tenby, near Cardiff, has been the creative and driving force behind cinema and television animations that have brought to life traditional and religious stories from throughout the world. Working in conjunction with the Welsh language television channel S4C, Right Angle researches, writes and oversees the whole production process, utilising animation studios from around the world.

Right Angle's focus is always primarily on the storytelling, and is never more evident than in the *Animated Tales of the World*. This series of 26, 15-minute films took traditional tales from as many nations and used a host of international animators to bring them to life. Right Angle's experience gained from previous productions, such as *Animated World Faiths*, *Animated Epics* and the feature film *The Miracle Maker*, coupled with S4C administrative support, meant a logistical nightmare was averted, allowing them to do what they do best.

Right Angle's Amanda Blake said, 'We were left to concentrate on the choice of stories, to edit the scripts, to organise the voice recordings, monitor the animation and supervise the post-production. We approached the storytelling with a simple aim: "No nation is poor in stories and we are all enriched by sharing them. So, let the village storytellers in each nation become global-village storytellers to children everywhere."

'Children the world over understand the conflicts of good and evil, and the sense of yearning and dread, from which stories are spun. Animation can reveal to them the colour, drama and excitement of this world heritage, and help them realise that their story can also be someone else's.'

FIG04

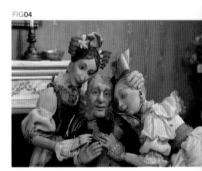

▲ *The English tale,* Cap O' Rushes, *was made using intricately detailed puppet animation by Christmas Films in Moscow.*

FIG05

▶ *The Chief and the Carpenter from Latin America is a tale of regal folly and its environmental consequences. It was animated by Walter Tournier in Montevideo, using clay models.*

FIG06

45
CASESTUDY

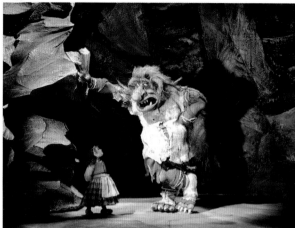

◄ *The huge, child-capturing troll in* The Hen's Running About in the Mountain, *was bought to life by Moscow's Man & Time studio for this Norwegian tale, also known as* The Three Sisters Who Fell into the Mountain.

FIG10

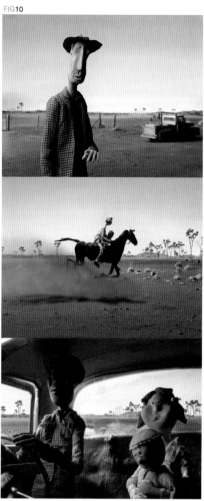

FIG07

▶ Aunt Tiger *is a story from Taiwan of an old tiger who discovers his dream to become human is possible if he eats three children in one sitting. But he is defeated by a clever little girl. The animation was done by Aaargh! in Wales.*

▼ King March *is a Welsh tale of a king with something to hide under his crown. It was made by Czech puppet animators Jiriho Trnky Studios.*

FIG08

With that dedication to the story, and the animation talents of studios such as Christmas Films in Moscow and Czech animator Jiri Barta, a truly unique body of work was produced that has garnered a mass of international animation award nominations and prizes.

Apart from the production of these international animation series, Right Angle is also actively involved in fostering new animation talent with its involvement in S4C's initiatives such as 'Short Shorts' and the 'Cartoon Forum'.

FIG09

▲ *The moral tale,* The Crown and the Sceptre, *of a mean merchant and an honest beggar, comes from the Gulf States, in the Middle East, and was told with humour using puppet animation from Man & Time in Moscow.*

▲ Bad Baby Amy *is an Australian tale from the drought-stricken outback. It was made by Anthony Lucas, of 3D Films in Melbourne, using modelling paste. The limited number of characters in the story made it easier to create using this medium. The sets were meticulously built to capture the intensity and harshness of the environment to the full.*

SIMPLEANIMATION

UNIT/20

What qualifies as simple animation? Some basic forms of 3D stop-action could, if found objects such as toys are used, and this is covered in the previous chapter. This chapter concentrates on 2D animation and looks at a variety of styles that use found objects, such as clip art, and combines them with stop-motion techniques.

This, and the other styles covered in this chapter, should be within reach of most people and require the absolute minimum of equipment. Any old computer and scanner will do the job. The beauty of these techniques is that they will also give an understanding of the fundamentals before you embark on a larger or more serious project. That is not to say that these aren't valid art forms in their own right, but they do tend to work better as short pieces. They are rather quirky, and may not always appeal to the younger, more sophisticated audience brought up on computerised 3D spectaculars.

Terry Gilliam, whose films include *Brazil*, *Time Bandits* and *Twelve Monkeys*, made some surreal and humourous animations for the 1970s cult British comedy series *Monty Python's Flying Circus*, using collage. Everybody's favourite preschool show, *Sesame Street*, always features an amazing range of simple animation techniques that use collage and cutout as well as simple line drawings. Because these animations use key strokes that are right there on your computer's keyboard, you can easily make something that is entertaining, educational and artistic all at the same time, with the simplest of software applications.

At the other end of the scale we have *South Park*. It is still incredibly simple in its approach to form, but its story and dialogue take it out of children's viewing time. The cult following it has amassed highlights the point that animation does not need to be sophisticated or lifelike to get its story or message across, and a lot of *South Park*'s success

FIG02

◀ *Making simple, jointed puppets from cutout cardboard is an easy way to start making animation. They can be shot with a video camera, digital still camera or an old Super 8 movie camera.*

FIG01

🔽 *Heli Kainulainen's The Town of the One-Handed People, is a hand-drawn and coloured cutout animation that was composited using After Effects. Despite its simplicity, this four-minute animation won the award for best short film at The London Science Fiction and Fantasy Film Festival 2003, against competition from longer and more sophisticated special effects and nonanimated films.*

FIG04

▶ Angela Anaconda *not only took cutout/ collage animation to a new level, but also raised people's perception about what could be achieved with the technique (see Case Study on page 68).*

Euro piAno SuPer

FIG03

FIG05

◀ *This cutout animation, by GB Hajim, was given extra depth and features by being airbrushed in Photoshop before being animated in After Effects.*

FIG06

is attributable to the simplicity of the animation. The irony is that it is now made with Maya, the same 3D software used to make *Final Fantasy: The Spirits Within*, one of the most realistic animations to date.

This chapter looks at a range of simple animations using pen and paper, starting with flipbooks, then using a camera or scanner and a computer, and then how to achieve the same effects entirely digitally with affordable, off-the-shelf software. What you do with the methods outlined, as always, is entirely up to you and your own imagination.

▲ *Letters cut from newspapers and magazines can be animated to make interesting titles or short educational animations, like those on* Sesame Street.

▶ *Rotoscoping is another technique that can be used for creating animations, without having any great drawing skills, by drawing over an existing film. This was used by Sverdlovsk Studio to produce* John Henry, *as its contribution to the* Animated Tales of the World *series (see page 44).*

AnimationHistory

THE EARLY DAYS

The history of animation starts in the early 19th century and has been inextricably linked with the development of still photography. This brief outline of their development will help give you an insight and understanding of how animation works.

Earlier we established that animation is made from a series of still images shown in sequential order, most commonly the 24 frame-per-second of projected film. These still images appear to move because of a phenomenon known as 'persistence of vision', in which the eye retains the projected image for a fraction of a second before it is replaced by the next one. The brain is then tricked into seeing this rapid sequence of images in the way most familiar to it – movement.

The earliest examples of moving pictures started to appear in the 19th century. A Belgian physicist, Joseph Plateau, invented a device called a phenakistiscope (fig 02). This was a disk with a sequence of eight drawings that were viewed through slots and reflected in a mirror. The next step was the zoetrope (fig 03), invented by the Briton William George Horner. This too used images viewed through slots, except this time they were drawn on the inside of a spinning drum. The sequences were short and repetitive, but still captivated viewers.

With the invention of photography, moving images took another step forwards. Eadweard Muybridge created a collection of photographs that are still used as reference material by animators to this day. By setting up a bank of cameras he was able to capture sequences of human and animal movement (figs 01 and 04). A more sophisticated version was recently adopted by John Gaeta for the 'Bullet time' sequences in *The Matrix* to halt motion.

Around the same time, a French painter, Emile Reynaud, took the concept of the zoetrope and amalgamated it with a magic lantern projector to create what was essentially the first animated film. His invention, the praxinoscope (figs 05 and 06), used up to 500 images on a strip of gelatin that was wound on a hand-cranked spool to make a show lasting up to 15 minutes that Reynaud called *Pantomimes Lumineuses*. What makes this machine significant for the generations of subsequent animators is that it told a story using drawings.

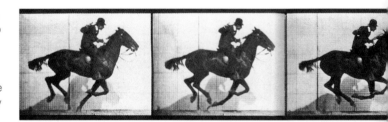

▼ *Using the system shown below (fig 04), Eadweard Muybridge was able to show for the first time that all four of a horse's hooves left the ground when galloping.*

FIG02

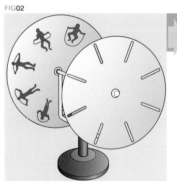

1832 Discs from a phenakistiscope, one of the earliest methods of animating a sequence of images.

FIG03

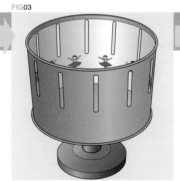

1834 The zoetrope's simple construction was cheap and easy to produce, making it a very popular form of entertainment.

Shortly after this came the Lumière brothers and what is recognised as the first cinema. Their earliest efforts were mundane, and the excitement of the technique soon dwindled. The public wanted to see stories, not everyday life.

As the cinema grew, so did animation. The public was already familiar with stories told through illustration. The accidental discovery of substitution by stopping the camera and replacing one object with another logically led to the development of stop-motion photography, or trick photography as it was known then. This soon split into the two different camps, line and 3D puppet animation, whose techniques remained almost unchanged until the introduction of computer-generated images.

Over the years came the rise of the master animators such as the Fleischer brothers, Paul Terry, Walter Lantz, Chuck Jones and, of course, the man whose name is synonymous with animation, Walt Disney. On the 3D side there was the legendary Ray Harryhausen and the unpredictable and eccentric Jan Svankmajer.

The arrival of television gave animation a huge boost as the networks needed short-duration children's entertainment. Companies such as Hanna-Barbera, produced hundreds of episodes featuring characters that became household names. They were not as well-crafted as Disney's feature films, but they were just as entertaining, and series such as *The Flintstones* are still popular today.

The history of animation is longer than that of live-action cinema, and filled with as many stylistic variations as there are animators. It's a fascinating subject to study to get a better understanding of the art form.

OVER TO YOU

OTY/**01**
Suggested Reading

The Art of Walt Disney by Christopher Finch

Of Mice and Magic by Leonard Maltin

That's All Folks by Steve Schneider

Masters of Animation by John Grant

The Encyclopedia of Animated Cartoons by Jeff Lenburg

Cartoons: One Hundred Years of Cinema Animation by Giannalberto Bendazzi

Before Mickey: The Animated Film 1898–1928 by Donald Crafton

FIG**01**

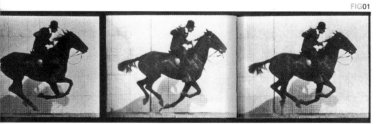

FIG**04**

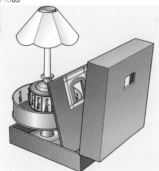

FIG**05**

FIG**06**

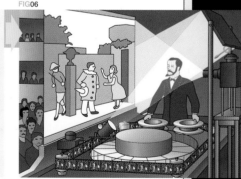

1872 Eadweard Muybridge's groundbreaking photographic work has been a source of reference for over a century. The bank of cameras was activated by the horse breaking the trip wires as it passed.

1892 Emile Reynaud's praxinoscope **(fig 05)** *was developed and enlarged to become Théâtre Optique* **(fig 06)**. *This was essentially the world's first back projected, drawn animation which ran for about 15 minutes.*

Flipbooks

UNIT/22

MAKING YOUR FIRST ANIMATION

The most basic form of do-it-yourself animation has to be the flipbook. This involves making drawings on small sheets of paper or card that can be easily held and thumbed. The flipbook is a variation on the earliest forms of moving images, such as the zoetrope, and is an ideal introduction to the basic techniques used in cel animation.

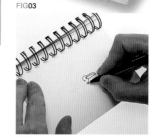

FIG03

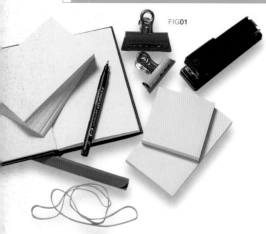

FIG01

SELECTING YOUR MATERIALS

You will need some paper or thin card. Paper should be thicker than standard copier (80gsm), but card should not be too thick, or you will not be able to see the underlying image. A pocket sketchbook that is already perfect-bound or ring-bound would be a good choice. Index cards are another possibility, and are something you will always find handy while working on an animation, from the writing stage onwards. You could even use a pad of peel-off reminder notes. The important thing to remember when selecting your stock is that it needs to be robust enough to withstand flipping but thin enough to allow tracing.

A black pen is best for drawing, to ensure that you can see the linework through the paper. You may want to start with a pencil sketch to get the first image right, before you ink it. If you want to add colour or shading you can do this at the end, as you would with cel.

You may also need a lightbox **(fig 03)**. This is a device that shines a light through your paper or card to make tracing easier. It is usually a metal box with fluorescent tubes inside (incandescent bulbs give off too much heat), covered with white glass or Plexiglas. These are available from most photographic or graphic arts suppliers. You may find them secondhand, or you

 The lightbox is a vital piece of equipment for a pencil and paper animator. Place your paper on the box and trace through. A standard lightbox can be adapted with the addition of a peg bar.

 Flipbooks can be made with a variety of papers from index cards to the corner of a book, and bound together with common stationery items, such as staples and bulldog clips.

 A flipbook is simplicity itself. Just take it firmly in one hand and fan through the pages with the thumb of your other hand.

FIG02

FIG04

51

◀

FLIPBOOKS

◀ *Something simple like a drop of water is ideal for creating a flipbook. Trace this onto one of the suggested media shown in* **fig 01**.

▶ *Taking the idea of a flipbook literally, Chris Nunwick took an old paperback novel as the base onto which he drew his animation. Rather than keeping it bound together, he shot each page with a camcorder to make a more traditional stop-motion animation. This could also be done using a scanner, as outlined for making a pencil test (page 92).*

could even build your own. If you are serious about pursuing 'traditional animation', a lightbox will be one of your essential tools, and it may be worthwhile getting a proper animator's one (page 72).

Finally, you will need something to hold all the loose pages together so they don't spill into a messy pile on the floor. The best is a bulldog clip or a plastic slide binder, but a strong elastic band or big staples can be used.

DOING IT
Like everything else in this book, you need to start with an idea. Because of the nature of the format it has to be simple, something that is going to last just a few seconds **(fig 04)**. A puff of smoke. A drop in the ocean. A snack. A sneeze. These are all

things you could animate. Whatever you decide to animate you have to start at the end and work backwards, tracing over the previous image, altering it as necessary to capture the sense of movement. Because this is no more than a fun exercise you don't need to be working to 24fps accuracy; the eye and mind will fill in the gaps. Once the drawings are finished, clip them together and marvel at your first moving pictures.

Hang onto these drawings, not just because they will be worth a fortune when you are a famous animator, but so you can use them to make an animated GIF (see page 106).

(page 72).

(see page 106).

OVER TO YOU

OTY/01
In addition to the suggestions for drawing on books and peel-off reminder notes, find some other media or original ideas suitable for creating flipbooks.

OTY/02
Flipbooks require only a simple idea or sequence to animate. Write a list of actions that would be suitable and start drawing them. The drawings can be quite simple, even matchstick men, but it is the accuracy of the movement and the registration that makes them work.

OTY/03
On page 106 are some sequences of animated GIFs. Try tracing them to get the feel of working with line drawings.

FIG05

Rostrum Camera

FROM CELLULOID TO DIGITAL

Until the rise of digital technology, animation was always shot on film – from 8mm to Super8, through 16mm up to 35mm, and even 70mm for cinema releases. Most serious home-based animators would shoot on 16mm. It was reasonably affordable and easily adaptable to theatre projection.

For 3D stop-motion the camera (usually a Bolex) was mounted on a tripod, but for 2D a camera stand called a rostrum was used. This is essentially a vertical column with an adjustable camera mount fixed to a base board with a lighting source. There are variations on this theme but that is the basic format. The most important thing is that it should be stable.

Many different styles of bases can be used for cel animation, from the simple to the complex. Your animation and budget will dictate which type you use. If the animation is straightforward, with no camera movement, you can use a simple platen. This is a piece of optical glass on a spring-loaded hinge that keeps the artwork flat and still while it is being photographed. It will also have a peg bar (page 50) for registration when working with cels. You could even construct your own.

If you want anything more sophisticated you will have to buy it, as you are entering into the world of precision mechanics. These professional-level rigs are designed and constructed to accommodate all manner of movements with very precise and automated controls. These set-ups can be expensive, although you may be able to find them secondhand. They are also primarily designed to be used with film cameras so you need to acquire one only if you intend to work with film. Most things now can be done on the computer.

USING A COPY STAND

Because so much work in cel animation is now done digitally the rostrum is a bit superfluous, but if you want to work in simple animation, such as cutout and collage, you will still need a camera stand. It does not need to be complex, as long as it is sturdy and adjustable. The base board can be plain, although a grid to keep everything square is a good idea. You may also prefer to work without a platen, because quite

MOUNTING METHODS

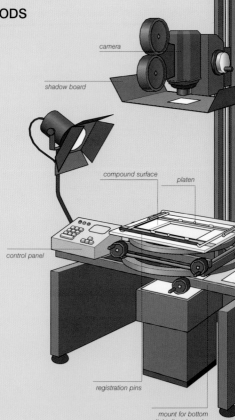

▶ *A rostrum is not a piece of equipment you are ever likely to buy, unless you find one at a car boot sale. This is a curiosity from the realms of cels and film, and requires an experienced operator to take full advantage of its complex processes. The pantograph has a series of plotting points and lines that help the cameraman with a particularly complicated sequence of movements, by moving a pointer connected to the compound. The compound is what holds the cels. This can move laterally and vertically and, depending on the model, rotate as well. These movements are determined by the instructions written on the dope (or exposure) sheet.*

camera

shadow board

compound surface

platen

control panel

registration pins

mount for bottom lights/hand cranks

pantogr

often your cutout will have depth or texture that you won't want to flatten under the glass. You could use a tripod but it is more advisable to use a dedicated piece of equipment.

Many photographic stores sell copy stands that come with lights already attached. Mainly used for photographing books and other manuscripts, they make an ideal option. They can easily be found secondhand. Most modern digital cameras come with a standard-sized tripod screw mount, so you should have no problem attaching your digital still or video camera.

LIGHT SOURCE
The other thing to consider is lighting. It is important to choose the right kind. Working with digital does not present the same problems as film when it comes to colour temperature (a huge topic that is not possible to cover in this book), but heat is still a problem. This can be particularly bad with cutout animation, because your character could start to curl. Low-wattage domestic spotlights are a good option and should fit into the copy stand's sockets. If possible, choose a copy stand with four lights so that you still get good light coverage with the low-wattage lamps but without lots of heat.

Once you have your camera stand set up you should be ready to start shooting your animation.

OVER TO YOU

OTY/01
Track down an animation studio that still has, and uses, an old-style rostrum camera (good luck!). Ask if you can see it in action.

OTY/02
If you are of a practical nature you could make your own platen from a piece of optical glass mounted onto hardboard.

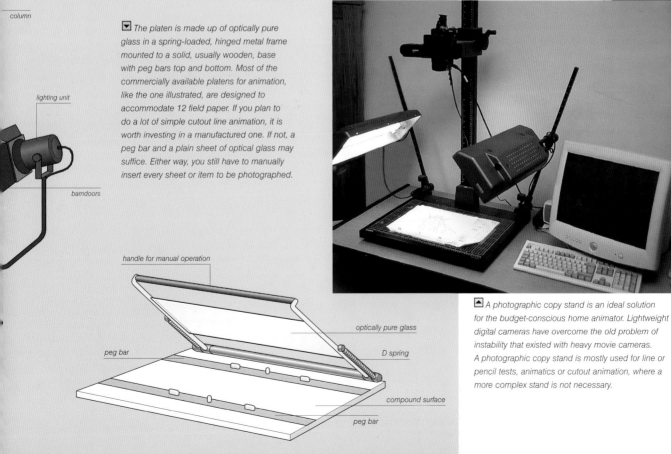

column

lighting unit

barndoors

▼ The platen is made up of optically pure glass in a spring-loaded, hinged metal frame mounted to a solid, usually wooden, base with peg bars top and bottom. Most of the commercially available platens for animation, like the one illustrated, are designed to accommodate 12 field paper. If you plan to do a lot of simple cutout line animation, it is worth investing in a manufactured one. If not, a peg bar and a plain sheet of optical glass may suffice. Either way, you still have to manually insert every sheet or item to be photographed.

handle for manual operation

optically pure glass

peg bar

D spring

compound surface

peg bar

▲ A photographic copy stand is an ideal solution for the budget-conscious home animator. Lightweight digital cameras have overcome the old problem of instability that existed with heavy movie cameras. A photographic copy stand is mostly used for line or pencil tests, animatics or cutout animation, where a more complex stand is not necessary.

Software

A DIGITAL TOOLBOX

Once you move past flipbooks, simple animation takes you and your craft kit on to cutout and collage. although reasonably similar in approach, they can be very diverse in results. Whether you choose to go down the camera-stand route or to use a scanner, you will need some software to put it all together.

Photoshop is essential. It is, for all intents and purposes, the default pixel-based image-editing software. It is the standard platform for plug-in compatibility – plug-ins being add-on third-party filters and effects. Because of its ubiquity, the best graphics programs also include compatibility with the format. Photoshop is excellent for still images but is not designed for movement, so once you have your pictures looking the way you want them, you have to move them into another program. For optimum integration with Photoshop your best option is After Effects. It may be overkill if you only intend to comp together cutout animation, but as an all-around animator's tool it is a necessity. It can do everything from titling (page 66) to rotoscoping (page 64) to a host of video and animation special effects that are reinforced by its own range of plug-ins. Premiere, Adobe's video-editing software, also works in unison with Photoshop, and can easily be

▶ *Painter* **(fig 01)** *and Photoshop* **(fig 02)** *are both principally image editing programs, designed to manipulate pixel-based images. As such they both have a similar range of tools, as can be seen by the tool palettes. They differ in their approach to the tools: Photoshop has divided its brushes and other 'pixel-pushing' tools into a group of eight; Painter has one Brush tool but one that does everything the Photoshop ones do, and then some. Apart from Photoshop's tool for adding notes the rest are the same: Text, a Pen tool for drawing bezier curves, image cropping and, for animators, the vital Paintbucket.*

FIG01

FIG02

FIG03

FIG04

◀ *What sets Painter apart from Photoshop is its overwhelming array of brushes* **(fig 03)**. *They go way beyond just simply emulating brushes. There is every artist's tool imaginable, from airbrushes to scraperboard tools, from coloured pencils to oil paint, and each one is totally editable. Photoshop brushes are also customisable* **(fig 04)** *but are more geared towards production work and retouching than emulating other media.*

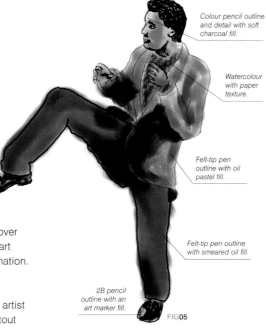

Colour pencil outline and detail with soft charcoal fill.

Watercolour with paper texture.

Felt-tip pen outline with oil pastel fill.

Felt-tip pen outline with smeared oil fill.

2B pencil outline with an art marker fill.

FIG05

◀ Getting the huge array of artist's tools in Painter to work well takes a lot of practice and experimentation with the masses of editable variables. It is the ultimate mixed media tool. This rotoscoped frame uses eight different 'media', purely for demonstration purposes.

adapted for comping stop-motion frames together. These can all be bought together as a reasonably-priced video production bundle that will cover just about all your needs, apart from generating 3D CGI animation.

PAINTER

If you are a struggling (poor) artist and want to create digital cutout animation, Procreate Painter is an excellent and diverse program. Known for its natural media tools that simulate the whole gamut of artistic media **(figs 03–05)**, it also has animation tools that even include onion-skinning, a technique where you can see the underlying layer and use it as a guide for the current drawing **(fig 06)**. To get optimum results from this program you will need to use a graphics tablet. These range in size and price according to your needs and budget. Again, this is a must-have tool for anyone working in 2D digital animation. Once you familiarise yourself with its sometimes quirky interface you will be able to produce illustrations that would be impossible to make anywhere else, mixing media such as chalk and oil paint.

If you are working in Windows you will find Stop Motion Pro an invaluable tool for capturing and editing all manner of frame-based animations, either 3D or 2D. If you

want to maintain a more traditional, organic feel to your work while employing digital cameras, you probably won't find a better program for such a reasonable price. Unfortunately it is not currently available for Mac users. They will have to settle for a shareware program such as Pencil Tester, which is more than capable of doing the job at a price anyone can afford.

Vector-based animation programs, such as Flash and Toon Boom Studio are covered on

pages 98–101, as they are in a software genre of their own, and although it is possible to adapt them for cutout animation, that is not where they excel.

This chapter focuses on the other software mentioned above.

Vector-based animation programs, such as Flash and Toon Boom Studio are covered on pages 98–101

FIG06

▶ When creating a movie in Painter you can select the number of onion skin layers to use – up to five. Using Painter for rotoscoping (see page 64) you have one layer that is your original film frame, the underlying layer and the current drawing layer. You can hide the completed drawing layer to make the tracing process easier.

Cutout

FIG02

ANIMATING WITH PAPER AND SCISSORS

If the idea of constructing 3D models and puppets seems a little daunting, you can start out with this easy 2D method of telling stories that is not dissimilar to shadow puppet theatre. All you need is some paper, pens and scissors or a scalpel/craft knife, And an image-capture device, of course.

FIG01

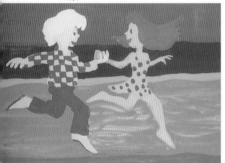

⬆ *Chris Nunwick created this short film about a man who escapes from an asylum and sets off to rescue God from kidnappers. Using a similar technique to the Loop HBO spot, Chris shot the cardboard cutouts with a standard 8 movie camera to help achieve the gritty image.*

⬆ *This animation, from Buzzco in New York, combines cut paper with traditional drawn cel animation. It also uses animated text to great effect. The film is about an all-too-familiar scenario for commercial artists – the last minute 'little' change. A very catchy song integrates with the animation to bring humour to the afore-mentioned professional artist's nightmare. The style and colouring for the animation was inspired by artist Henri Matisse.*

The traditional method of producing cutout animation can be fraught with disasters from failed lighting to, more commonly, the paper characters being blown across the scene by a sudden sneeze or the wind from an accidentally opened window or door.

MAKING THE PUPPET

The first step, after you have your story, naturally, is to make your puppets. These can be as simple or as complex as you wish. Choose a fairly heavy paper stock that will withstand wear and tear. You can use the coloured craft papers that are readily available

from your local art supply shop. Alternatively, you can take some plain drawing paper and colour it yourself with paint, felt-tip pens or other materials. Make each moving part a separate piece that ends where it would normally be a joint on the body (for example, from knee to hip). Joining the various body parts with thread or metal paper fasteners will help keep the puppets together. Try to keep these joints hidden, wherever possible, unless they are going to become part of the design. If you are really confident that you won't scatter the cutout pieces everywhere, you can leave them loose. This will make the scene

much flatter and smoother to shoot **(fig 01)**.

Animation using collage is described later in the book (page 62), but the methodology is identical. You may want to use some collage with your cutout animation. Use bits of material to

FIG03

FIG04

OVER TO YOU

OTY/01

As you can see from the examples on this page, cutout animation does not have to be very simple. Try mixing different media and techniques to produce your own unique style and effects.

OTY/02

As with all animation, plan out everything before you start. Have all your models, backgrounds etc. prepared before you start 'filming'. Keep everything in a logical order or filing system.

OTY/03

Experiment with different image capture methods (see next page).

clothe the puppets or bits of yarn for hair, just like you did in primary school. You could even stick photographs of people's faces on the heads. This is done to great effect in the children's series *Angela Anaconda* (see **fig 04** and page 68). Although it is all made digitally, it is not impossible to do something similar with a camera.

TEAR IT UP

Do not think you have to restrict yourself to nicely cut-out shapes in colourful card. Try doing it in monotone or duotone **(fig 02)**. Use black card and brown paper (recycled packaging or envelopes) and carefully tear them rather than

using scissors or a blade. Instead of making jointed puppets you might want to make a series of characters in different poses that can be changed to create the motion. Draw them first, as a guide, before you tear them, and always make at least one or two duplicates. It will be a long, slow process, but it will produce an interesting effect.

If you are not particularly dexterous, or patient, you may want to try making your cutout animation digitally **(fig 03)**. Turn to page 60 for an outline of how to do it with your computer.

▲ *Angela Anaconda, a popular children's television show, is a sophisticated use of cutout and collage animation, made using purpose-shot images put together using Houdini, a high-end 3D animation program. See page 68 for more about how it was made.*

▶ *Another animation from Buzzco, inspired by a song written by the animator Candy Kugel concerns why it is easier to mourn the loss of an object than a loved one. This film is a mixture of cutout and collage that was put together in After Effects; the layering capabilities were used to create the richly textured look.*

◄ *This is part of a sequence from a promotion for US television channel HBO, created by Loop Filmworks in New York. This is cutout animation at a sophisticated level. Each of the character's poses was hand-drawn, then scanned into the computer and coloured. They were then printed and mounted on card in a three-dimensional set and shot using standard stop-motion techniques. Compositing and additional effects were carried out digitally, using Flame.*

FIG05

FIG01

Image**Capture**

UNIT/26

SHOOTING CUTOUT ANIMATION

Whether you are shooting clay models, paper puppets or line drawings, the same basic technique is used – shooting sequences of single frames. With 2D paper models or images, because they need to be kept flat on a horizontal surface, you have to use some sort of rostrum camera.

You have your own simplified version of the rostrum camera set up on a sturdy table in a place where it is not going to be disturbed by people or by the elements. For the purpose of the exercise, let's assume it is a photographic copy stand, because this is the easiest solution. On this stand you have mounted your digital camera, either a still or video, and you are ready for action.

If you are using a DV camera, you get many useful options not available to users of consumer-level still cameras. Among these are an adjustable viewer (so you can see what you're doing), built-in timer, single-frame, digital stills to a memory card and remote control. This last one is extremely useful if you are at all worried about moving the camera. All these features come at a price, of course, although one that is constantly falling. They also connect easily to any computer that has an IEEE1394 (FireWire, i-Link) connection that will let them be controlled by your animation software. If you intend to do a lot of stop-motion animation, whether 2D or 3D, then it is worth investing the money in a high-quality DV camera.

Using a digital still camera **(figs 02–03)** is still a viable option, although one that offers all the features listed above will cost

FIG02

▶ *A digital still camera is an affordable option as an image capture device for simple animation. Always aim for quality before price.*

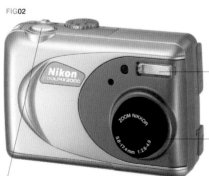

FLASH: *Most digital cameras have the option to switch off the flash. It is much better to use a separate light source, preferably with two lamps.*

LENS: *If the camera comes with a 'digital zoom' do not use it as it will produce inferior-quality images. It is much better to reposition the camera.*

SHUTTER RELEASE: *If you have used a normal 35mm camera, it can take a while to get used to using a digital camera as there is a delay from when you press the button to when the picture is taken. It is not as critical when shooting your animation but it is frustrating when taking snapshots.*

FIG03

MEMORY CARD: *Under this flap you will find a slot to add an additional memory card. Get one as large as you can. It will hold hundreds, or even thousands of images. The connection to your computer is usually concealed under this flap too. Some cameras can even take images directly to the computer's disk.*

VIEWING SCREEN: *Important for framing your shot correctly. Some digital cameras come with a separate viewfinder but they are not accurate. You should only need to use the viewing screen during the initial set-up. Leaving the screen on will quickly drain your batteries. If possible, get a mains adaptor and/or rechargable batteries. Rechargables are cheaper in the long run, and better for the environment.*

Place your cutout puppet on a background and carefully move it for each shot. No matter how simple or sophisticated your equipment, this is the most vital part of the operation.

more than a DV camera. What it does offer is very high resolution image capture. This is not a vital feature, however, as most digital video is shot at 720 x 480 pixels, and a 1-megapixel camera should cope with that. Make sure that your digital camera has a viewing screen on it so that you can accurately frame what you are going to photograph. Unless you are using an SLR, the viewfinder will be offset. Anything below a professional-level still camera is unlikely to have options for cable release or remote control, though they usually have a self-timer. You can use this to minimise the possibility of camera movement.

Start by sticking your background to the base board with masking tape or removable MagicTape, and position your camera so that you can see the whole area you will be using through the viewfinder or preview screen. Now carefully place the character(s) in their starting position(s) and capture the image. You may want to use a low-tack glue or removable tape behind the characters if you are concerned about accidentally moving them more than you had planned. Because of the simplicity of this style of animation you will find that 24 single frames per second is more than you need, so you may shoot two or three frames with your video camera. If you are using a still camera, you will need only the one shot that can be

repeated in software. Your final output is what will determine your frame rate (see page 43).

As with 3D stop-action, you carefully and patiently move your characters and photograph them until you have completed the sequence **(fig 01)**. Start by creating a short sequence and playing it back to see how it works. Do you need to increase or decrease the number of frames? Is the lighting and exposure correct? Do the characters work? Are they too simple or too detailed?

The beauty of working with digital tools is that you can see everything instantly. You don't have to wait hours or days for film to be returned, and there's no extra expense if it doesn't work; just

delete the files and start again (or burn them to CD before you delete them if you want to keep them for future reference).

If you find this method too fiddly and demanding, you may want to take the next step and do it all digitally, using a scanner and software. This is shown on the next page.

Scanning your cutout elements to comp together using software such as Photoshop and After Effects is a lot safer and more controllable than paper on your desktop. Different scanners have their own software, with which you will need to familiarise yourself before you start. Most work as plug-ins to Photoshop.

Choose either RGB (for colour) or Greyscale (for black and white), depending on your original and your intended end film.

Choose a resolution higher than you need. 288ppi is four times the 72ppi you will be working with.

The elements can be scanned together and separated into layers in Photoshop, or you can scan them individually and bring them into Photoshop one at a time.

FIG04

Cutout – Digital

CUTTING OUT THE CAMERA

Creating your cutout animation digitally may take away its organic feel, but you will keep your hair and your sanity. You can still create your characters in the method described earlier, but instead of joining them with pins or thread, you do it on the computer.

Take all the different pieces and scan them into the computer. If you are using white card, you will need to tape a piece of contrasting coloured paper onto the scanner lid – a matt black is best, although any solid colour not used by your characters will do.

Once you have scanned all the different elements, you will need to put them all together. Do this initially in Photoshop, as it is the most commonly available image-editing program; then the animation can be created in After Effects.

Each element will have to be cut out and placed on its own layer in Photoshop, with the background as the bottom layer and the others following on in a logical sequence, as is done in cel animation. There are many different methods of cutting out objects and removing backgrounds in Photoshop, so use the one you are most comfortable with. The important thing is to have a solid object on a transparent background. To avoid complication, include only the elements that will be used for a particular scene.

Once you have your initial image as a layered Photoshop file, you can open it in After Effects to begin the animation. The interface can be a bit daunting and the learning curve steep, but it is worth persevering. Because After Effects will open the Photoshop file with all the layers intact, you can start moving the elements as you need to, layer by layer. Each layer has a drop-down selection of effects and transformations that are controlled by inserting key frames on the Timeline, then adjusting the item into the beginning and end position. The software takes care of the in-betweens.

100% DIGITAL

An alternative to making cardboard characters and scanning them is to make the shapes directly in your image-editing software. Draw the shapes you require, then fill them with colour. Use the Pen tool in Photoshop to create bezier curves that are editable and easier to control. If you prefer using Adobe Illustrator, After Effects can import those files as well.

For a natural, organic feel you can create your elements in Painter. This has a whole range of paper textures and natural media brushes (the latest versions of Photoshop and Illustrator have some natural media brushes as well). Painter can also be used to make animations, although it uses a frame-by-frame method that makes it more labour-intensive. To help with this it has an onion-skinning feature so that you can see what is happening on the previous layer(s). If you prefer to do your animating with After Effects, you can save the Painter file in Photoshop format and import that.

Your other choice is Flash, which will give you flat colours, clean lines and very small files. Flash and other vector animation tools, which are covered later in the book (page 100), are as easy to use as the pixel-based programs mentioned above, but produce a different style of image.

Choose your tools and start creating; who knows, you might come up with the next *South Park*.

FIG01

◀ *All the pictures in Heli Kainulainen's* The Town of the One-Handed People, *were drawn by hand, then scanned and cleaned up in Photoshop before being animated in After Effects. Kainulainen says that After Effects offered a degree of control over the different elements not possible with nondigital cutout animation.*

FIG02

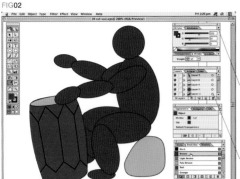

Colours were mixed using the RGB option required for working in video. This can be set by clicking on the drop-down menu under the arrow.

Each element was placed on its own layer to make it easier to control, especially when it was imported into other programs.

▲ *Making an animation from basic shapes, such as the one used on this page, is best started in Macromedia FreeHand or Adobe Illustrator. In this example, Illustrator was used, mainly for its compatibility with other programs.*

FIG03

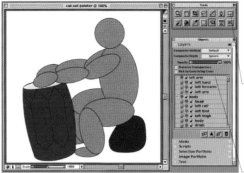

Make shapes with the Shape tool. Colours are set under the Shapes menu.

Each shape creates a new layer. Layers can be rearranged by dragging them. You can also group them.

▲ *To make your animation in Procreate Painter, you have two options. You can import the file you created in Illustrator (save it in an early version, such as 5) – this will bring in all the layers. Alternatively, create it from scratch in Painter. When you create a new file you have a choice of opening an image or movie file. Start with an image file, then make a movie file after.*

FIG04

One of the great things about Painter is the way it emulates different media. You can add a paper texture to your character if you want to. Choose your paper texture from the Art Materials palette and apply it under the Effects menu -> Surface Control.

FIG05

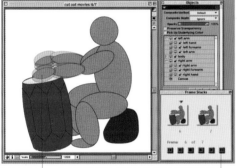

Onion-skinning means you can see what is happening on other frames – up to five deep.

You can now start moving the elements on that frame. You will have to select the layer before you can move the object. Repeat the process for each frame. A word of warning – when you move onto another frame the individual elements create a single image that cannot be edited, so you will have to delete the frame and redo it. Also, when you save the file, all the shapes are removed so you will need to complete your scene in one session.

◀ *To turn your picture into a film, start by making a new file, this time a movie file with a single frame, the same size as the image you created. Drag the elements from the image file to the new movie file. Having the elements in groups really helps here. To activate the Onion-skinning feature choose Canvas -> Tracing paper. To make a new frame, click on the frame advance button.*

When importing a single, multilayer image file into After Effects it should be brought in as a Composition, rather than Footage.

Each layer should contain just one element that is to be animated using the huge array of precise editing options.

FIG06

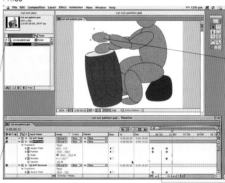

Setting the Anchor Point where the joint would normally appear gives a smoother, more natural movement.

Animation is controlled on the Timeline palette. Key frames are inserted at the appropriate places, and the position of the object is set at each key frame. The program calculates the movement according to these settings.

▲ *Working with After Effects gives you much greater control over your animation and does all the in-betweening for you as well. Here, the textured Painter file was exported as a Photoshop (psd) file and brought into After Effects. You can also import Illustrator and Photoshop files, all with their layers intact, and each of those layers can be animated.*

FIG07

◀ *Flash is ideal for creating this type of simple cutout style animation. It can be drawn directly in the program, or a vector file can be imported. There is more on using Flash on page 108.*

OVER TO YOU

OTY/01

When creating your own cutout animation, your style will influence the software you choose, or inversely your software will affect the look of your film.

OTY/02

If you are working with an existing package learn its limitations and its strong points and work with them. Don't be afraid to experiment. One of the beauties of working with digital files is the ability to undo, revert and save copies so you should never waste any work.

OTY/03

If you have a particular style in mind (such as the example by Heli Kainulainen in **fig 01**) then find out which software is best for the job. It will invariably be After Effects and something else, which does make the Adobe Digital Video Collection an obvious choice for animators. Don't limit yourself, though, as there is a lot of capable software at very reasonable prices.

Collage

GIVING OLD PICTURES A NEW LIFE

Making a collage is something most of us did in art class during our school days, using pictures cut from magazines, photographs, bits of cloth, leaves and twigs – anything we could find to create a picture. Now that we have access to loads of digital technology, we can take it one step further and animate the pieces to tell a story.

The first thing to do is find some images. Using magazines or books means you have to be aware of copyright issues, so it is best to avoid them. Your best bet is to use clip art. This is usually royalty- and copyright-free and can be downloaded from Internet sites or bought on CDs. Many graphics programs come with clip art collections. Dover Books also produces a huge collection of clip art, both printed and digitised.

Once you have collected all your images, there are two ways of putting your animation together. A more traditional method is to photograph each frame individually using a camera stand and then comp it together with After Effects or one of the other stop-action programs mentioned earlier in the book.

The other alternative is to do it all digitally. If you are using clip art that is already digitised, this is the obvious option. If you have printed pictures, you will need to scan them into the computer as described on page 60.

◀ Using photographs of textures and materials, together with line work, this short animation, from Buzzco Associates, was put together using After Effects.

CREATING A COLLAGE WITH AFTER EFFECTS

To make this surreal dream sequence some black and white images were taken from the Art Explosion clip art collection by Nova Development. All the images were in Bitmap format, which means just black and white. The first image, the background scenery, was opened in Photoshop 6 and converted to Greyscale (Image->Mode->Greyscale) so that it could be further edited. To make it easier to colour, the white background was removed by adjusting the Layer options in (fig 01). This left a black image on a transparent background (fig 02). To colour the image, it was changed to RGB Colour (Image->Mode->RGB Colour) – video only works with this colour format so don't use any other – and a new transparent layer was added beneath the black one.

Keeping this new layer the active one, and the black one visible, the details were painted in using the Paintbrush tool (fig 03). The sky was painted on a separate layer and the three layers were linked together (fig 04) to create a single image (fig 05). The colouring procedure was repeated with the other pictures to produce a single multilayered psd file. To simplify

FIG01

By moving the right hand slide (circled) very slightly to the left any white in the image will disappear.

FIG02

The original picture with the white background removed.

Putting the images together is best done initially in Photoshop. This has all the tools you need for cutting out, colouring, retouching and placing the different elements on layers. You will be working only in the RGB colour space, so the cut-down version of Photoshop that comes bundled with scanners is more than adequate. As mentioned before, Photoshop is not designed for making animation. You could try moving the elements on their different layers, then save a copy of the new picture as a JPEG file. Once you have all the images saved in their own folder, sequentially numbered, you can put them together using the software and method suggested for stop-motion, but it will be a long and arduous task.

Page 60 describes how to create digital cutout animation using After Effects. Collage is no different in its approach. You can import the layered Photoshop file into After Effects and maintain the individual elements on their own layers, which can now be animated. Because After Effects is designed for creating animation from stills, you can set the key frames and the program will do the tweening (the filling in of intermediate frames) for you, saving you a lot of work. Once you have finished, the file can be exported to a variety of formats for broadcast or the Web.

Experimentation is the key with collage; spend time trying out different materials as well as the way you bring them to life.

OVER TO YOU

OTY/01

If you want to make collage animation, start collecting as many pictures as you can. If you are using magazine photos make sure you cut them up so they are unrecognisable, e.g., just the hair or an eye.

OTY/02

Keep an eye out for bargain-priced clip art CDs. They will be ideal for your purpose as you won't need them print-quality.

matters, the layers of the different image elements were merged so that each picture was a single layer. Photoshop (psd) files will import directly into Final Effects, retaining all the layer information. In this case they were imported as a Composition (fig 07). After Effects works with a Timeline (fig 08) in a similar way to Flash (see page 108), although more complex. To move objects around the scene you need to attach them to a motion path (fig 09) as well as setting their attributes in the Timeline.

FIG03

FIG06

The coloured layer with the original black layer hidden.

FIG04

Linking layers together stops them moving out of alignment and makes it possible to merge them into one layer.

FIG05

Three layers viewed together.

FIG07

The three images coloured on separate layers and ready to take into After Effects.

The After Effects Timeline, showing its array of controls. This timeline can be viewed in seconds or frames, which are determined by the frame rate you set for the project.

After Effects project window showing the imported Photoshop file and its layers.

FIG09

FIG08

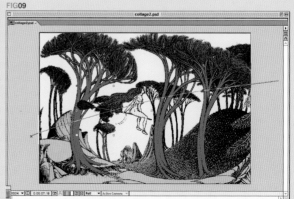

The scene window showing the motion path with the element attached.

FIG01

FIG02

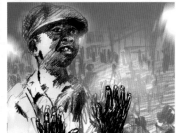

FIG03

 Part of the Animated Tales of the World *series (see page 44), this film about African-American railroad legend John Henry was made by Sverdlosk Studios in Ykaterinburg, Russia (on the Asian border). This very free style of drawing and painting on live-action footage was awarded a Prime-Time Emmy for animation. It did, however, create a problem for the director. Because of a lack of African-Americans in the Urals, he had to go to San Francisco to shoot the requisite base footage. You should be able to achieve a similar effect, digitally, using Procreate Painter.*

Rotoscoping

UNIT/29

DRAWING ON LIVE ACTION

Rotoscoping is a technique developed by Max Fleischer, creator of Betty Boop and Koko the Klown. (he is also, incidentally, the grandfather of the creator of Poser software.) Rotoscoping is used principally for capturing realistic human movement by drawing over film footage of actors.

At its inception, each frame of the film was projected through a light table using a mirror, and the image was traced, and then transferred onto cel. In classic rotoscoping, the drawn animation and the live footage were combined.

IS IT ART?

With the arrival of computers as graphic tools, it became much easier to create animation using rotoscoping. Although purists may see it as cheating, it is still a valid way of creating realistic action with an artistic feel **(figs 01–03)**. It also extends the possibilities far beyond that available to ordinary live-action. Ralph Bakshi's 1978 version of *The Lord of the Rings* used rotoscoping to achieve a mood that conveyed the classic story in a way that other types of animation might not have been able to do. It does not match Peter Jackson's heavily CGI-enhanced version, but animation technology has advanced beyond imagination in the intervening 20 years.

Rotoscoping is also a good learning exercise for novice animators. By taking existing, or specifically shot, video footage you can study each movement and draw over it. Using currently available desktop computers and software, a broadcast-quality result can be achieved that was almost impossible less than two years ago.

GOING SOFT

There are many programs on the market that can be used for rotoscoping, from expensive professional video-editing packages to reasonably priced consumer software. The versatile Painter's animation tools can be used for this as well **(fig 04)**. By importing AVI or QuickTime movies into a frame stack – a group of individual sequential frames – you can either digitally paint each frame individually or apply one of the program's many filters or effects. Alternatively, you can simply draw brushstrokes over the video for a simplified line

animation. If you opt for an overall filter effect this can be saved as a script that can batch process the whole film while you do something else. If you like painterly effects and use a Mac you can try Studio Artist (www.synthetik.com), which will also automatically add effects to imported movie files **(fig 06)**.

After Effects will also do rotoscoping. The expensive Production Bundle version has Vector Paint, which offers a superb range of tools. Boris FX has an After Effects plug-in, called Cartooner, that will automatically create an outline animation from a video. This filter works with all versions of After Effects.

These are by no means the only solutions for digital rotoscoping, but they are the ones that are achievable using the software recommended elsewhere in this book.

FIG04

65

ROTOSCOPING

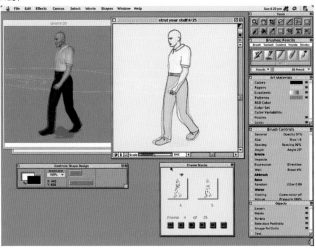

OVER TO YOU

OTY/01

Use rotoscoping as an exercise in perfecting your 2D animation skills by hand-drawing over video files. You will need a graphics tablet for this. For the purpose of the exercise, avoid using filters or plug-ins. Try it with a talking head to practise drawing mouth shapes for dialogue.

OTY/02

Instead of using live-action films, try creating an animation in Poser (see page 136). If you are using it as a base for rotoscoping you don't have to use a high-definition render. The simpler you keep the Poser file the more freedom you will have when you redraw it.

▲ You don't need to use live-action video for rotoscoping in Painter. Using an animation created in Poser (see page 136) as a base, you can fine-tune your digital drawing and colouring skills. Open your Poser movie in Painter, then open a new movie with the same dimensions and number of frames. In your original movie, set to the first frame, go to the menu bar, and choose Movie -> Set Movie Clone Source. Now go to the new movie and select Tracing Paper from the Canvas menu and the original movie frame will appear ghosted out, as if under tracing paper. You can now draw and paint over the image using any of Painter's tools. Move through the frames using the Frame Stacks palette, where you can also preview the animation. Once finished, it can be exported as a QuickTime movie.

▶ Loop Filmworks created this public service announcement aimed at New York teenagers to help them cope with any problems resulting from the events of September 11, 2001. The live-action footage was redrawn using Adobe Illustrator, with additional work being done in Photoshop. The final compositing was carried out in After Effects. Using rotoscoped animation helped soften the harsh reality of the images without losing the impact of the message.

FIG05

FIG06

◀ Studio Artist is a rather unusual Mac-only program described as a graphics synthesiser. Essentially, it is a stand-alone application that works like the plug-in filters in Photoshop. Apart from creating painting effects for still images, it can also process QuickTime movies. There are hundreds of editable effects that can be automatically applied to create interesting 'animations'. Here, a Poser animation was used as the base image. If you are using Studio Artist, you may want to make your Poser animation more detailed with the choice of clothing, colour and lighting than you would using Painter.

FIG01

Titling – Animated Text

MAKING WORDS THAT MOVE

Titling is one type of animation that is often overlooked, yet when it is done well it is extremely effective and memorable. Titling is often very easy to execute once the creative concept has been decided.

The opening credits to Cronenberg's *Naked Lunch* are moving coloured geometric shapes on a black background that reveal black type as they intersect and cross over. The simplicity of it is in marked contrast to the complexity of the film. This type of graphic opening credits was very popular in the 1960s with the work of designers such as Saul Bass in *The Man with the Golden Arm*, and

Hitchcock's *Psycho*. The opening credits to *Ghost in the Shell* are entirely text-based. They were made from the computer code for the Japanese letter characters for the person's name, which reduced the name down to one line of readable letters.

Animated text is also very popular with television broadcasters for station identifications and advertising,

as we see so often on MTV. And let's not forget *Sesame Street*, which relies on animating the alphabet in as many interesting ways as it can to teach its viewers their numbers and letters.

Digital technology has greatly increased the creative possibilities of this animation niche **(figs 04–07)**. The massive range of typeface designs now available means there is no longer any need for you

to hand-draw letters, and all the programs referred to in this book handle type very well.

If you want to make a completely computer-generated text animation, your best choices of software are Flash and After Effects. Your choice will depend on how you intend to use the finished piece. If it is to be integrated with an existing film, then After Effects is the way to go **(fig 08)**. A stand-alone type of animation might best be created in Flash, especially if it is destined for a range of different media (such as web, CD and screen), although it can also be integrated into After Effects.

POETRY IN MOTION

You are by no means limited to working exclusively on the computer. Many things are possible with stop-motion. Use

FIG02

 The opening credits for Our Hero, *a teen comedy-drama about a girl who compiles a zine (a self-published magazine or newsletter, published for passion rather than profit) on her take on teenage life, are designed to emulate the process of laying out the zine's pages on a photo-copier. Head Gear Animation created this fast-moving title sequence that is part collage, part live-action and part animation to convey the show's style and content.*

FIG03

⬛ Working with letters found around the house can produce interesting effects. Children's magnetic letters can be used to spell out words on a fridge door. Use stop-motion or time-lapse photography (page 42). Enlist the help of a small child to place the letters in the right order (or not). Include any spelling mistakes and upside-down letters that may occur, or you may choose to insert mistakes deliberately. For something more sinister use a similar technique, with letters cut from newspapers and pasted onto paper. For a real film noir feel, use reduced lighting and hands in surgical gloves.

time-lapse to film a child spelling out words with magnetic letters on a refrigerator or someone writing by hand. Letters and words torn and/or cut from newspapers and magazines can be used to make ransom-note-style titles **(fig 03)**.

When working with type, avoid the trap that many people fall into when they have a huge selection of typefaces, which is to use too many of them. Try to keep to two or three fonts. Don't make the type too big, so that it looks like a children's book, or too small either. Also try to avoid using too many effects; select one or two that help get the message across. The important thing to remember is that it has to be legible, which is the point of putting it there in the first place (see page 146).

⬛ This animation, by Buzzco Associates in New York, is dedicated to anyone who has worked as a commercial artist. Using a mixture of cel and simple cut paper animation, it uses words to tell the whole heartbreaking story with humour, vibrant colour, a catchy tune and a little inspiration from the work of artist Henri Matisse.

▼ Typographic animation moves in and out of vogue in the advertising industry. After Effects is one of the most popular programs for doing this, with its huge array of graphic and lighting effects and ability to work in a 3D space. Creating a multilayered background and text file in Illustrator or Photoshop opens up a huge range of creative possibilities. After Effects also makes it easy to integrate text effects for titling with the rest of your film.

OVER TO YOU

OTY/01
When you watch a film, study the opening titles. Are they independent or superimposed over the action? Is the type static or moving? When do they come? Before the action starts or later in the film? How much information do they give? How do titles differ between animation and live action?

OTY/02
If you are new to After Effects, practise using words to experiment with different filters and animation techniques.

FIG08

FIG04

FIG05

FIG06

FIG07

◀ One of the easiest ways to animate text is with a program like Wildform SWfx. With hundreds of preset styles in a variety of tastes, it creates complex Flash effects that can be saved as swf files for use in Flash or as web site banners, or exported as QuickTime files.

Case**Study**

ANGELA ANACONDA

Taking cutout animation and mixing it with movie visual effects software, C.O.R.E. Digital Pictures Inc., in conjunction with DECODE Entertainment, produced the highly original, award-winning children's show *Angela Anaconda*.

FIG01

The star of her own show.

FIG02

Where *Angela Anaconda* differs from other collage, or cut-and-paste, animation is in its attempt to make the characters seem realistic while maintaining the simplicity of a cutout style. Rather than use existing images, C.O.R.E.'s animators cast models to play the characters and photographed them in hundreds of different ways **(fig 03)**. One of C.O.R.E.'s founders, John Mariella, explains the process:

'The models' faces were photographed from three separate angles simultaneously as they pronounced various speech fragments and performed a series of facial expressions. This gave us a robust library of hundreds of images that we could extract bits and pieces from, and because we shot the photos from three angles, we were able to maintain a facial expression through a complete head turn.'

TWO-AND-A-HALF-D

The photographs were scanned, then cut out, recoloured and retouched in Photoshop. After that, they were distorted using a program called Elastic Reality, so that the original models were no

Some of the hundreds of mouth shapes that were photographed for lip synching (see page 88) and other facial expressions.

FIG03

On the right-hand side of the Houdini 3D animation software screen is the customised software plug-in C.O.R.E. wrote to add in the different facial shapes for the characters. This system speeds up what would otherwise be a very laborious task. It is a little ironic that the two currently best known 'simple' animations, Angela Anaconda and South Park, are both produced with high-end 3D animation software: Houdini and Maya.

FIG04

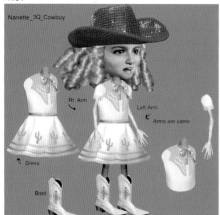

Nanette_3Q_Cowboy

Rt Arm
Left Arm
Arms are same
Dress
Boot

FIG05

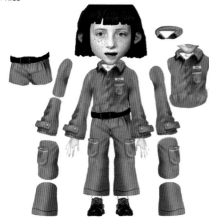

☐ *Closely resembling cutout paper dolls, the characters (Angela and her nemesis, Nanette Manoir) and their costumes are divided up into the various moving parts that can be easily animated in software.*

longer totally recognisable. To make the animations, C.O.R.E. used Houdini **(fig 02)**, the same software their visual effects department uses for feature films such as *Dr Dolittle*, *The Time Machine* and *X-Men*. Mariella explains their choice: 'We chose Houdini, since it allowed us to rig our characters in a simple, easy-to-use fashion. When you consider that each face had about 25 mouth positions, and each phoneme was pronounced while smiling, frowning, angry, etc., and then you add a half dozen eye

positions to each, and then you have the same library duplicated for each of the three camera views – you can see how the complexity of what we were dealing with built up. Houdini allowed us to manage all these elements intuitively. We could just select body parts and rotate, position and key frame them much like you would in any other animation package. Then we'd be able to rotate the character as though it were three-dimensional, but it would simply snap to the appropriate view in our library, based on the direction the character needed to be facing.'

They called this two-and-a-half-D animation. To lip-synch and animate the facial expressions C.O.R.E. wrote their own software plug-in for Houdini. Scrolling through the library of facial elements, the animators would select and click on the appropriate image, which would automatically be key framed into the animation. The system allowed the team of up to 50 artists and animators to produce each 11-minute episode in about two weeks.

FIG06

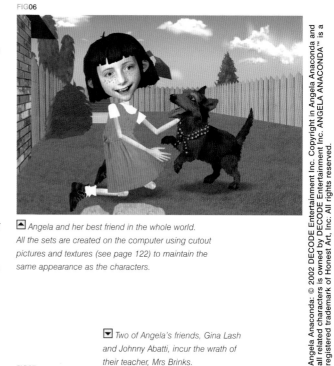

▲ *Angela and her best friend in the whole world. All the sets are created on the computer using cutout pictures and textures (see page 122) to maintain the same appearance as the characters.*

▼ *Two of Angela's friends, Gina Lash and Johnny Abatti, incur the wrath of their teacher, Mrs Brinks.*

FIG07

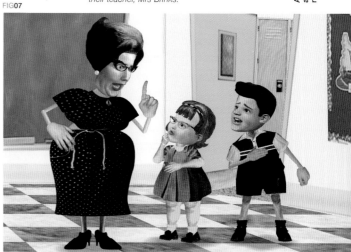

FIG01

FIG02

Allegro Non Troppo: *This 1976 feature-length mixture of animation and live-action from Italian director Bruno Bozzetto is a witty and intelligent parody of* Fantasia *that uses a variety of animation styles set to short, popular, classical, orchestral pieces.*

CELANIMATION

When we think of animation, we think of cel animation, that is, cartoons. We were brought up on them, whether they were Disney feature animations, Bugs Bunny and the rest of the Looney Tunes' gang or the countless Hanna-Barbera characters.

Most people reading this book will be from the cable and satellite generation, which has grown up with dedicated cartoon channels providing a nonstop feast of classic cartoons as well as the more edgy contemporary shows such as *The Simpsons* and *South Park*. Whatever your taste, cartoons have entertained you and inspired you to start thinking about making your own.

Just as comics and graphic novels have reached a new level of sophisticated illustration and storytelling, this new visually literate generation has come to expect the same from the moving images they watch, and animation has matured because of it. Disney is still a staple of the preteens (and their parents), but with Manga titles such as *Ghost in the Shell* and *Akira* and the works of Ralph Bakshi (*Fritz the Cat*, *Cool World*, *The Lord of the Rings*) animation can tell stories that adults want to watch on their own, and the art form is much better for it.

We have all been captivated by the imaginary worlds of animators, often becoming immersed in their fantasies. Is it any wonder that films where the worlds of reality and toon cross over, such as the childhood favourite *Mary Poppins* and the more mature films such as

How the Tortoise Won Respect *is one of 26 15-minute films that made up the* Animated Tales of the World. *The painted style, by Moscow studio Animose, gives it a richly textured illustrative feel.*

Cel animation is sometimes known as line animation, and for this short entitled A Warm Reception in LA, *Buzzco made it literally so. The bright coloured linework resembles not only chalk on a blackboard, but also the enticing neon lights of the big city.*

FIG03

FIG04

FIG05

◀ *In Italian director and actor Maurizio Nichetti's film* Volere Volare, *he plays a sound effects man for animated films who slowly, during the course of the film, turns into a cartoon character.*

FIG06

◀ Ruairi *is an Irish children's cartoon about the eponymous menace, adapted by The Cartoon Saloon from a popular series of books. It is voiced only in Irish and other Gaelic and Celtic languages.*

FIG07

◀ *Independent New York animators Buzzco made this award-winning short entitled* Fast Food Matador, *about a Manhattan coffee shop delivery boy who daydreams of a more exciting life. The painterly style was inspired by Picasso's bullfight sketches and is accompanied by an original Latin-flavoured song.*

FIG08

◀ Atomic Betty – *a vibrant and highly stylised animation – is a fusion of cel, 3D and Flash, made by Atomic Cartoons in Canada, one of the pioneers of this method of producing animation for broadcast.*

Who Framed Roger Rabbit?, *Cool World* and Italian Maurizio Nichetti's *Volere Volare*, are so successful?

Pure cel animation is a rarity these days as more and more of the work is done on computers, but the integration of cel and computer animation is really an obvious evolutionary step. Computers and digital technology are just another tool at the animator's disposal. A lot of the time using a computer merely removes the film and camera process. At other times it streamlines the production by ensuring consistent quality or by replacing repetitive tasks that can be expensive.

No matter how clever the computer program, it will never replace human creative talent and as long as there is a market for cartoons, for hand-drawn animations, there will be work for artists who want to bring their drawings to life.

This chapter will guide you through the basic techniques and equipment of cel animation and show you how to integrate them with a computer. You should then

be able to start producing your own animation at home, using the equipment outlined on page 8, along with that recommended on the following pages. Making your first cel animation on your own can be a long and arduous task, which is why studios have teams of artists, but it is not impossible, especially with today's digital technology.

▶ *The animations for the 1980 television version of Douglas Adams' cult radio series/books, The Hitchhiker's Guide to the Galaxy, were used to illustrate entries in the series title's encyclopedic book. To create the look of the computer screen, information graphics animator Rod Lord used traditional animation techniques, as CGI was still in its infancy and much too expensive for the series' budget. Instead, traced cels were contact-photographed onto litho film, backlit with coloured gels and photographed using a rostrum camera (see page 52). Interestingly, Disney's CG classic, Tron, was created mostly with traditional cel animation because of the limitations of contemporary technology.*

FIG09

BasicEquipment

GETTING KITTED OUT

Setting yourself up to create cel animations will require an investment in some equipment, over and above the list of digital equipment mentioned at the beginning of the book. Even if your natural inclination is towards paper and pencil, at some stage you will have to take the digital leap, but in the meantime get yourself the necessary basics.

FIG01

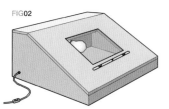

🔺 An animation disc, usually manufactured from black anodised aluminium, is a flexible tool that can be clamped to desks, lightboxes or under a camera for shooting registered cels.

FIG02

🔺 A simple home-made light table, although rather bulky and inflexible, is easy to make.

FIG03

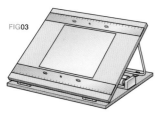

🔺 This more adaptable, home-made solution requires careful planning and building but it is certainly worth taking the time to make a lightbox like this.

YOUR DESKTOP

The top of the list would have to be a drawing table, or more specifically, a lightbox. If you are serious about pursuing a career in animation, then invest in a proper animator's lightbox. It will make the arduous task of producing hundreds of drawings that much easier.

There are several ways to get your own lightbox. The first option is to make your own **(figs 02 and 03)**. It would require only rudimentary carpentry skills, but if aren't skilled, then it is best to get someone else to do it for you. You don't want to damage your drawing hands. Use plywood for the desktop, as it will not warp. Cut a hole in the centre of it into which a piece of frosted glass or white-tinted Plexiglas is mounted. Fix a peg bar to the top. Peg bars come in two styles: three-pegged and Acme. The Acme is the better option. You could even make your own from dowelling, and punch the holes with a standard office hole punch, although this isn't

recommended because registration is critical and can't be guaranteed with any of the home-made solutions.

Now construct the supporting frame. You may want to make it so you can adjust the working angle until you find one that suits you. You will need to put a light source inside, either a pair of fluorescent tubes or a single bulb. Energy-saving bulbs are perfect for the job; they last a long time, use very little energy, and give a good white light with very little heat.

The other alternative is to buy one ready-made **(fig 01)**. These range from relatively cheap portable plastic lightboxes to more expensive, integrated desk units.

Ideally you'll want to buy an animator's disc. These too come in different styles and prices, the best being a precision-constructed metal disc with a glass plate and calibrated Peg-Board. It is designed to rotate to make drawing easier. This solution is used with a desk with a light source.

FIG04

FIG05

🔺 For this custom-made animator's desk a large, rotating Plexiglas disc allows different field-size paper. The peg bar can be fixed where it best suits the artist. A small lip on the bottom holds pencils. A large area on the right can be used for taping storyboards (page 24), X-sheets (page 76) or model sheets (page 82). This table was made for the Blue Sunflower studio.

FIG**09**

THE OTHER BITS

Once you have your desk set up, the next most important thing is a decent chair **(fig 06)**. You'll be spending a lot of time on it, so spend as much as you can afford, and a little more. You don't have to go to the expense of an Aeron chair, but it does have to be comfortable and give you proper support. Make sure it meets all the necessary design regulations.

You'll also need some proper desk lighting **(figs 07 and 08)**. Daylight is the best to work by but you don't want the ambient lighting so strong that it overpowers the back light on your lightbox. Your studio will also need plenty of shelf space for storing consumables and reference material. Another indispensable tool is the mirror **(fig 09)**. Your face will be an immediate resource for expressions while working. The other important things for your studio are a stereo, a constant

supply of drinking water (really) and the phone number of your favourite takeaway restaurant delivery service.

Your consumables will include paper, lots of it. You can buy it ready-punched, or you can buy a specialised punch **(fig 11)** to match your peg bar. Punches are very expensive, and you will have to use A LOT of paper to justify the expense. And last, pencils and erasers.

Because we're going down the digital route, cel and paints aren't covered here. They are not something you're likely to use at home or, given the development of animation, in a modern studio.

To reiterate: when buying equipment always buy the best you can afford, especially when it comes to physical working surfaces such as desks and chairs. Make yourself comfortable and, even if you are going to work long hours, take regular breaks and don't eat pizza off your light table.

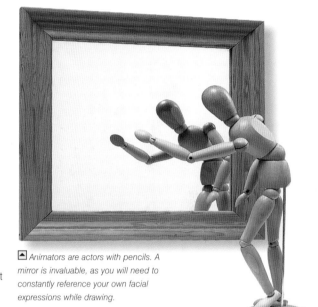

▲ *An adjustable chair with good back support is essential. Most office suppliers carry a complete range of computer operator's chairs. Always try before you buy. Don't try to save money by buying a cheap model that's not comfortable or well made.*

FIG06

▲ *Animators are actors with pencils. A mirror is invaluable, as you will need to constantly reference your own facial expressions while drawing.*

FIG10

▼ *A desk lamp* **(fig 08)** *with a bulb made to match the colour of daylight* **(fig 07)** *makes working late into the night less of a strain on your eyes.*

FIG**07**

FIG**08**

▶ *Whether you are going to ink and paint digitally or with cels, you are going to need a lot of paper to make the original drawings. For a large studio a specialised paper punch* **(fig 11)** *is probably a good investment, but as it can cost as much a computer, you will be better off starting with pre-punched paper.*

FIG11

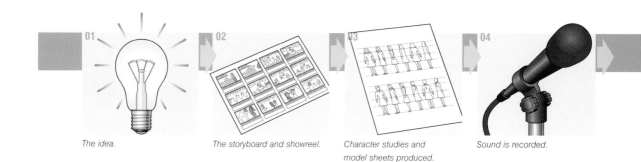

01 The idea.

02 The storyboard and showreel.

03 Character studies and model sheets produced.

04 Sound is recorded.

Production**Cycle**

A STEP-BY-STEP GUIDE

Like most endeavours, animation is full of jargon that can confuse the novice. The best way to understand these terms is to take you through the production cycle from the beginning. Once you have your story, you write the script (page 22) and a treatment – a brief outline of the story – to pitch (or sell) to a producer.

The producer is like a manager, who oversees the film and usually controls the budgets. Producers don't have much creative input. Storyboards are made (page 24) to give a clear visual idea of how the story is going to work – and to help stimulate the producer's imagination. The storyboard drawings are made into an animatic (page 26), or storyreel, to see how the film's timing works. Once this is approved the art directors and animators start working on the look of the film, creating the backgrounds (page 78) and character model sheets (page 82). The voice-over track is recorded (page 86) by actors so the animators can draw the correct lip synching (page 88). The director takes the sound track and a rough layout, starts working out the timing of the movement and scenes and writes them down on a dope sheet (page 76).

FROM THE DRAWING BOARD

Now begins the long and arduous work of producing all the necessary drawings. The lead animator makes roughs of the key frames (extremes of an action) in a scene, and passes them on to the assistant animator, who cleans up the linework and possibly creates some of the in-between drawings. These drawings are done with pencil on a standardised, specially punched paper that fits a peg bar (page 72) that keeps all the drawings registered. These sheets are then passed on to the in-betweener, who makes all the other drawings to complete the action established by the animator's key frames. The in-betweener follows the instructions written on the dope sheet to determine how many drawings are needed. Most action is shot on twos or doubles – one drawing is photographed twice before changing it – making twelve drawings per second on film. Special effects and other fast action may be shot on singles and slower action on threes.

Once all these drawings are finished, a pencil test (page 92) is made to check the movement. When this is approved, the drawings go to a cleanup artist, who traces the roughs to ensure that the linework is consistent. These are then passed to the inker, who transfers the cleaned-up drawings onto cel before they are given to the paint department to colour. The inker often uses a technique called trace-back to copy the nonmoving part of a previous cel onto a new one. In a digital studio (page 94), once the scanned drawings are in the system, a lot of the cleanup, inking and painting stages merge into one person's job.

CELS ON FILM

When all the cels have been inked and coloured, they are given to the camera person, who photographs the painted background and all the

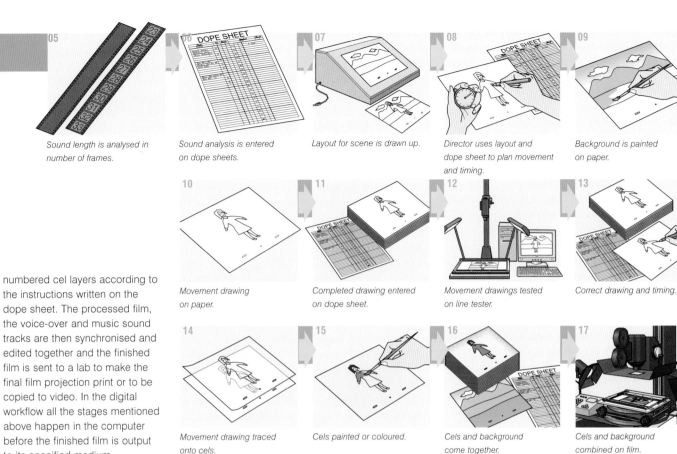

05 Sound length is analysed in number of frames.

06 Sound analysis is entered on dope sheets.

07 Layout for scene is drawn up.

08 Director uses layout and dope sheet to plan movement and timing.

09 Background is painted on paper.

10 Movement drawing on paper.

11 Completed drawing entered on dope sheet.

12 Movement drawings tested on line tester.

13 Correct drawing and timing.

numbered cel layers according to the instructions written on the dope sheet. The processed film, the voice-over and music sound tracks are then synchronised and edited together and the finished film is sent to a lab to make the final film projection print or to be copied to video. In the digital workflow all the stages mentioned above happen in the computer before the finished film is output to its specified medium.

If you are working alone on your animation, you will still need to follow this schedule, more or less, but going digital will simplify a lot of the workload. Unfortunately, if you want to make line, or cel, animation you're still going to have to do an awful lot of planning and drawing, even with the help of a computer. Nevertheless the finished product will give you great satisfaction, once you recover from the exhaustion.

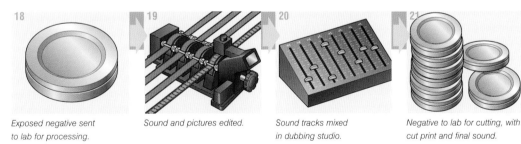

14 Movement drawing traced onto cels.

15 Cels painted or coloured.

16 Cels and background come together.

17 Cels and background combined on film.

18 Exposed negative sent to lab for processing.

19 Sound and pictures edited.

20 Sound tracks mixed in dubbing studio.

21 Negative to lab for cutting, with cut print and final sound.

22 Lab makes final print.

23 Print projected to audience or...

24 ...film transferred to videotape or DVD.

DopeSheet

UNIT/35

KEEPING TRACK OF EACH FRAME

A dope sheet is jargon for the camera instruction or exposure sheet (also known as a cue sheet or X-sheet). Even if you intend to do the whole animation on your own, it is still a good idea to use one of these to keep your work in order, and it is essential for synching the sound track.

The dope sheet also starts you off on the right foot for working in an animation studio where such production tools are essential to the making of the finished film.

Ordered planning is vital in animation because of the sheer volume of drawn images to contend with. Getting everything in the right order to start with will save you hours of shooting and editing time.

There is a fairly standard format for the dope sheet. Essentially it should consist of columns for action, dialogue, cel levels and camera instructions; traditionally it is divided horizontally into groups of eight (24 frames per second; 16 frames per foot of 35mm film or 40 frames per foot of 16mm film), but with the arrival of video and digital compositing this has changed slightly. From left to right the columns are:

ACTION Here the animator can write descriptive notes and make thumbnail sketches.

DIALOGUE Here the phonetic sounds are entered to correspond

with the mouth movements (see page 88 for lip synching). This can also have a column for the musical score if it needs to be synched with the action.

CEL LAYERS These are numbered in descending order from 6 to 1 where 6 is the top layer and 1 is the background. Alternatively, the bottom layer column may be called BG and the others may be numbered 5 to 1. The lowest number is the cel that gets changed the least (that is, the background) and the highest number is the one that changes most. The animator or artist writes the code number of the individual cel in these columns, so the camera operator knows what to shoot and how many frames to shoot it for.

CAMERA INSTRUCTIONS Here are any other directions for the camera person, such as fades, dissolves, zooms and so on. All the other information pertinent to the film, such as title, sequence number, scene number and page number, appears at the top of the sheet.

FIG01

A note about a sound effect that has to be added at the editing stage.

The dialogue is written phonetically, sometimes with mouth shape sketches, to match the timing. This sheet is set up for shooting on film.

The cel numbers are written to correspond with each frame. Layer 2 is being shot 'on twos', which means each cel is photographed twice. This layer has the most movement – the mouth, eyes and perspiration.

Apart from the lip movements, any other movement that needs to be animated is written here.

Layer 1 and the background have no movement in them, so they remain fixed throughout this sheet of shooting.

FIG02

FIG03

◀ **Fig 02** *shows a widescreen 15 field guide. With the proliferation of widescreen televisions, it is a good idea to make all your animations in the 16:9 format. It will increase your chances of selling your film to a broadcaster. A 10 field guide (**fig 03**) is very useful for animators working from home, as it can be printed on standard letter size paper or acetate.*

imator

EX

Sheet No.
3

Camera instruction

8 FIELD
(15 F.C.)

The camera instruction tells the camera operator to shoot an area 8 fields wide at the centre of a 15 field guide. This is the equivalent of a medium close up. The camera can then zoom out later in the sequence.

GRATICULES

Graticules, or field guides, are standardised grid forms instructing the camera operator where to position the camera for tracking and zooming shots. The graticule is printed onto clear acetate to match your registration system. Drawn to the standard film ratio of 4:3, it is divided into a numbered grid. The standard size for a grid is 30.48cm wide by 22.22cm high, although it can be 38.1cm wide by 28.69cm high. A 25.4-cm-wide grid is also common, as it fits standard letter paper formats. If you want to shoot in wide screen your grid area will measure 38.1 by 20.57cm. The graticule area is divided through the centre vertically and horizontally, then each quarter is divided by the field size (10, 12 or 15) and numbered from the centre, starting at zero. The numbers are placed on the edge of the grid as well as diagonally. The four cardinal compass points (N, S, W, E) are used to show direction (not top, bottom, left, right).

This grid system is then used to instruct the camera operator which area of the cel needs to be filmed and where to zoom, pan or track. Because all coordinates are calculated from the centre, you may wish to start a shot wide, then zoom into the top left corner and then pan across to the right, following an action. The instructions you write on the right-hand column of your dope sheet will be a set of coordinates, field sizes and time, usually shown in feet of film. Thus your instructions would start something like this: '10 field (10FC) start 12ft track/pan to 5 field (5S, 1E 10FC)' (see **fig 01**).

▼ *This scene is overlayed with a 10 field guide. The red area is the final pan and zoom, which is held until the boy runs off camera.*

FIG04

FIG01

▲ *It is important to draw the viewer's eye towards the action. In a simple scene like this, where the background fills most of the screen, highlighting the area where the movement takes place keeps the audience focused.*

Backgrounds

UNIT/36

SETTING THE SCENE

Backgrounds are your location, your set, your stage. They are the most static part of your animation and where the action takes place. They can be as simple or as complex as you wish; they can even be blank if it helps to convey your idea better.

In feature cel animation the backgrounds are beautifully crafted vistas, lovingly painted by specialist artists. Because the backgrounds are on screen longer, and cover more area than any other single image in the animation, it is important that they are both believable and executed with an exactitude that can withstand scrutiny when shown on a large cinema screen. The details have to be perfect, as does the perspective and the lighting. Backgrounds have to be painted in such a way that the eye is naturally drawn to the main action. This can be achieved by using bright, contrasting colours in

the areas where the main action is taking place and subdued colours for other areas.

Background artists have to ensure not only that the scenes are proper representations, but that they fit the overall style of the animation's design. Colours should fall within the agreed palette.

The layout artists supply the coloured roughs from which the background artists will produce the final artworks, in much the same way that the cleanup and inking artists take the animators' drawings to produce the cels that are used in the final shooting.

Backgrounds are generally painted onto paper using

FIG03

▲ *By using a limited colour palette for the background, the protagonist becomes the centre of attention. The background designs are dictated by the overall style of the film and also by the method used for its creation. When developing Atomic Betty, Atomic Cartoons came up with a 'neo retro' style for the animation, which was largely created in Flash, giving it its appeal.*

▶ *This highly detailed interior, from Accio Studios, is reminiscent of those in Disney feature animations. By using this wide view, the animator can move the characters around the scene, maintaining the 4:3 television aspect ratio and a consistent, seamless background.*

FIG02

FIG04

FIG06

A layout sketch for an exterior scene. On the finished scene, the flowers, leaves and foreground grass would probably be painted onto separate cels/layers to give extra depth to the scene, especially if there was any camera movement, such as zooming or tracking.

A highly stylised, illustrative treatment was given to the background for this animation created for primary school children in Ireland. The story of Ruairi was already popular in book form, but the original illustrations and characters were completely redesigned by Cartoon Saloon for its animated version.

In Chicken Limb by Amitai Plasse, a judicious use of dark colours transformed the line drawing into a menacing urban nightscape, where even the buildings look threatening. The use of perspective and silhouettes gives it added depth, as the hero strolls obliviously along the road. The intense colour contrast between the character and the background seems to reinforce this. (See page 102 for the whole story.)

consistency of image, known as *panning backgrounds*. These wider sheets have additional sets of peg holes, usually along the bottom, to keep the registration accurate and allow a separate, controlled movement.

Although the base image is static, outdoor scenery is not always so. Of course, as animators, we're in charge. If we want perfect summer weather with clear blue skies and no wind, then the elements are at our command. If a scene requires more atmosphere, these elements and their effects have to be added using cels. These are called special effects.

The advent of computers has allowed the special effects to be incorporated at the same time. Disney Studios had been adding depth to backgrounds for decades using their Multiplane camera, but with their Deep Canvas software they have given it a whole new perspective. Deep Canvas creates a 3D environment that uses digital painting techniques to emulate

traditional hand-painted backgrounds that blend in naturally with the cel animation. This was used to great effect with the tree-surfing sequences in *Tarzan*. This software is not available at your local computer shop, although there are some excellent scenery creation programs available. Not all of them were designed to be customised to match cel frames, but some of the top-of-the-range 3D programs can be adapted to create these effects (see the chapter on 3D).

If you're going down the traditional hand-painted route and want to integrate it using a computer, there are many advantages. One is being able to create your backgrounds much larger than the standard cel size, so you can easily move your characters around. Your image size will be limited by the size or resolution of your scanner, but you can always send your painting to be professionally scanned. Once you get the image into the computer, you'll have a much wider range of animation possibilities available to you.

The important thing to remember when making your backgrounds is quality, consistency and believability. Follow these criteria and your backgrounds will literally blend into the background.

watercolours. The paper has to be of a very high quality that won't distort when the watercolours are applied, because it still has to match the registration system and also remain flat as the various layers of cels are placed on top. Sometimes the backgrounds are painted onto sheets wider than standard cels to maintain a

5

OVER TO YOU

OTY/01

With a computer you can create backgrounds much larger than the standard cel size. Have your image professionally scanned – the quality will be worth the expense.

OTY/02

Quick backgrounds can be created by using a photograph and altering it in Photoshop or Painter with plug-in filters.

TrackingShots

WALK THROUGH/FLY THROUGH CAMERA MOVEMENTS

Intricate single tracking shots where the camera roams through a scene, rising and swooping over landscapes and through buildings, are almost impossible to produce in live-action films, but for the animator it is relatively easy with a little careful planning. It becomes even easier when it is produced on a computer.

The labyrinthine shot shown here was initially sketched so that all the shots and camera positions could be drawn on to get a clear idea of how it was going to work before committing to the final, multilayered coloured image. The different layers were used to give a greater sense of depth to the movement, and also for adding effects such as clouds. For the greatest possibilities select a software program, such as After Effects, that will let you work in a 3D space.

The multiplane camera developed by the Disney Studio gave added depth to the tracking shot as scenery went out of focus and then out of view. By building your scenes with layers and using After Effects, or a vector animation program like Toon Boom Studio, you can emulate the multiplane look.

If you have trouble getting your concept to work on paper you could try using a 3D software program such as Bryce (see page 134). Learning 3D programs is a different discipline to 2D, but once learned the two can be easily and seamlessly integrated.

How complex you make your tracking shot will be dictated by your choice of software or by the detail you give to your background drawing, but try not to be too ambitious with your first attempt. Just remember to plan and storyboard everything properly.

02 Hold the shot at the top point for 3 seconds, with a 'worm's-eye' view

01 Start here and zoom in slowly. Note the camera tilting gently from side to side.

OVER TO YOU

OTY/01

Study tracking shots in animated and live action films to see how they work. They are often used as the opening shot. Some suggestions are *The Player* by Robert Altman, *Men in Black* and Disney's *Rescuers Down Under*.

OTY/02

Look at ways of achieving depth or a 3D effect for your tracking shot using 3D software such as After Effects.

TIP: PICTURE SIZING

When sizing the image (for example, in Photoshop) before animating the camera move, it is important to remember that the point of your most extreme zoom must be your minimum canvas size. In this case, the minimum canvas size was a 1280 x 720 pixel screen, so the end of the shot (right) had to be 1280 pixels across, which resulted in the whole image being about 6000 pixels across.

07 *Fade through to next shot*

03 *Then pull backwards through to a 'bird's-eye' view…*

04 *…into the wide shot. Hold here for 3 seconds…*

06 *…and up the temple before cresting the ridge at the top*

05 *…then swoop down and across the city in a fast zoom…*

STORYBOARD

Below is a section of the final camera moves before adding effects and lighting. The most notable difference is that a new temple has replaced the original. In the new sequence, the camera zooms into a window rather than tracking up and over the outside of the building.

DrawingCharacters1

A GOOD LINE OF ACTORS

Despite the advances made in 3D animation by the likes of Pixar, hand-drawn characters are still the basis of the majority of animation – cartoons. Even where major feature-length animations are filled with computer-generated images, the main characters are still painstakingly created with pencil and paper. Why?

Apart from almost 100 years of tradition that makes us expect animation to be drawn, there is the magic that comes from seeing drawings move. Couple this with the limitless diversity of the human imagination and artistic style, and we end up with the fantastic range of cartoons we see today.

Most artists develop their own style as they mature, whether it be derived originally from imitation or inspiration. This style is a combination of the linework and their perception of the world. No one is going to deny that most cartoonists have quite a different view of the world than the average person. You presumably fit into this category and have already discovered your talent for drawing.

MODEL BEHAVIOUR

When you start to draw your characters, you must have their characteristics firmly established in your mind, just as an actor does when playing a role, because you will be acting out that role with your drawings. The personality of

▶ Making model sheets is a vital part of the line animator's work. They establish the characters' proportions as well as defining their overall shapes. These three examples show three different character styles and presentations. The first one (fig 01) shows the artist's construction lines and some annotations, which can be a useful guide to other artists who may work on the project.

the character will go a long way towards determining its physical attributes (fig 09). Although it is best to avoid stereotypes wherever possible, certain body shapes will help convey the character's personality to the audience in the quickest way. For example, heroes have triangular-shaped bodies with broad shoulders, very active people tend to be thin, jolly people are plump and so on. As discussed earlier, people-watching is an important part of the animator's work.

Once you have got past the initial sketch stages and have a firm idea

FIG01

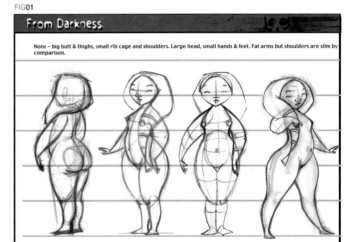

From Darkness.

Note – big butt & thighs, small rib cage and shoulders. Large head, small hands & feet. Fat arms but shoulders are slim by comparison.

FIG02

FIG03

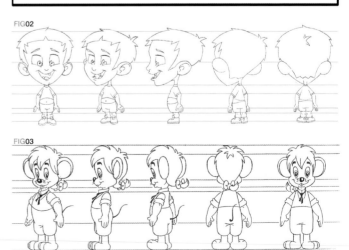

FIG04

EVITAR ESTOS PANTALONES.

FIG05

FIG06

 While the story is still the most important aspect of any film, animated or not, television cartoon series rely more heavily on the characters. There are many artists, such as Tim Beaumont, who specialise in creating and developing characters and an animation's style. Once created these characters can be sold to studios for further development and animation.

 Spanish animation studio Accio produced a comprehensive range of model sheets for the characters they developed for a children's cartoon. Not only did they create the standard proportions sheet (fig 03) but also ones showing facial expressions and body movements. These are just a small selection of those developed for one of the characters.

of how the character will look, you need to make some model sheets **(figs 01–03)**. These are the blueprints from which you'll be working. They show the character from different angles – front, back, sides, three-quarter view, top – with clearly marked proportion guides. You'll also need to produce a sheet of facial expressions portraying a full range of emotions **(fig 04)**. Don't limit yourself to drawing those needed in your film. The more you create, the more alive the character becomes in your own mind, and the practice can be helpful when you are developing other characters.

HERE'S LOOKING AT YOU, KID
Another useful aid, especially when you come to working on the final animation, is a maquette. This is a three-dimensional sculpture of the character, usually made from clay, which is the easiest medium to work in. You may prefer to make this 3D model before you start on

your model sheets, or conversely you can use the model sheet as a guide for the sculpture.

Once you have established the form of your character, you will need to work on how it is going to move. This is covered on the following page.

Canadian studio Atomic Cartoons created some unusual characters for its series Dirty Lil Baster. Gil is an alligator 'raised in the Bayou by human kin', Ma Gil and Pa Gil Richards. Pencil drawings were used to develop character expressions. The coloured character studies were done in Flash, the program used for the final animation, thereby reducing the need to redraw Gil for each wardrobe test.

FIG07

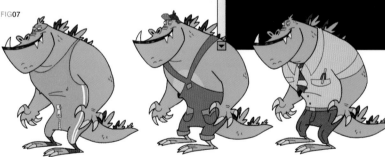

FIG08

FIG09

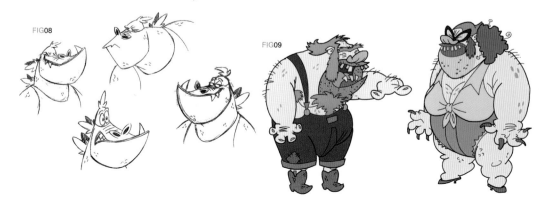

FIG 01

 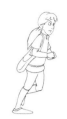

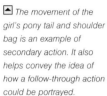

▲ *The movement of the girl's pony tail and shoulder bag is an example of secondary action. It also helps convey the idea of how a follow-through action could be portrayed.*

Drawing**Characters**2

UNIT/39

MOVING ACTION

Once you have your character designed, you'll want to get it moving; after all, that's what animation is all about – acting out a story by giving life to your drawings. The style of your animation will determine how you approach the task of creating the action. If you're making a humourous toon, in the *Looney Tunes* tradition, the action is going to be fast and exaggerated, whereas if you're making something atmospheric, as in a Manga style, movement will sometimes be minimal and subtle.

▼ *Despite their simplicity, these drawings of the skateboarder are clearly the key frames of a pose-to-pose action where each action anticipates the next one. Each frame's movement is exaggerated, as is the arc of the action, especially in the first five drawings.*

FIG 02

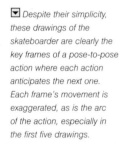

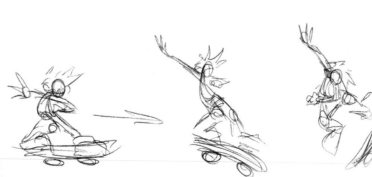

No matter what style you are working in, it's vital to keep the movement fluid and realistic, even when the character is being crushed under a ten-ton weight. This is achieved by using squash and stretch and is probably the most important technique you'll need to master. Almost all physical movement involves some squash and stretch, whether it be leg muscles and torso during a walk or a ball bouncing off the ground.

Squash and stretch is the first of twelve basic principles of animation outlined in what most animators consider to be the bible of the craft, *Illusion of Life* by Frank Thomas and Ollie Johnston. These twelve principles are listed here:

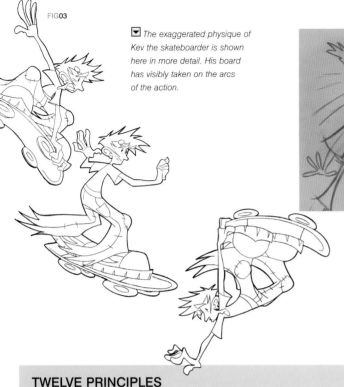

FIG03

▼ The exaggerated physique of Kev the skateboarder is shown here in more detail. His board has visibly taken on the arcs of the action.

FIG04

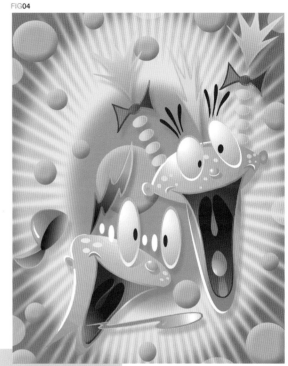

▲▶ Eyes popping and jaws dropping are commonly used exaggerated expressions. Combined with the explosion of colour, they bring this still image (right) to life.

TWELVE PRINCIPLES OF ANIMATION

1. SQUASH AND STRETCH

2. ANTICIPATION *This is setting up the action before it happens, usually with a slight movement in the opposite direction to the main one* **(fig 02)**.

3. STAGING *This is related to the way the film as a whole is 'shot', considering angles, framing and scene length.*

4. STRAIGHT-AHEAD ACTION AND POSE-TO-POSE *Straight-ahead action starts at one point and finishes at another in a single continuous movement, such as running,* **(fig 01)** *whereas pose-to-pose is a variety of actions in one scene requiring clearly delineated key frames to mark the action's extreme point* **(fig 02)**. *How the in-betweens are executed can alter the whole rhythm of the action.*

5. FOLLOW-THROUGH AND OVERLAPPING ACTION *Follow-through is the opposite of anticipation. When a character stops, certain parts remain in motion, such as hair or clothes* **(fig 02)**. *Overlapping action is where the follow-*

through of one action becomes the anticipation of the next one **(fig 02)**.

6. SLOW IN – SLOW OUT *This means using more drawings at the beginning and end of an action and fewer in the middle. This creates a more lifelike feeling to the movement.*

7. ARCS *These are used to describe natural movement. All actions create circular movements because they usually pivot around a central point, usually a joint. Arcs are also used to describe a line of action through a character* **(fig 03)**.

8. SECONDARY ACTION *Is just that, another action that takes place at the same time as the main one. This may be something as simple as turning the head from side to side during a walk sequence.*

9. TIMING *This is something that can't be taught. In the same way that comedians who rely on it to get the most from their gags have to learn it through experience, you too will get it right only through practice. Timing is how*

you get characters to interact naturally. Timing also has to do with the technical side of deciding how many drawings are used to portray an action.

10. EXAGGERATION *This is the enhancement of a physical attribute or movement, but don't make the mistake of exaggerating the exaggeration* **(fig 04)**.

11. SOLID DRAWING *This conveys a sense of three-dimensionality through linework, colour and shading* **(fig 04)**.

12. APPEAL *This is giving personality to the characters you draw. If you can convey it without the sound track, you know you are on the right track.*

These are not hard and fast rules, but they have been found to work since the early days of animation. Bear them in mind at the storyboard stage and your animation will definitely have more fluidity and believability.

Sound

FIG02

UNIT/40

ADDING VOICES AND MUSIC

Incorporating sound into an animation is what gives it added depth and reality. From the recording of the voices to sound effects and background music, sound adds extra texture. Try watching a cartoon without sound – not very interesting. Certainly, you can do it as a test to see if the visuals work, if they stand up on their own, but it won't win your audience over.

⬆ *Always use a quality microphone for recording voice-overs. This one has a pop shield, which stops popping when pronouncing Ps. It is inexpensive and highly recommended.*

We are so used to watching films with background music that if it is missing we almost feel uneasy. The same goes for sound effects. So how do we get the audio onto our film?

Let's start with the voice-over track. This is best recorded in a professional recording studio, if

⬇ *Setting up your own recording studio at home can be reasonably inexpensive, especially if you already have a computer. If you are musically inclined then it will be a worthwhile investment.*

possible. They will have the highest-quality microphones and tape equipment. If you are using professional actors, the extra cost of a studio is comparatively small. Check through the Yellow Pages or a professional directory to find one that offers good rates. Many colleges and youth organisations have their own recording facilities, too. If you use an external studio, get them to supply the recording on a CD in a format that your editing software recognises (WAV or AIFF).

It's not impossible to record at home, though, especially with the continually declining prices of digital equipment **(fig 01)**. Just look at the hundreds of demo discs and tapes that arrive at record companies every day. All you need is a decent dynamic microphone **(fig 02)** with an interface to your computer (a mini-jack adaptor to plug it directly into your computer should be enough) and digital recording software such as Pro Tools – and a soundproof room.

FIG03

⬆ *The Internet is a great source of sound files for your animation, but with variable quality. Sites such as www.soundoftheweb. com offer very high-grade sounds at affordable prices.*

FIG01

SPEAKERS: *A pair of quality speakers is essential to hear all the subtle nuances of music and sound effects.*

KEYBOARD/SYNTHESISER: *These range in price from below £150 to well over £1500. Your level of ability and commitment will determine what you buy. The important thing is for the keyboard to have a MIDI port.*

RECORDING/SEQUENCING SOFTWARE: *This ranges from freebies such as ProTools Free up to professional programs like MOTU Digital Performer, shown here.*

CONTROLLER: *Hardware that plugs into the computer to allow you to interface microphones and MIDI instruments as well as control recording functions. The Tascam US-428, shown here, is an excellent choice and comes with Steinberg Cubasis sequencing and recording software.*

SOUND FX

Sound effects can be derived from a variety of sources. You can buy CDs of every conceivable sound effect **(fig 04)**. Like everything else, they vary in quality and price. Large production companies have vast sound libraries, with a professional price tag. A search of the Internet will unearth huge collections of sounds that can be downloaded. Many of them are free, but remember, you get what you pay for, and many of them will be suitable only for using on the Web.

Making your own may be more work than it merits. However, if you need non-specific sounds and effects, such as sci-fi machinery, a half-decent synthesiser will do the job when used in conjunction with a MIDI sequencer or a sound editing program.

MAKING MUSIC

For music, as with sound effects, you can purchase pre-recorded royalty-free CDs. Royalty-free means you pay only once for the rights, when you purchase the disc, and not each time you use it. Like sound effects, they vary in price and quality but may not always be relevant to your film's style or atmosphere.

If your talent also extends to music, you can always compose your own, and be free from the whole royalties issue. If you have a good ear for music but can't play any instruments yourself, you can always try programs such as

Libraries of sound effects and royalty-free music are commercially available on CDs. Search for 'Royalty free music' on the Internet.

Band-in-a-Box or GrooveMaker **(fig 06)**, which supply sampled sounds that can be sequenced together. They can make an interesting sound track for sci-fi and contemporary-themed films.

Using existing musical releases for your film will plunge you into the murky world of copyright clearance and royalty payments. Unless you plan to make a major cinema release and issue a sound-track album, or are a personal friend of the composer, then stay away from this. And don't use copyright-protected music without permission because it's just not worth it. The only ones who benefit from this in the end are the lawyers.

Techniques for incorporating the sound into your film are covered on page 144.

Mark of the Unicorn's Digital Performer is one of the market leaders for sequencing and digital sound recording. Because it is a professional program, it has a steep learning curve and more features than you may need, but if music is your thing then such a program may be worth getting.

Initially designed as a tool for DJs, Groovemaker has enough sounds and rhythms to make a driving sound track for a sci-fi animation or game. It's very easy to use and requires only a good ear for mixing prerecorded sounds together.

OVER TO YOU

OTY/01

When you write up your dope sheet, don't forget to mark all the places where you need sound effects. With them listed, it will make it much easier to source them. Most CDs and websites are categorised for ease of selection.

OTY/02

If any of your friends are musicians, then enlist their help. Do an exchange of skills – they help with your sound track, you help them with their next pop video.

OTY/03

Try contacting a local amateur dramatics club to help with the voice-overs. Even amateur actors have had some training and will add an extra touch of authenticity and professionalism. Offer your artistic skills to help with one of their productions.

Lip**Synch**

PUTTING MOUTHS IN THEIR WORDS

Unless you are making a silent film, at some time you are going to have to deal with lip synchronisation (or lip synching). This means matching realistic mouth, and even facial, movements to the words being spoken. The level of realism of these movements will depend on the style of your animation. A simple or collage animation will have nothing more than an opening and shutting movement, whereas a feature cel animation will have a full range of mouth shapes or visemes.

Visemes are the standard shapes mouths make when sounding the consonants and vowels that form a word. These sounds are known as *phonemes*. If you look up a word in a dictionary, it shows the word spelled in the familiar way followed by a stranger spelling, in brackets, with accented letters and hyphens between the syllables. This is the phonetic spelling, a guide to the way it is said or pronounced. Phonetic spellings are an invaluable aid for animators when used with a standardised set of phonemes and visemes.

IN THE BEGINNING WAS THE WORD

In animations made today, the voice track is usually recorded first and the mouth movements and facial expressions are drawn to match afterwards. This gives the voice-over actors a lot more freedom of expression, which ultimately enhances the way the characters are represented on

screen. The classic example of this is Robin Williams' voicing of the genie in Disney's *Aladdin*. The ad-libbing and spontaneity of his performance completely changed how the genie was portrayed on screen.

Apart from the examples of the nine basic shapes (four vowels, five consonants) shown in **fig 01**, a video of the actor performing his or her lines is a useful guide, as is a mirror for observing your own face while making the drawings. If you are making a cel animation, there is no easy way out – you have to draw each frame.

To ensure that this is done accurately, the phonetic sounds need to be written on the dope sheet (page 76) in the dialogue column, carefully matching the timing. Sometimes the animator may draw simple miniature visemes next to the phonetic spellings, as an aid when characterising the mouth.

FIG01

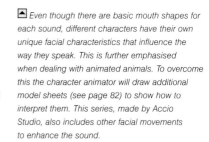

▲ *Even though there are basic mouth shapes for each sound, different characters have their own unique facial characteristics that influence the way they speak. This is further emphasised when dealing with animated animals. To overcome this the character animator will draw additional model sheets (see page 82) to show how to interpret them. This series, made by Accio Studio, also includes other facial movements to enhance the sound.*

FIG02

The recording shown as sound waves and their place in relation to the frames.

This shows an animated version of the sound, so you can check it as it plays.

Sound Element Editor

Sound Element

102

(D)

A B C D

E F G X

Current Frame: 78

Start Frame:

Lip-sync Delete Insert...

Current Sound

Name: Time: Sample Rate: Stereo: Bit Rate:

Start Time: Number of loops: Stop Time:

Cancel OK

The eight basic mouth shapes the program utilises for creating the lip synch. The letters are for naming purposes only and do not correspond to the shape shown.

DIGITAL DIALOGUE

It's a different story with 3D CGI animation, because there are many software programs that do the work for you. Some work just with sound files, whereas others can take the information from a live video of an actor and convert it into a format that the animation program can use. More on this in the chapter on 3D.

The biggest problem for lip synching comes with the international distribution of films. Countries such as Italy are masters of dubbing live-action films, so they manage successfully to overcome synching discrepancies with animation as well. Japanese animation studios tend to create the

mouth movements before adding the voice-over. Although this is not always the most accurate method, it does mean that translated versions are equally approximate in their synching, and many people even see this as part of their charm.

Whatever style of animation you are employing, the proper use of lip synching and facial expressions will increase the credibility of your characters more than any other trick you may try.

◣ *If you are creating your animation digitally, there are many tools to help you with lip synching. In Toon Boom Studio, recorded dialogue can be added, and the program will analyse it and display the appropriate mouth shapes. The generated mouth shapes can then be drawn onto the characters in the relevant style.*

OVER TO YOU

OTY 01
Sit in front of a mirror and make sketches of yourself pronouncing different words. Compare your sketches with the standardised shapes on this page.

OTY 02
Try using different moods and ways of expressing the same words and see how much the mouth shapes change. Look at how the rest of the facial expression changes relative to the mouth.

OTY 03
If you are using experienced actors to do the voice-over, video them while they are reciting the lines as they will often add some useful expressions that can be used in the drawing.

OTY 04
Look in a dictionary at the phonetic spelling of words and make sketches using the standard mouth shapes, then make sketches of the same words as you speak them in a mirror. If you prefer, you can video it and draw from the still-frame playback.

▶ *These are the nine basic mouth shapes that can be used to cover most words and should be sufficient for all but the most demanding and intricate animations. Preston Blair's book* Cartoon Animation *is considered the standard work on drawing cartoon pronunciation, and is an invaluable guide to anyone starting in line animation.*

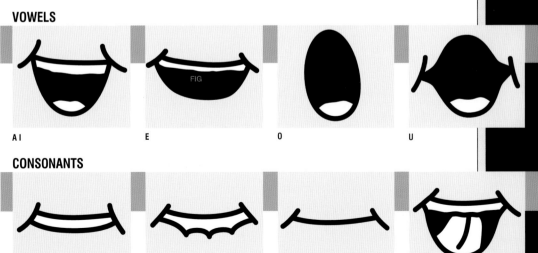

VOWELS

A I E O U

CONSONANTS

C D G K N R S T H Y Z V F M B P L W Q

The idea, the all-important story.

The storyboard.

Recording the sound track. The voice-over has to be done here. The music is optional and can be left until stage 08.

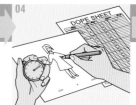

Timing breakdown and planning. Your choice of method and software will dictate your next move. If you are working with paper go to 05a; to 05 if working entirely digitally.

Adapting to Digital

UNIT/42

WORKING WITHOUT CELS

We have already established that, for the home studio, digital is the best option and, by choosing the right equipment and software, is affordable as well. Most of the major animation studios have been using digital systems for years, for the same reasons – efficiency, accuracy and economics. These professional software systems naturally come with professional price tags, but are integrated to manage every stage of the production, from scanning to editing and output.

▼ *Animation Stand comes in a reasonably priced Pro version and a free Personal Edition. For its price, it is very powerful, with excellent digital paint tools (shown here) and multiplane cameras.*

FIG01

The efficiency of working digitally comes from having all the images in one central place so that any artist is able to work on any part of the production. This is especially useful when it comes to the laborious task of ink and paint. The top-end digital systems also allow colour palettes to be universally amended. This means that colours can be changed at any time during the production, something that would be unthinkable with traditional cels. Most digital animation systems now don't even require paper originals, although it will be a long time before all artists give up their pencils and paper.

When everything is digital, there is far less risk of losing or damaging cels, and because the job is kept on a central server, all the work is regularly backed up. In the long run, using digital systems allows the production of a greater volume of intricate work in far less time.

CHOOSING SOFTWARE

If you want to use dedicated digital animation software, you have a choice of four industry favourites and some relative newcomers. The big studios seem to opt for either USAnimation, which works on Irix (SGI), Windows or Linux; Cambridge Animation Systems' Animo, which runs on Windows or Mac OS X; RETAS!Pro for Windows or Mac (see **fig 02**); or AXA Team 2D for Windows. These programs can do everything you could possibly want from an animation program, including converting 3D scenes into traditional cartoon style. They are usually sold in modules so that you purchase only the parts you need. For example, you may need only one scanning module but many paint and ink ones. Of course, these programs may be well out of your price range.

The newcomer alternative is DigiCel FlipBook, which has most of the features of the others, but with a lower sliding-scale price.

05 Draw your animation with a stylus and graphics tablet. Use software's built-in Exposure Sheet and sound facilities for lip-synching.

05a Draw animation using standard punched animation paper.

05b Scan drawings and pencil test.

05c Trace and clean-up drawings in software.

06 Colour, using digital ink and paint.

07 Save completed animation to a format compatible with editing software (such as QuickTime or swf).

08 Edit scenes and add sound effects and music.

www. Save final output to relevant format (swf for web, Beta, DV, DVD or for transfer to film).

It has yet to gain acceptance from the industry's major players but is popular with smaller studios that lack funding. At the time of writing it was available only for Windows, with the Mac version under development. Animation Stand by Linker Systems (see **fig 01**) is another full-featured, cross-platform solution worth looking at. The good thing with most of these packages is that they offer educational licences at highly reduced prices (but with restrictions).

What are the options for a solo operator on a tight budget? The previously mentioned Painter is an excellent option and can be used for everything from pencil tests (see page 92) to paint and ink. The ever-trusty Photoshop can also be employed for colouring images. Most people are familiar with this program, making it quick for them to use, but its lack of animation tools does mean it needs to be used in conjunction with After Effects and/or Premiere.

The other alternative is the ever-increasing range of vector animation software, which has many advantages over the other pixel-based systems mentioned above. The following pages outline some of the systems and techniques for creating digital cel animation.

FIG02

RETAS Pro! is Japan's most widely used 2D animation software available for Windows and Mac OS. It is a modular system that has scanning, pencil test, tracing, painting and compositing/camera units. The multi-window compositing module, shown here, uses a digital exposure sheet (top left) to control the images created in the other modules.

Pencil Test

FIG01

CHECKING YOUR DRAWINGS

The pencil test is a crucial part of the animation process. It involves taking the animator's pencil drawings and putting them into a running sequence. It is done to ensure that the animation works properly and so that any errors can be corrected at this rough pencil stage before moving on to the expensive stage of tracing the drawings onto cels, cleaning up the linework and adding the colour.

Fixing a peg bar to a scanner is the easiest way of digitising your drawings for a pencil test. Your peg must sit squarely on the scanner. To ensure everything is lining up properly, place a punched field guide (see page 77) that matches your drawing paper, onto the peg bar, butting it up to the leading edge of the scanner's platen. Tape down the peg bar. Scan the field guide at a resolution of 300 or 600 dpi (depending on your scanner). Open the scan in Photoshop and use the ruler guides to make sure the lines are straight horizontally and vertically.

With traditional methods, once the pencil test has been approved it is discarded, or possibly archived for DVD extras. When using digital technology, we can use this work towards the finished production.

First, digitise the drawings. Top-of-the-range animation systems, like those mentioned on page 90, use an automated, sheet-fed scanning system that recognises the standard peg-hole registration. Of course, you are not likely to have this system at home, so you will have to adapt your equipment for the purpose. All you need is a scanner and a standard peg bar for accurate registration (see **figs 01–03**).

SCANNERS

Once the scanner is set up, place the first drawing on the pegs and scan it. Use the greyscale setting, but with plenty of contrast, as it will capture more detail than the line art setting, and set the resolution to 288 dpi. This is four times what you will need, but it is much easier to discard information than to retrieve what isn't there.

Naming the files is very important. Try to make the names of the files match up with the dope sheet. The file could be called sqA-sc2-sh1-l2-001 (sequence A,

FIG03

Peg bars are available in metal (shown here) or the cheaper plastic version. The metal one is going to be more robust, making it ideal for your light table, while the plastic one is perfect for attaching to your scanner. Make sure your paper and peg bars are all from the same system (Acme or Oxberry are the standards).

There are many different ways of doing a pencil test, from manual scans and low-cost software to batch scanners using dedicated high-end animation software such as Animo, to a rostrum camera set up (shown here).

FIG02

The initial pencil drawings are completed on paper.

The drawings are placed, in order, on the baseboard of the rostrum camera. Here, a DV camera is mounted on a copy stand.

The camera is attached to a PC using a dedicated pencil test software, Crater CTP Line Tester that is designed to capture each frame sequentially. Once all the drawings have been shot, the clip can be played back and checked.

scene 2, sheet 1, layer 2, picture 1 [of 100]). If you have 100 images or more you must use zeroes to start your numbers, such as 002 or 027. Likewise, with up to 99 images, single digits must be preceded by a zero. Whatever code system you use, it must be consistent – and you have to remember what it means. Save each sequence into its own named folder or directory.

SEQUENCING

Once you have scanned in all the images, you have to decide how you want to put them together. You also have to decide if and how you want to use these scans for your final animation.

Most people will probably opt for the Adobe route of Photoshop with After Effects and/or Premiere but Painter is more practical if you are on a limited budget.

It is very easy to create your film in Painter. Go to 'Open' under the 'File' menu. This will bring up a dialogue box **(fig 04)**. Here select 'Open Numbered Files' and choose the folder where you have saved the sequence using the numbering system outlined above. Choose the first file in your sequence, then the last, when asked. You will now be asked to save the file. This will create a frame stack that you can play back within Painter or export as a QuickTime or AVI movie. Be aware that these frame stacks can create very big files, so make sure you have plenty of disk space.

If you have opted for working with Adobe's suite of video-editing software, you can do the same trick of importing sequences of TIFF files into either Premiere or After Effects. One advantage of using either of these programs is that they don't actually import all the files into the program but use reference links, thus keeping files small. It does mean, however, that you have to be very methodical with your computer filing system. You can't indiscriminately move folders around or the links become broken and the sequences won't work.

Using your pencil test scans for your final animation is covered on the following pages.

FIG04

▲ ▶ *Procreate Painter's animation tools* **(fig 04)** *are an option when making a pencil test. Select the first and last image of a sequence, when prompted. Painter will create a 'Frame Stack', a sequence of images* **(fig 05)**. *Select the number of onion skin layers you want, and your colour option. If you are only making a pencil test, select the 8-bit grey. If you intend to add colour, select the 24-bit option* **(fig 03)**. *This palette will appear on your Painter desktop. You can play the Frame Stack sequence or scroll through the individual frames.*

FIG05

FIG06

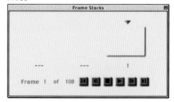

FIG09

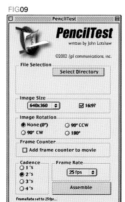

FIG07

FIG08

▲ *Scanned images can be imported into Premiere as a sequence simply by selecting the first image and choosing the 'Numbered Stills' option* **(fig 07)**. *When the dialogue box* **(fig 08)** *appears, choose the 'Merged Layers' option. The sequence will appear in the Project window where you can add it and other sequences to the timeline for playing and/or exporting.*

◀ *John Lotshaw's shareware, PencilTest, is an easy and inexpensive way for Mac users to make a line test.*

OVER TO YOU

OTY/01

You need minimal equipment to make your pencil test, but it is important that the pencil test is done accurately. The future of your finished animation relies on it. If you are on a tight budget, experiment with your existing hardware and software. If you do need to buy something new, look for something that you can use elsewhere in your project.

OTY/02

Neatness and organisation are vital when working with so many sheets of paper. Make sure you number each sheet near the registration holes and use those numbers for the digitised file names.

DigitalTechniques1

FIG05

UNIT/44

DIGITAL INK AND PAINT

If you are satisfied with the pencil test, you are ready to start the laborious task of inking and painting the animator's (your) drawings. We will look at some different methods of doing this, utilising both affordable software and a professional system.

◢ Drawing with a mouse has been likened to drawing with a bar of soap, so if you intend to do a lot of digital line animation, invest in a good stylus and graphics tablet.

FIG01

◀ When tracing pencil drawings in Photoshop, use the Paintbrush tool, as opposed to the Pencil tool, as it will give a cleaner and softer line, due to anti-aliasing.

FIG02

◢ This example shows two highly magnified lines created in Photoshop. The top one is made with the Paintbrush Tool. The softness is created by a process called anti-aliasing, where pixels are blended with the adjoining colour, in this case a range of greys. This prevents what are commonly known as 'jaggies' – hard-edged pixels that we can see in the second example drawn with the Pencil tool.

Assuming that the drawings you used for the pencil test on the previous page were acceptable, you can start by cleaning these up. As versatile as Painter is, this exercise concentrates on Photoshop, as it is the most popular image-editing software and integrates well with After Effects. You will also need a graphics tablet. These range in size from A6 to A3. Buy what you can afford, but an A3 one would be a little excessive.

TRACING
Open the first scan of the pencil-drawing sequence in Photoshop and create a new layer. You will redraw over the top of the pencil lines on this new layer. If, until now, you have been working in

greyscale for the pencil test, you will need to change to colour. To do this choose 'Mode' from the 'Image' menu and select RGB. This is the colour space used for video and has more vibrant and varied colours than the CMYK used for printing. Computers are perfect for colouring animation. You create your palette of colours and they remain consistent throughout the project, and they never spill, run or smudge.

Select a drawing tool from Photoshop's tool palette – brush or pencil **(fig 01)**. Choose the brush size you want. It's easy to make a palette of brush sizes you will need for different line weights, but don't make your brushes too soft. Because graphics tablets emulate real tools, they are pressure sensitive – the harder you push, the thicker or darker the line appears on screen. Because you will probably want consistent and

▶ To colour your line drawing select the Paint Bucket Tool, choose the colour from the palette, and click into the area.

▶ The areas circled in red show where the line work has not been closed up. If you use the Paint Bucket Tool here, the colour will simply fill the whole background area. Check your drawings before you start colouring. The 'Undo' command will remedy the mistake, so you can close the gap.

The options for the selected tool are shown here. In most cases, the default settings for the Paint Bucket work fine.

To fill the area just place the cursor over the area and click.

All your colours for the animation are stored in the Swatches palette. Give them names that you will be able to understand.

The Paint Bucket Tool is used to fill large areas with a single colour.

FIG03

FIG04

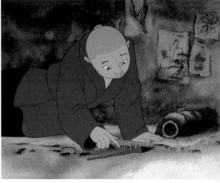

▼ *Christmas Films, in Moscow, used broad areas of flat colour bound by clean, simple lines to starkly contrast with the soft watercolour wash backgrounds in this Chinese story of* The Magic Paintbrush.

◤ *To produce his animation,* The Lighthouse, *Mårten Jönmark drew all the character movements in pencil and scanned them into Photoshop to be coloured.* **Fig 06** *shows the pencil drawing on its own layer. The layer was set to 'Multiply' in the layer options, so that the white of the paper becomes transparent when layers are placed below it. In* **fig 07**, *we see the colour painted onto a separate transparent layer. In the third picture* **(fig 08)** *we see the two layers together with the background, as it appears in the finished film.*

even lines, adjust the pressure options as well.

Once you are comfortable with using these new tools, and have had a little practice, you can start laying down some lines. There are many benefits to cleaning up drawings on the computer, but the most useful is the ability to correct mistakes instantly. Most illustration and image-editing programs now offer up to 100 levels of 'undo' to remove any errors.

Whether to use colour or just black for your linework is a decision you should make based on the style of animation you are doing. Cartoons work better with black outlines (see **fig 10**) whereas more complex character animation will look better with colour, to reduce the hard edge.

When it comes to doing the linework, one of the advantages Painter offers over Photoshop is

the ability to rotate the page while you are drawing, as you would when working on paper or cels. Some of the dedicated animation programs also do this. If you still prefer working in Photoshop without this facility then by all means do so. The methods described on this page are just as valid for both programs, or any other you may prefer.

DIGITAL PAINT
Applying the colour to your outlines is extremely simple. Select the 'Fill' or 'Paint Bucket' tool, click on the colour you require from your palette, and click in the area you want to colour **(figs 03** and **04)**. If you want to add soft shading, shadows or other highlights, they can be added afterwards, preferably on a new layer.

You may want to keep your outlines on a layer of their own. This method is preferred by comic book artists and is an equally valid

way of working for animators too, especially if they are supplying cleaned-up drawings. All you need to do is create a duplicate layer that sits below the linework and colour it as described previously. It is a good idea to link the two layers together to keep them from accidentally going out of register. When you have finished colouring the image, it is a good idea to delete the layer with the pencil drawing and save the completed file to a new directory, maintaining the naming system you established earlier.

Now you have your first frame finished and saved as a Photoshop file – only hundreds more to go. But it's got to be easier than doing it by hand. Once that job is done you just have to composite them all together in Final Effects, before editing and adding the sound track.

FIG09

OVER TO YOU

OTY/01

If you are new to using a graphics tablet, take the time to practise and familiarise yourself with how the pen responds. Tweak the controls for the pen in its own software, as well as in the drawing program. It will take a little time before you are comfortable with it. Remember how long it took for you to feel natural with a pencil or pen.

▶ *In this example, by Accio Studios, black lines are used for outlining the shapes, except where there are dark colours and a paler, contrasting colour is used, giving the characters more solidity. There is a general acceptance of using these outlines in animated characters that has developed over the decades of watching cartoons and reading comics. However, it is much rarer to find backgrounds that are delineated in the same way.*

FIG10

Digital Techniques 2

FIG01

PUTTING THE FILM TOGETHER

Creating a multilayered animation using Photoshop for the ink and paint has some disadvantages compared to using a dedicated digital cel animation program. The main problem is synchronising and registering the different layers when it is imported into After Effects, especially if some are shot on singles, some on twos and some on threes. To avoid any errors follow the work described here. that should work well if there are no complicated camera moves.

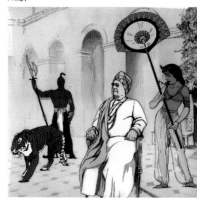

⬆ The Eyes of Karras by Hedley Griffin was made using Animo. The animator was particularly impressed by the realistic skin tones and shading, and also by being able to give the film the look of a watercolour painting, which is difficult to create consistently with traditional cel techniques.

Using the exposure sheet, find all the static elements, backgrounds and other scenery or props, and place them on the lowest layer(s). Now take all the elements of the first frame and place them in the layer order marked on your exposure sheet. Name each layer to correspond with the frame number and layer. Add the 'cels' for the next 'exposure,' building up the Photoshop file until you have 2 or 3 seconds worth. Activate only the cels needed for the first frame and do a 'Save Copy,' using the chosen name coding method. A Photoshop (psd) file will give you more flexibility, but choose a format your comping/editing software recognises. Once you finish that stack create a duplicate file and continue in the same way, until you have completed a sequence.

You should now have a mass of coloured Photoshop files, all properly named and sequentially numbered and ready to animate in any number of programs from After Effects to Premiere to iMovie or one of the programs suggested for stop-motion animation. As you are dealing with a sequence of still images, all you need is for them to play one after the other.

This method is long winded and possibly unreliable. Simpler animations can be made using Photoshop and After Effects, but it is best to use a dedicated software (see page 90). You may want to try one of the lower priced options first or one of the professional programs, such as Animo.

DIGITAL CELS

Your initial outlay in money and learning time is going to be high, but it will soon pay for itself with what you save on production costs. Here are the advantages of using a program like Animo.

Animo can make life easier for you right from the outset. Its scan module is designed to work with sheet-fed scanners. Instead of placing individual sheets onto the peg bar manually, Animo scans 'off peg' (the software automatically registers the peg holes on the scan), so a batch of drawings can be loaded into the scanner and digitised. It will even play back the scanned files in order for a pencil test preview.

Once all the images are scanned and pencil-tested they are placed in the InkPaint module to be cleaned up and coloured. A lot of this process can be automated to speed up the production. There is also an option that allows you to work with vectors for smoother lines and/or Flash output.

When everything has been coloured and checked, the animation is assembled in the Director Module. All the different elements, such as backgrounds, sound, lip-synching, special effects, 3D elements and even live-action are added using integrated, optional modules before it is edited and rendered for final output to film or video.

For feature animation makers, using such powerful compositing tools not only speeds up the workflow but can add new depth to the production as well. Recent Warner Brothers' animations such as Space Jam and The Iron Giant were all made with Animo.

Animo is by no means the only digital cel animation software available and its price is prohibitive to most home-users. If you do want to work with an integrated 2D animation software, then you should look at all the options and try them out (see page 91).

FIG02

FIG04

FIG03

⬆ Putting your animation together in iMovie is a little more problematic because you can only import one image at a time. You will also need to manually set the time value for each frame. All very time-consuming. If your budget is very tight use PencilTest, an inexpensive shareware program (see page 93), and edit the sequences together in iMovie.

In this file, each animation layer is made of two Photoshop layers. The top one is the line work and the other one is the colour. The 'Multiply' in the Mode column makes the white transparent so the colour layer below shows through.

FIG05

The In/Out points for each layer set to cover two frames (if you are shooting on twos) with one layer beginning where the other ends.

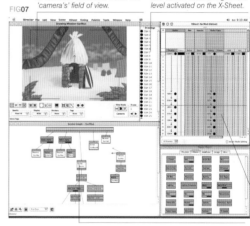

The bottom layer is the background.

Moving this slider expands and contracts the Timeline. Here, it is almost at maximum magnification, so we can see the frame counter, in twos.

Set the In/Out points for the background to the length of the sequence.

◀ Once a layered file is imported into After Effects, most of the operations are controlled from the Timeline palette. If you import a layered file, it should be as a Composition, which will bring all the Photoshop layer attributes with it.

⬆ Importing your Photoshop sequence into After Effects **(fig 02)** or Premiere **(fig 03)** is essentially the same process. The main difference is that Premiere does not accept layered files. If you intend to use Premiere, it will be easier to save your files 'flattened' – without layers – while you are working in Photoshop.

FIG06

The Drawing Window is a monitor to see each frame and watch the 'camera's' field of view.

This lists all the drawings in the level activated on the X-Sheet.

FIG07

The X-Sheet is much the same as an old-fashioned paper one, except it is completed by dragging or placing drawings in the appropriate frame instead of having to write them in. It also automates the camera work, rather than informing the camera operator, who then physically lays all different cels to photograph one at a time. All digital 2D animation software works with its own version of an X-Sheet.

The Reference Window shows the current drawing and can also contain indicators about which colours from the palette are used for different areas.

The Palette Window is what makes digital ink and paint a more efficient way of working than traditional cel methods. Once colours are created, they can be given specific names for the area they relate to. The Palettes can be exchanged between different models and sequences to maintain absolute colour consistency and fidelity. Any changes made to the 'master' palette will affect all the others so that changing a colour is not a major undertaking.

⬆ Animo's InkPaint module is designed to make the colouring of 'cels' quick and flexible.

The Painting Window where the colour is added to the line drawing. A Paint Bucket Fill Tool is used, as described on the previous page when using Photoshop.

The Scene Graph is a representation of all the elements in a scene and how they are linked and layered together. It is the X-Sheet that controls all these elements and strings them together.

⬆ The Director Module of Animo is the digital equivalent of the rostrum camera. All the different layers are combined here and any special effects are added. The flexibility to experiment and change is more practical than with a traditional camera method; of course, you are still limited to what has been drawn in the first place. The time taken to make changes is reduced from days to hours, which means considerable savings on production costs.

OVER TO YOU

OTY/01

Working digitally is a balancing act between what you want to do, what you need to do it and what you can afford. Choose your digital solutions carefully as there is always a simpler way of doing things.

OTY/02

Find ways of simplifying your animation so that you don't need to use very complicated software and equipment. But don't sacrifice the artistic integrity of the work either.

OTY/03

It is very easy to become a slave to technology. Use it as a tool to make your work easier but don't let it compromise or influence your concepts.

OTY/04

Always experiment. When working digitally, you may discover an effect or technique that will enhance your work.

Vector Images

MAKING RESOLUTION-FREE PICTURES

Graphic images on the computer can be divided into two basic categories: pixel (or raster or bitmap), which we have been dealing with up to now in Photoshop; and vector. Whereas pixels are, by definition, a measure of resolution. vector images are mathematical calculations expressed visually. They have no resolution.

Vector images can be enlarged to any size and the quality remains the same, whereas bitmaps deteriorate. And, because vector images are simply mathematical equations, the file size is very small and remains that way no matter how much it is enlarged, making it ideal for producing web graphics (see page 104).

The other main advantage of vector graphics over pixels, is the quality and smoothness of the lines, particularly curves. Not only are the curves smooth, because of their mathematical origins, but they always remain editable. You can change any characteristic of a line, whether its colour or weight, without affecting its surrounding elements.

Vector images are great for flat colours, although they are no match for their bitmap cousins when it comes to blends and vignettes. Most vector image programs can automatically update colours within a document, if they are edited in the colour palette.

WHY VECTOR?

So why use vector images for animation? For all the reasons given above. For detailed feature-style animation, which requires greater subtlety in the use of colour, pixel-based images are still the best option, but for most cartoons, such as those seen on television, vector is definitely a viable option.

There are many vector illustration programs on the market, such as the popular CorelDRAW for Windows and Deneba Canvas, but the industry heavyweights are Illustrator and Macromedia FreeHand. Both have their devoted users. For those familiar with the Adobe interface, Illustrator would be the natural choice, especially for its integration with its stable-mates, Photoshop and After Effects. If you want to use Flash, then FreeHand is your best option, because they are designed to work together and can be bought as a package.

There is one other program that is a bit of a curiosity and that is

▶ *Working in Illustrator, or other vector programs, the pictures are built up by adding the elements one on top of the other. In this example, the black lines are placed on a separate layer. Using layers is very useful when the images are imported into Flash.*

FIG01

The fill and outline colours are set here.

The Pen tool is used to draw shapes by clicking and dragging the control points.

FIG02

The colour layer is set below the black outline layer.

FIG03

This picture, created in Freehand, uses Gradients (where two or more colours blend into each other). The background sky was created with a linear graduated fill.

FIG04

FIG05

The skyscrapers here were given a Radial Gradient fill. This is circular gradation that gives the effect of the sun reflecting on glass. Most of this picture was made up of simple geometric shapes to give it a graphic feel.

◀ A huge variety of styles is achievable with vector illustration software that combines multilayered elements with strong flat colours and clean curves. Most vector drawings are recognisable by their large areas of flat colour, but tone and shading are easily achievable **(fig 05)**.

Creature House Expression. If you like the natural media effects of Painter, this is the vector equivalent. You get all the artist's brushes but with the editability of vector, and you can export your files to the Flash format.

Generally, all these vector programs are designed to produce top-quality illustrations and, over the many years they have been on the market, an intricate set of tools has been developed.

If you decide to use one of these illustration programs to create your animations, you're still going to need animation software to bring them to life, just as Photoshop needs After Effects. Flash, and its swf format, have become the industry standard, especially for web graphics, and is probably your best choice. Flash is covered in more detail on page 108.

Vector illustration programs can take a little getting used to, but are worth persevering with. They all support pressure-sensitive graphics tablets (some better than others) so you can draw quite naturally. You may feel more comfortable initially working with paper and pencils, then scanning and tracing over them.

There is another alternative to vector illustration programs and that is using a dedicated vector animation program, which is covered on the next page.

▼ Solid colour is used to fill in vector illustrations and is ideal for cartoon animation.

FIG06

FIG07

The diverse range of styles can even include a wood-cut look. This can be done with a mouse, although a stylus is more natural to work with when drawing.

FIG08

Shapes can be created using only straight lines. These coloured shapes were laid over a black background to give the effect of variable-width outlines.

OVER TO YOU

OTY/01

To find out which program suits your way of working, download demo versions and try them. A list of relevant links can be found on page 154.

OTY/02

You can either draw directly into the vector program or scan in pencil drawings then trace over them, until you get used to the graphics tablet. Most programs can do the tracing automatically, but it may be better to do it manually, especially if you want the cleanest lines and smallest files.

VectorAnimation

CHOOSING THE RIGHT PACKAGE

Apart from Flash, which will be covered in the chapter on Web animation, there are some dedicated vector animation programs with features to match those of full-blown studio animation programs and at a fraction of the cost.

◨ *Creating simple characters is one thing vector animation excels at. Cartoon Saloon's Dress Rehearsal is a short tale of a show magician's wand that practises on its own.*

FIG01

FIG02

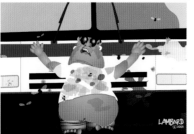

▲ *Not all colour in vector animation has to be flat. To add depth, shapes can be filled with a radial blend. If the original drawings are done in Illustrator or FreeHand, then far greater control of the colour and shading can be achieved, but Flash is just as capable using a combination of radial blend fill and the Fill Transform tool.*

▶ *This shows the Sceneplanning windows in Toon Boom Studio 2, showing the Timeline and Field of View and how the tracking shot is going to work.*

Without a doubt the best of these is Toon Boom Studio. Because of its professional origins, Toon Boom looks complicated on first viewing but is actually very logical, especially for someone already familiar with working in a traditional way. As with any animation project, preplanning is the key, but one of the great advantages of working with vector files is being able to make changes without having to completely redo the work.

THE PAPERLESS STUDIO

One of the big differences between Toon Boom Studio and

FIG03

other animation software is that it is practically paperless. Toon Boom works best with direct input from a stylus and graphics tablet. It is possible to import scanned images, but it is a long, drawn-out process. If you are unfamiliar with using a stylus, it can take some time to produce linework that matches the subtlety of pencil work, so you may find that the 'undo' command is your best friend. Because Toon Boom was designed for creating web animation, the bold, simplistic drawing is not always seen as a problem, but practice and fine-

tuning the software drawing tools will help to refine your technique. If you feel more comfortable using Illustrator, however, you can import those files as key frames, and adjust the vector curves for the in-betweens, using onion-skinning on the virtual lightbox.

Toon Boom is divided into two separate sections – drawing and scene planning. The drawing tools do take a little getting used to, but once you have adapted to them, working in this digital studio is quite natural. It has everything you would expect to find in a real studio – field guides, rotatable light box and exposure sheet with almost unlimited layers. Trace-backs are easily done by simply duplicating the frame. Creating properly named and designated colour palettes makes painting easy. It also means that if you, or someone else, decide to change the colours, it just takes a couple of mouse clicks to update them.

Because vector drawing is mostly done with flat colour, backgrounds can look just that – flat – but it is possible to import bitmap images into the program.

FIG04

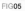 Vector animation has developed incredibly in recent years, as the tools improve and more creative animators adopt it. George Varga's Danville Hustle is a surreal tale of a mysterious black cloud that descends upon an unsuspecting suburb during the night. The atmosphere in the short film, created in Flash, is enhanced by the uniformity of the vector colours.

FIG06

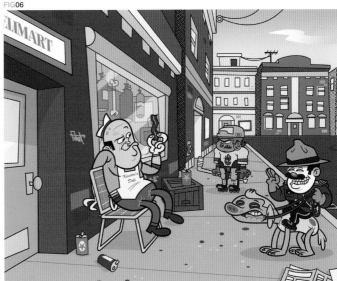

FIG05

Although drawing digitally may not be as fluid as pencil on paper, once you get the feel of it you can produce stunning images. George Varga's animation Row uses light and shadow to great effect in this short about a confrontation between Mods and Rockers in a 1960s London alley.

They are best used only for backgrounds where you need plenty of tonal variety because they will increase the file size, which is fine as long as you're not making the animation for the Web.

LIP SERVICE

One of the trickiest parts of animation is lip synching – getting your drawings to match the sound track. Toon Boom will analyse the voice track and create the correct mouth shapes, saving you from having to spend hours staring into a mirror.

When you have finished working on the drawings for a scene, you flip the program over to the Sceneplanning mode to put everything together **(fig 03)**. One of the great features of Toon Boom Studio is its 3D stage. Here you can organise all the different elements onto perspective-controlled layers. Remember all those Disney films shot with a Multiplane camera that made you feel like you were moving through the scenery? Toon Boom lets you create this and other cinematic effects such as zooming and panning through a 3D plane, and if all the elements are created with vector drawings, there is no problem with calculating image resolution. You tell the program where and how you want the camera to move, and it does the in-betweening work for you.

For short 2D animations, Toon Boom Studio is as good a tool as you will find anywhere and very affordable. With this program, a laptop and a small Wacom tablet, you have a complete portable animation studio capable of producing top-quality cartoons.

Whether you use Flash, Toon Boom Studio, or any other vector package, in the end it comes down to your talent at storytelling, character development and how they are presented. Choosing a software and technique you are comfortable with is the most important consideration. Carneys, Garnet Cyberg-Olsen's show for Atomic Cartoons, works well with the format to bring to life his carnival characters, in a way that other methods might not have achieved.

OVER TO YOU

OTY/01
Download a demo version (Mac OS X and Windows) from www.toonboomstudio.com and give it a try.

OTY/02
If you don't have a graphics tablet, you can use the mouse to draw (ever tried drawing with a bar of soap?) or use some clip art.

Using a stylus, or even a mouse, can help you to make effective animations with simple linework. This type of vector animation will create a very small file that is scalable to any size, as well as making a dynamic animation.

FIG07

Case Study

UNIT/54

FIG 01

CHICKEN LIMB BY AMITAI PLASSE

The chapter at the beginning of the book discussing ideas for stories, suggests that you should write about what you know. Well, New York artist and animator Amitai Plasse did just that, taking his love of chicken wings to create a bizarre and surreal Flash animation.

◀ *On the original storyboard the hero had a toilet for a head, but this was changed after Plasse discovered Robert Crumb had already created a similar character.*

Plasse's original idea was to create greeting cards with macabre tales of vengeance. The initial sketches produced one of a fat man sitting on a bench with a big bucket of wings, his faced lathered with sauce, surrounded by a gang of angry chickens. 'The idea grew from there' he said. 'My target audience initially was vegans, the chicken wing industry, and the makers of poultry prosthetics. However, after I was done I realised that this piece

could be a couple of minutes of fun for the whole family.'

He started the project with rough storyboards in his sketchbook. The main character, Potty Mouf, originally had a toilet for a head, as shown in **fig 01**. However, Plasse accidentally discovered that Robert Crumb had already created a character with a toilet for a head, named Tommy Toilet. Plasse decided to redesign his character rather than invoke the ire of the legendary cartoonist.

FIG 05

FIG02

FIG03

◀ ▼ *From the storyboard Plasse made this initial sketch. The sketch was traced and inked to create the basis for the background. This was scanned, vectorised and coloured in Illustrator. The character was added to the coloured background, on separate layers, and taken into Flash for animating.*

From the storyboards, he made rough scene sketches that were then overlaid with tracing paper for the final ink drawings of the backgrounds, see **figs 02–04**. Further overlays were used over the backgrounds to draw the characters and the other various animated parts. Plasse then scanned all of his inked art into his old Mac, as well as sketches to use as layout guides. The scanned artwork was cleaned up in Photoshop, then run through Adobe Streamline to vectorise it. The resulting vector files were opened in Illustrator and coloured.

Each scene was set up as a separate layered file, with all the different elements sitting on their own layer.

The finished layered Illustrator files were imported into Flash to make the final animation **(fig 04)**. Because Flash maintains all the layers when importing Illustrator or FreeHand files, it made it much easier for Plasse to execute the final animation.

▼ *In this sequence from the finished short, Potty Mouf's meal is disturbed by a heavy pounding on the door. On seeing the angry chickens, he makes a quick escape through the window and down the fire escape.*

FIG04

WEBANIMATION

What is web animation and how does it differ from other forms of animation? Essentially it is the same – making still images move – but delivered over the Internet. Given the growth and technological advances over recent years, most of the initial limitations placed on this medium have all but disappeared.

▼ Creating an animated web site is an ideal way to promote your talents.

FIG02

FIG01

Apart from the increased power of computers, which has no noticeable effect on Internet connection speed, the biggest advances have been vector animation, and most important, the increased availability of broadband in the home. Whether it is DSL, cable or satellite is not important; the fact that high-speed connections are within the reach of most people means that content providers can now show better-quality material.

In the early days of the Web, putting even small images on a page slowed its loading time to an unbearable crawl. As modems reached their peak speed (56K),

web designers pushed the visual content of their pages to the limits of download acceptability, by adding more and more 'bells and whistles'. As simple rollover buttons became the norm, people thought they should get more sophisticated, with style (or more usually a lack of it) winning out over content.

Before the arrival and general acceptance of the Flash format, the only way to get any sort of movement on a web page was to use animated GIFs. These are becoming more the exception than the rule, but I have included a short tutorial on how to make them over the page.

Flash and its swf format has transformed the way we view web content. Whole web sites are constructed using the Flash program, making them closer to multimedia presentations than simple pages of information.

◄ No Guts No Galaxy *is a short anime-style film noir made with Flash by Rea Productions. Its limited palette of black, white and red and the high-contrast line drawings, reminiscent of DC Comics'* Batman Black and White, *mixed with an original music score, highlight the creative potential of Flash and vector 3D when placed in the right hands.*

▼ To show off its personal, non-commercial projects, US studio Renegade Animation created Renegade Cartoons. Pick up a ticket at the box office, move into the foyer and select your entertainment. Enter the vault to find episodes of the sometimes surreal Flash animation, Bulk Register – or jump the queue.

FIG05

FIG03

◀ The popularity of e-cards rivals that of paper competitors. The immediacy of their delivery means you can cover yourself when you 'forget' that all-important birthday or anniversary. They also make great calling cards for animators. This Bon Voyage e-card was created by Cartoon Saloon and takes full advantage of vector graphics to create a quirky and colourful animation with a very small file size.

FIG04

▲ The uses of Flash are limited only by imagination, whether it is for straight animation or web site interfaces. This front end for applecore.tv is an imaginative use of Flash that sets the atmosphere for the rest of the web site.

Because of its multimedia capabilities of combining sound and moving images, there are artists who have been pushing it to creative extremes. As most web animation is vector-based, it is resolution-independent, and with the arrival of programs such as Toon Boom Studio, web-oriented animation has broken out into the world of television and video. In fact, the borders between the broadcast media are slowly dissolving.

The latest advancement on the Web is 3D. Although 3D itself is not new, it is now in a format that can be easily viewed by most people. Apart from its use on e-commerce sites to view products in a virtual 3D space, it is also used for games and other interactive sites. The technology has also meant that 3D animation can easily be displayed over the Internet. For those with broadband connections, where file size is not an issue, viewing streaming DVD-quality movies is normal, so fully rendered 3D animations can be shown at decent sizes, but for everyone else there is still a chance to create and show simpler 3D animation.

This chapter will look at some of the ways of getting your animations onto the World Wide Web, in a variety of the current formats available.

FIG06

FIG07

FIG08

FIG01

Animated**GIF**

MAKE A SIMPLE ANIMATED GIF

The Animated GIF (Graphics Interchange Format) could be described as the flipbook of web-based animation. The advantage of animated GIFs over other formats is that any browser can display them without the need for a plug-in, which is why they are used for the majority of banner ads that seem to appear on almost every web page you visit.

FIG02

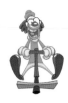

 Because our mind can be tricked into filling in the details we expect to see, an effective animation can be created with very few images of key moments of action that are properly timed, as shown in **figs 01–04** on this page.

Animated GIFs are ideally suited to these and other simple animations. The simplest GIF animation is a button or a rollover that is made from between two and four frames that are controlled by JavaScript, a platform-independent programming language.

Using the same principles described earlier, we can create a simple animation of a man pacing back and forth across the screen. There are many software programs for creating web graphics, but for the purpose of this exercise we will use Macromedia Fireworks, which is probably the best all-round application for web graphics.

As with any animation, planning is vital, so decide what you want

FIG03

your animation to do before you begin. If you start with hand-drawn images, you will need to scan them first and then open them in Fireworks, or you can create them from scratch in the program.

On the Web, size is everything: the smaller the file size the better. Remember this during the planning stage. Each frame you add increases the file size and the time it takes to load in the browser. You may find that you can achieve the effect you want at five frames

per second (fps) as opposed to the 30 fps required for cel animation. The number of colours used will also affect your file size.

Fireworks automatically adds the .gif suffix so that the file will work when uploaded to your web server. It is also important to remember to only use alphanumeric characters in your file name with no spaces. Hyphens and underscores are acceptable as spaces if you need them.

If you do not have Fireworks there are plenty of other alternatives including freeware, shareware and an assortment of commercial software programs for both Macs and Windows, a list of which appears on page 154.

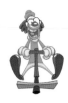

FIG04

▶ The animation of the man pacing was made from six basic drawings – four of the actual steps (**figs 05–08**), a resting side-on view (**fig 09**) and a resting front view (**fig 10**).

FIG05
FIG06
FIG07
FIG08
FIG09
FIG10

FIG12

Test your animation by pressing the 'play' button in your main window.

▲ You may want him to pace the entire width of your browser window, so you'll need to create a document with the appropriate width and number of frames. Fireworks has an onion-skinning (**fig 12**) feature so that you see images on either side of the one on which you are working to get proper positioning (as in 3D). When he reaches the end, he stops (**fig 09**), turns (**fig 10**) and starts his walk back. You use the same four basic images by duplicating previous layers, but 'flip' them in Fireworks until he arrives at the other end, where you reuse them (**figs 09 and 10**).

Once you have all the images placed in the correct sequence, you can test it, to see if it works smoothly, by pressing the play button in your main window. You can then make any adjustments to position and delay until you are completely satisfied. When you are happy with the result, you can export the finished job.

▶ Each image is placed on a single frame that is allocated a delay time – in this case 14/100 of a second (**fig 11**). The four steps are repeated by duplicating the frame until the character reaches the required distance.

Once all the frames have been created, click on the 'loop' icon and your character will pace backwards and forwards forever.

FIG11

Frames	Effect	
Frame 1		14
Frame 2		14
Frame 3		14
Frame 4		14
Frame 5		14
Frame 6		14
Frame 7		14
Frame 8		14
Frame 9		14
Frame 10		14
Frame 11		14
Frame 12		14
Frame 13		14
Frame 14		14
Frame 15		14
Frame 16		14
Frame 17		14
Frame 18		14
Frame 19		14
Frame 20		14

Forever

OVER TO YOU

OTY 01
Whatever software you decide to use, learn how it works before you start making your animation. It will save you a lot of time in the long run.

OTY 02
Try something simple to start with, such as a bouncing circle, to familiarise yourself with the frames, frame rates and positioning. If you are using Fireworks, it will even do the tweening for you, making life a lot easier.

OTY 03
Adapt the flipbook exercise to the digital format.

▶ This file has a very limited colour palette, so in the 'Optimize' options (**fig 13**), the colours are set to eight. Then the file type is set as Animated GIF and 'Export' is selected from the File menu.

FIG13

Optimize (Document)

| Optimize | Object | Stroke | Fill |

Settings :

Animated GIF — Matte :

Web Adaptive — Colors : 8

Loss : 0 — Dither : 0%

Alpha Transparency

Set the file type to Animated GIF before selecting 'Export' from the File drop-down menu.

Set the number of colours used in the 'Optimize' options.

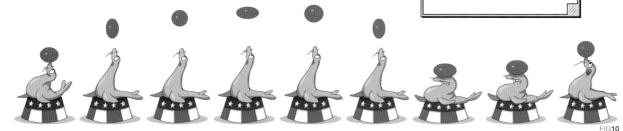

FIG10

FIG01

Flash

INTRODUCTION TO LEARNING A WEB STANDARD

For many animators and web designers, Flash is the program of choice. What started out as a tool for creating simple, quick-loading animations for the Web has grown into a full-blown multimedia program that rivals its big brother, Macromedia Director. As it has developed, many recent features have made it more complicated to learn, but luckily the basics have remained the same.

▼ *The Flash interface has easy access to all its tools and the palettes help to reduce onscreen clutter.*

The following describes how to create a simple animation to familiarise you with Flash's interface using key frames and the Timeline system. Flash MX is surprisingly simple to start using. At the bottom of the screen is the Properties palette, which tells you just about everything you need to know about the project, so begin there by setting the size (in pixels), frame rate (12fps is standard for

web animation), and background colour (see **fig 02**).

Now you need a character. For this exercise use a still image. It should be drawn in a vector illustration program, such as Illustrator or FreeHand, or directly in Flash. Bitmap images can be placed in Flash but this defeats the objective of keeping file sizes small. The example shown **(fig 03)** was made from just one image.

To bring your image into Flash, either use 'Import' from the 'File' menu or simply drag and drop it from your illustration program. This will place it on Layer 1 of the Timeline at the first frame, which is a key frame by default **(fig 03)**. Now change the image to a 'Symbol' so it can be moved around. Select the image and press F8, which will also add it to the document's library. Size and position the image where you want

FIG02

▲ *The dimensions and frame rate of your file are entered here in Document Properties, along with the background colour.*

FIG03

Timeline: This is where the different elements are controlled on their various layers.

The spaceboy Symbol is placed in its starting position and size on the Stage (or in this case off it), at Frame 1 on the Timeline.

Library palette: Where the different elements or Symbols are stored for easy access. They can be drag-and-dropped onto the Stage from here.

Tools palette: The basic tools needed for creating and editing your file.

Properties palette: The attributes of the various elements on the stage are edited here.

Stage: This is where the action takes place. The black line is the viewing area but elements can be kept on the surrounding 'pasteboard' area.

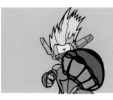

▶ *The motion path (**A**) is drawn with the pen tool (**B**). This path sits on the Motion Guide Layer (**C**), which is added by clicking on (**D**). When the animation is finished, hide this layer by clicking under the eye icon. The Symbol has to be joined to the motion path by 'snapping' it to the centre registration mark (**E**). The spaceboy Symbol is shown in its final position at keyframe 50. The coloured bar with the arrow (**E**) indicates motion tweening between the two keyframes.*

FIG04

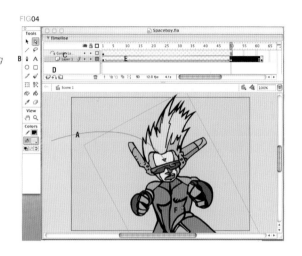

FIG05

▲ *The tweening settings for the spaceboy Symbol frames.*

FIG06

▲ *The settings in the Properties palette for fading the first Symbol to black.*

it to begin. On the Timeline choose your end frame. Click the selected frame once, then press F6, which will make it a key frame. Position and resize the image in this final frame of the action **(fig 04)**.

GOING ROUND THE BEND
To give a greater impression of depth, move the character along an arc. To add a guide go to Insert -> Motion Guide. This will add a new layer where you can draw a line for the character to follow **(fig 04)**. Use the Pen tool to make a smooth bezier curve, or draw one freehand with the Pencil tool. Go back to Frame 1 and join the end of the line with the crossed circle in the middle of your symbol. Repeat this with the end frame.

To get this to move select the first frame on Layer 1. Set up your Properties palette so that it looks

like **fig 05**. Flash will create all the necessary in-betweens.

These are motion tweens, and this automatic tweening can't be used to create the drawings needed to complete a walk cycle, for instance. Use a vector animation program that uses bones, such as Moho, and is capable of creating those types of in-betweens. The animation can then be incorporated into Flash, as a symbol, using the method described above.

FADE TO BLACK
To finish this quick animation, with the fist fading to black, the fist was extracted from the original drawing, in Freehand, and brought into Flash as a separate symbol. A new layer was created to sit above the Motion Guide layer. The fist was placed on this new layer

exactly over the existing fist, as a new key frame. Repeating the same process as before, a new end key frame was created and the fist rotated and enlarged to fill the stage. To get the blackout, the image was selected as Graphic in the Properties palette and the Colour pop-up menu was set to Brightness 0% for the initial key frame of the sequence **(fig 06)**. For the final key frame the Brightness was set to –100% and Flash took care of the rest. If you wanted to fade to white, or something in between, the brightness would be set to a + value. The finished swf file, ready for uploading to the Internet, was just 8kb.

These are the very basics of starting to animate with Flash. After that it gets complicated, as you start to add sound, QuickTime movies or scripting for interactivity.

3DontheWeb

ADDING EXTRA DIMENSION TO YOUR SITE

Viewing 2D animation in a web browser is easy if you use swf files created with Flash or a program such as Toon Boom Studio. Now there is a growing interest in putting 3D on the Web. At present this technology is mostly being used by online shops to demonstrate their products or by online games creators, but it could easily be adapted to animation.

▼ *Theory7's web site is an excellent example of Flash interface design. It also serves as a showcase for its experiments with Swift3D.*

FIG01

FIG02

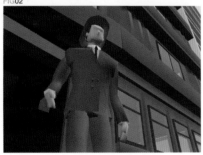

▲ *'Farfalla Incantator' is a 3D interactive online game about a private detective. Some of it was made with 3DS Max but most of it was done directly in Mind Avenue's AXELedge, including textures and interactivity.*

FIG03

Early attempts at 3D were virtual-reality vistas viewed using plug-ins such as QuickTimeVR. These were still images that could be scrolled and zoomed in multiple directions so you could get a complete 360-degree view of a scene. Not real 3D, but when done well it gives an effective walk-through feeling (check out www.taj-mahal.net).

With new technologies comes a battle to establish a standard. So far, the Web has succeeded in adopting standards that work well (swf, QuickTime, Java). At the moment the two main contenders are Macromedia Shockwave3D (the file format of Flash's big brother, Director) and Viewpoint VET. VET is popular with commercial sites for viewing products in a 3D space, whereas Shockwave, because of Director's multimedia roots, is the choice of creatives. And we must not ignore Flash either, because, although it isn't used to create 3D content, a lot of programs can export to the swf format where they can be further enhanced with Flash.

3D IN A FLASH

One program, Swift 3D, was designed with the sole purpose of creating vector 3D content for Flash. You can use Swift 3D to build and animate complex models, saved as swf files and imported into Flash, where interactivity can be added using ActionScript. As Flash is one of the must-have programs for web animators, Swift 3D is a good-priced option for adding that extra dimension **(figs 03–05)**.

An alternative is AXELedge **(figs 01 and 02)**, a program specifically designed to make 3D web content. It will do everything you want, from modelling to animation and interactivity. It has its own export file format that requires a plug-in for your browser, but it will also export to swf and QuickTime.

If telling a story with fully rendered 3D animation is what you want to concentrate on, chances are, placing 3D animation on the Web is going to come as an afterthought to a more complex project. Most of the popular 3D packages can export to a web-friendly format, either directly or by

FIG04

FIG05

Dragging the mouse pointer along the bar rotates the seacraft.

◀ *US Flash maestros, 2advanced, created this showcase to demonstrate the power and possibilities of Swift3D. More information about different features of the Subaqueous Habitat can be found by clicking on the structure, which opens a new window with the details* **(fig 04)**. *Because the image is created as a vector image and exported to Flash, it is possible to enlarge sections within the window to see the detail more clearly* **(fig 05)**.

FIG06

◀ *Rea Productions' short animated vector film featured three-dimensional cityscapes created in Swift3D. More images from the film are on page 104.*

access. This means keeping your file sizes to a minimum, just as you must with 2D. The vector route is always a safe one but will give a flat-shaded cartoon look to your work, which just may be the effect you're after anyway. The other way is to use low polygon models, as in games, or to replace some of the smaller modelling with texture maps (see the next chapter for more details on 3D).

When it comes to using the Web as a medium for creative expression, approach it with caution because it can distract you from what you really want to do. By all means learn how to use 3D web tools as an additional skill, but if animated filmmaking is your goal, then stick with that.

◀ *Horses for Courses is an award-winning, multi-lingual, interactive 3D film by The Quality in London. It is the story of Pan, mischievous god of nature, who comes face-to-face with the mundane world of modern city workers* **(fig 07)**. *The 3D modelling and animation were done in 3DS Max, with web animation, editing and interactivity carried out in Brilliant Digital Studio Pro. This scene from Horses for Courses* **(fig 08)** *is playing in the Brilliant Digital (b3d) projector. The projector is used to show animations created with Brilliant Digital Studio.*

using plug-ins, so that you will be able to show off or share your latest masterpiece without having to do too much extra work.

PLAN AHEAD
One of the main issues with the Internet is bandwidth, and despite the constantly growing number of people signing up for domestic broadband, the majority of Internet users still have modem dial-up

OVER TO YOU

FIG07

FIG08

InternetProsandCons

USING THE WEB AS A SHOWCASE

When you've made your first animation using Flash, or any of the other swf-compatible programs, you'll want to show it off. That's only natural. You have some web space, so you upload it and e-mail the URL to all your friends, family and most important, your potential clients, then sit back and wait for the accolades and offers of work to come flooding in. Meanwhile, back in the real world ..

The Internet, the World Wide Web, is a great place to advertise yourself and your work. It is the most accessible place to put a portfolio of your masterpieces for everyone to see. Therein lies the crux of the dilemma. You want as many people as possible to see your work, especially if you have any ambitions about becoming a professional animator. Getting them to your web site will require either sending out a lot of e-mails or getting yourself a good ranking on a search engine – or ten. If you can get the right people to your site, and your stuff is original and brilliant (which it naturally is), then the gods will smile upon you and your future in the annals of animation history will be assured. That is the positive side of using the Internet.

Unfortunately there is a downside too, apart from no one actually finding the site in the first place. The Web is an open marketplace and having your work up there for

▶ *Two Animators are, well, two animators working in New Jersey. Actually they are more than just animators and they use their Flash-based web site to advertise the fact.*

all and sundry to see can leave it exposed to rip-offs. There is very little you can do to prevent it from happening, but there are some measures you can take to protect yourself. At the end of the book (page 150) are some suggestions on how to do this and on other ways to get your work seen by the right people.

Some technical issues will also need to be addressed that can affect what you put on your web site and how you do it. The growth of home broadband services means that placing high-quality animations on your site does not create the major problems for end-users that it used to. For you, though, it is another matter. Putting streaming video on a web server is

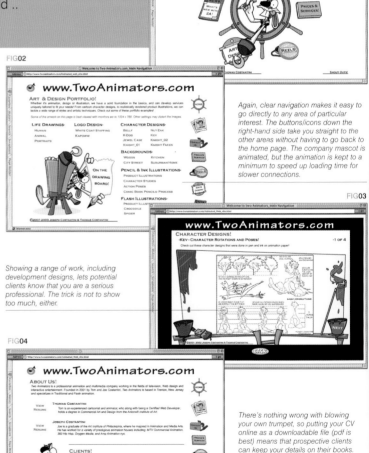

FIG01

The important thing with any web site is being able to navigate easily between the different areas. The opening screen makes it very clear how to move to another section. It also gives the viewer a good idea of their style from the outset.

FIG02

Again, clear navigation makes it easy to go directly to any area of particular interest. The buttons/icons down the right-hand side take you straight to the other areas without having to go back to the home page. The company mascot is animated, but the animation is kept to a minimum to speed up loading time for slower connections.

FIG03

Showing a range of work, including development designs, lets potential clients know that you are a serious professional. The trick is not to show too much, either.

FIG04

There's nothing wrong with blowing your own trumpet, so putting your CV online as a downloadable file (pdf is best) means that prospective clients can keep your details on their books.

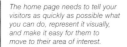

FIG05

The home page needs to tell your visitors as quickly as possible what you can do, represent it visually, and make it easy for them to move to their area of interest.

FIG06

Maintaining a consistent interface is another way to help with navigation. Using thumbnails that link to pop-up windows is another way to stop viewers becoming lost in the maze of page links.

◀ *Amitai Plasse is a New York-based, multitalented artist and animator whose work is featured on page 102. While his web site uses Flash to show animations, it is primarily built using HTML. There are advantages and disadvantages to both methods of creating web pages. It depends entirely on how you design your site.*

OVER TO YOU

OTY/01

Before you start building a web site plan it out carefully on a large sheet of paper. The creative look of the site will be the easy part. Making it work is another matter.

OTY/02

Decide if you want to make it an entirely Flash-based site, HTML or a mixture of the two.

OTY/03

If you have never built a web site, speak to someone who has. Find out what is the best way to implement your design concepts and how feasible they are. Most things are achievable but you still need to consider variables such as bandwidth, browsers and operating systems.

OTY/04

Banner ads are a way of helping to pay for the site's maintenance but if you are using it to promote yourself it is counterproductive to publicise someone else. And banner ads are really annoying.

not just a matter of adding a link on a web page, as you can with swf files. You have to use a dedicated streaming server, usually either QuickTime or Real, and these can be expensive. If you don't want to (or can't) pay for a streaming server, there are tools, such as Wildform Flix, that can convert movie files to the swf format. An increasing number of animation software packages, both 2D and 3D, offer an swf export

option. If your animation is complex, with a full tonal range, this is not always a satisfactory solution, and can detract from the quality of all your hard work, so you may just have to pay up. Shop around before you commit. Competition is strong among ISPs, and one of the beauties of the Internet is that you don't have to rely on a local provider; they can be anywhere in the world. Trawl the net carefully; you may find yourself

a good bargain. The Internet is what it is. Use it wisely to get as much exposure as you want, but be prepared to accept the negative aspects. Use it as an advertising tool, but don't expect to get anything back from it. But who knows? Check out the story on page 142.

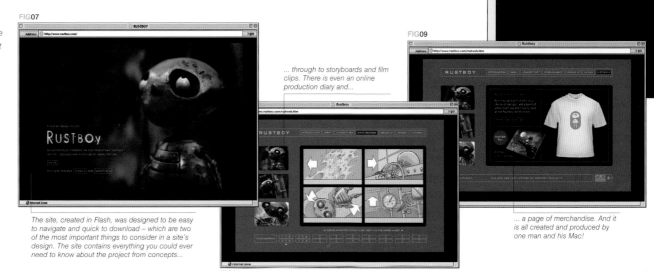

FIG07

▶ *The Rustboy web site is slightly different in that it is promoting a single project rather than the animator, Brian Taylor, but it has done its job very successfully (see page 142).*

The site, created in Flash, was designed to be easy to navigate and quick to download – which are two of the most important things to consider in a site's design. The site contains everything you could ever need to know about the project from concepts...

FIG08

... through to storyboards and film clips. There is even an online production diary and...

FIG09

... a page of merchandise. And it is all created and produced by one man and his Mac!

Case Study

UNIT/54

BROKEN SAINTS

As the Web has helped to break down barriers between cultures, so the boundaries between different media have also dissipated. The most high-profile example of this is *The Matrix*. With its blend of eastern philosophy, martial arts and sci-fi, and its solid grounding in the comic book tradition, Broken Saints is a product of the same cultural amalgam.

Broken Saints is a 24-part Web-based graphic novel that takes full advantage of the possibilities of the medium. Although not strictly an animation, it adds movement and sound to the still images to keep the narrative vital and moving. And it is the story that is the main emphasis.

The tale, originally conceived by Canadian writer/director/producer Brooke Burgess, tells of four disparate strangers who receive a message, and are brought together in a search for the Truth in the face of an impending Darkness. It was not until Burgess joined up with fellow wunderkinds, Andrew West and Ian Kirby, that the project became a reality. It was their combined passion, enthusiasm and talents that finally brought it into being.

Their original idea was to take the flagging graphic-novel concept and breathe new life into it using digital tools, such as Flash, and the publishing freedom offered by the Internet.

Functioning as a tight-knit team, they began working on the visuals; Andrew West created character and setting designs for Burgess' story, while Ian Kirby looked after the technical side of putting it all together.

In spite of the originality of the production, the *Broken Saints* team still use time-honoured animation methods to make each episode,

FIG01

◄ *Although it is made entirely of still images, special effects are added in Flash to create a cinematic feel.*

FIG02

◀ *Because of the amount of work, and cost, involved in recording dialogue and creating lip-synch animation, the Broken Saints team opted for the traditional comic book solution of speech bubbles. This also adds a level of viewer interaction.*

from creating storyboards and shot lists, to making 'pencil' sketches (all the artwork was created using a Wacom tablet in Painter, Illustrator and Photoshop) for checking composition. When Andrew had finished all the artworks, they were given to Ian Kirby to add the cinematic effects, using Flash and Toon Boom Studio. In addition to the visuals, sound effects and an original musical score, composed by Burgess' Berlin-based cousin Tobias Tinker, were added to make the production a complete audio-visual experience.

The complexity of the project made work on it very time-consuming for the team, but their dedication to the story's vision meant they were prepared to make certain compromises, such as foregoing monetary rewards. But dedication has proven to be its own reward as the finished 'product' is a powerful piece of storytelling that has garnered many prestigious awards, including one at the 2003 Sundance Film Festival. It has also generated a lot of excitement and interest within the film, game and publishing industries, so the creators may start receiving the financial rewards they deserve. However, they point out that 'the crew will not consider any offer that compromises the integrity of the material'.

FIG03

▲ *The Broken Saints interface was created using Flash, which offers a universally accepted format that is easy to stream and to playback.*

FIG04

▲ *All the images used in the series are drawn and painted directly on the computer using a Wacom tablet and programs such as Painter.*

FIG05

▲ *The story is one of the quest for Truth.*

3DCGI

The computer has become an invaluable tool for 2D and stop-action animators but it has also opened up new possibilities for those who want to tackle the arcane world of 3D modelling.

FIG02

▲ *A 40-second opener for the Taos Talking Picture Festival 2002 created by Igor Choromanski. Shot in a sepia tone to catch the feeling of the old West, it has the look of 3D stop-motion rather than 3D CGI.*

In recent years we have seen a huge increase in the number of CGI (Computer Generated Imagery) animations in film and television, so much so that there is now an Oscar for Feature Animation. 3D has been around since the 1980s in films such as Disney's *Tron* and on television in series such as *Max Headroom*, but it was fairly rudimentary. Now we have brilliant work coming out of the Pixar studios, from the groundbreaking *Toy Story* **(fig 01)** to the incredible *Monsters, Inc.* Square Picture's *Final Fantasy: The Spirits Within* also set new standards for 3D animation with its realistic human character animations.

3D has also been seamlessly integrated into 2D cel animation. A lot of backgrounds (Disney's *Atlantis* and *Tarzan*) and most props are created in 3D software and then coloured and rendered to match the drawn elements. It is becoming more common for lead characters to be animated in this way too. Although it will not completely replace hand-drawn animation, it is a valid and useful tool in certain types of films.

Away from the world of feature animation, is a whole other world of 3D animation disguised under the name of special effects. Effects that were once created using models and stop-motion animation are now made digitally. The dinosaurs of *Jurassic Park*, huge amounts of the *Star Wars* prequels, Spiderman swinging through New York (the list is endless) are all made with the same 3D software as the full-length animations. And this same software will now run on the latest home computers.

HIGH SPECIFICATIONS, LOW COST

The incredible developments in computer technology mean that we can now have a 3D computer animation system on our desktops for less than £2000 – a system that would have cost ten times that five years ago and will match anything used by the major effects houses.

Because this computing power is now available to anyone, we are

FIG01

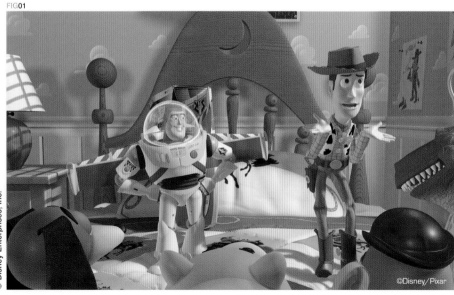

◄ *Toy Story is recognised as the first full-length feature film to be made with CGI. Not only was Pixar's animation stunning but, more importantly, the film had a great story, great characters and a great script. And it was believable to the extent that it was easy to forget you were watching a CGI animation.*

FIG03

◀ The 30-second opening sequence to UK arts and culture programme The South Bank Show was created by Pat Gavin and EYE Studios. To show the diversity of the arts covered by the 25-year-old show, an eclectic procession of artists, musicians, actors, writers and filmmakers from the past are animated. The clip shows their journey and interactions from the Metropolis to the Tree of Knowledge. Caricatures of the personalities were hand-drawn by Pat Gavin and texture-mapped onto the 3D models created by EYE Studios.

FIG04

◀ Small independent studios, generally, operate differently than larger ones, in that they work on their personal projects between commercial commissions. Awakening, by Anthony Adinolfi, is an animation in development about a young boy's spiritual journey made with Lightwave on a Mac.

FIG06

SUBJECT : EDISON CARTER
RIGHT
SYNAPTIC ANALYSIS

FIG07

likely to see a continuing growth in 3D animated films – just as Digital Video has opened up the market for independent filmmakers. But, it's all about the story. That's why Pixar's films work, not because of the fantastic rendering software, or the way they get fur to move, but because the stories and the characters are great.

This chapter takes you through the basics of 3D animation using affordable software. It will be very software oriented, just by the nature of the technique, but we have already been through the story part at the beginning of the book, so let's get on with bringing your characters to life.

FIG05

▲ Many of the larger commercial animation studios are so busy doing work for their clients that the animators rarely get the chance to make their own personal projects. The Snowman, by Lane Nakamura of Duck Soup Studios in Los Angeles, is one of those labour-of-love projects that actually saw the light of day. It is a comedic story of less-than-intelligent alien lifeforms that kidnap a snowman for interrogation with obvious (to us) consequences. Made with Maya.

▲ In the early 1980s, Max Headroom was a cult figure on television, the original TV cyberpunk. Apart from appearing as the host of an entertainment show, he was also featured in a full-length film and an accompanying series. In the film, Twenty Minutes into the Future, maverick TV reporter Edison Carter has an accident and part of him becomes the virtual alter ego Max Headroom. Rod Lord's wireframe animation of the brain was created on state-of-the-art equipment – a Prime computer with 256kb RAM and a massive 96Mb disk running a 3D engineering software called Medusa.

3DSoftware

CHOOSING THE RIGHT PACKAGE

CGI animation is highly technical with terms and jargon such as NURBS, B-Splines, radiosity, polygon count, x, y, and z axes, extrusions, Boolean operation; the list goes on and on. When you start looking into the software, you are presented with huge lists of all these terms and of the functions that the programs are capable of performing.

Coming from a 2D animation world, where the longest name for any of your equipment is 'eraser', this technical jargon can be overwhelming.

An extensive range of software is available to animators, from freeware to software costing thousands of pounds, and it is all very capable, in the right hands. 3D software for home users has been around since the 1980s, so it has had plenty of time to develop.

Realsoft 3D is one that has survived and made the transition to Windows and UNIX. For a novice 3D user, one of the cheaper options is going to be the best choice. It will be easier to learn, because it will not have as many complex features or hardware demands. Blender **(fig 03)** is a free program that has a cult following on Windows and Linux platforms, and is also available for Mac OS.

THE PROFESSIONALS

One of the factors that will affect your decision is the type of animation you want to tackle. Some programs will handle stories that are heavily character-based, better than creating, say, spaceships or terrains. The top-end commercial software packages, such as Maya, NewTek's LightWave, SOFTIMAGE, Maxon's CINEMA 4D **(fig 01)** or Discreet's 3D Studio Max **(fig 05)**

▼ Carrara Studio and its little brother Carrara Basics are both full-featured 3D modelling and animation programs for Macs and Windows at very affordable prices. The main difference between them is a much better rendering engine in the more expensive Studio version. For animation, both programs use a timeline and key frame system like most other animation software. What they do, though, is take the concept of the storyboard so that you visually control each key frame and see it as it will appear in the final render.

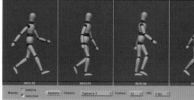

FIG02

are very complex programs that can handle everything, but learning one could take you a year or more. These are the programs used to create the realistic special-effects animation we are used to seeing in Hollywood spectaculars. The price of these software programs has dropped dramatically recently. Most of the companies that produce these programs have also made free learning editions available. These are full working versions that place limitations on the final output, either in the form of reduced-sized renders or watermarks. If you want to learn to use one of these professional packages, this is a great opportunity to do so without the

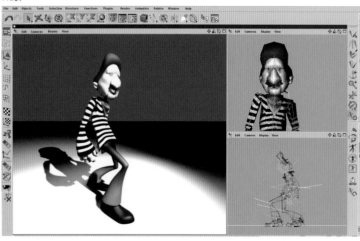

FIG01

◀ Maxon CINEMA 4D is a modular software program. Its core modelling program is very affordable for a professional-level application, so you can start working with it right away, then add the extra modules as you need them. Alternatively, you can buy one of the bundles that contain different modules, depending on your requirements. Cinema 4D also has a reputation of being easy to use, a plus, especially if you have aspirations of becoming a serious 3D animator.

FIG03

Blender is a bit of a curiosity in that it is free. Its interface is a bit of a curiosity too. The advantage that it does have, apart from the price, is a devoted community of users and plenty of online help. There is a version for just about every modern operating system (except Mac Classic), so for your first taste of 3D you could give it a try.

Hash Animation: Master is another one of those very able 3D animation packages priced to suit most home users. It excels at character animation and even has a function that allows the creation of anime-style characters, complete with a toon renderer.

FIG04

expense of buying the program or the risk of being caught with a pirate copy.

KEEPING IT REAL

Of course you probably don't want to spend all your time learning complex software. Luckily there are 3D programs that allow artists to create models and animation in simple and intuitive ways. These programs have rather quirky graphical interfaces that may give the impression they are not serious tools, but they are more than capable. Without listing and describing every piece of 3D software on the market, it is sufficient to say that a large and varied amount is available. Each

has its own characteristics and specialisations. The ones described below have been chosen for their ease of use and similarity in approach. Most of this chapter therefore focuses on four reasonably priced programs: Amorphium, Carrara Studio, Poser and Bryce.

Amorphium approaches 3D modelling in a way that will seem natural to artists, by giving you a shape that you sculpt like a lump of clay, to which you then add texture details with a brush. Carrara Studio takes a more traditional approach, but has some very powerful animation functions **(fig 02)**. There is also a low-priced version of the program, called

Carrara 3D Basics, that is an excellent introduction to 3D but with simpler animation tools. Bryce is a landscape generator, and Poser is a character generator. If you want to learn more about 3D

modelling and animation, take a look at dvGarage's 3D Toolkit, a series of video lessons and tutorials that comes with Electric Image's Universe, a powerful 3D software program, all for less than £200.

See page 154 for a fairly comprehensive list of 3D software for all platforms.

FIG05

When it comes to working in professional 3D animation studios the names that are going to keep coming up are Lightwave, Maya and 3D Studio Max, shown here. These are the ones that produce most of the special effects animation for film and advertising as well as for games. They are extremely powerful and complex programs that require a high-spec computer. If you are lucky enough to have an opportunity to learn one of these programs, take it.

OVER TO YOU

OTY/01
The Maya PLE (Personal Learning Edition) is free and offers a great opportunity to learn this industry standard program. Until you feel comfortable with constructing 3D models, you may be overwhelmed by its complexity, however.

OTY/02
If you are new to 3D then start with something simple and inexpensive, such as Carrara Basics or Blender.

FIG01

FIG02

Basic3DModelling

CONSTRUCTING SOLID SHAPES

Before you start doing any modelling, it's a good idea to have a clear concept of what it is you want to create. The best place to start is with good, old-fashioned, low-tech pencil and paper.

FIG03

Two primitives (a cube and a sphere) are overlapped **(fig 01)**. 3D Boolean operation is chosen from the menu and the appropriate option is selected **(fig 02)**. In this case the sphere is knocked out of the cube to leave the resulting shape **(fig 03)**.

Make sketches of the character or object from many different angles, just as you would with a 2D animation character (see page 82). You could even build a clay maquette. If you are going to make a computer 3D model, starting with one you can hold and move around will make life a lot easier. Start with something simple, such as a stylised animal or the ever-popular robots and spaceships.

One of the advantages of creating mechanical characters is that they are usually made up of basic geometric shapes that are included in every 3D program. For beginners, other advantages of

this type of model come when applying surface textures and animating. Once you have familiarised yourself with how your 3D software works, you can then start experimenting with more organic shapes.

Whatever shape of creature you decide to make, animating it means you'll have to create it with what is called a vertex modeller. This allows you to take a basic shape that has been divided into a series of smaller geometric surfaces and reshape it by moving the intersecting points (vertices). If you think that working with all that geometry will be too confusing, try

using Amorphium, which performs the same functions but in a way that simulates clay modelling.

Most 3D programs divide the screen into four separate camera views so that you can clearly see what is happening to your object as you manipulate it. It takes a little getting used to, but it does make navigating through 3D space a lot easier and more accurate.

Apart from pulling and pushing vertices, shapes can be made by lathing, which works in much the same way as a lathe in a workshop, by creating a shape using a profile and virtually spinning that profile around a

FIG09

FIG10

FIG11

FIG04 FIG05 FIG06 FIG07 FIG08

▲ *For creating organic shapes, using metaballs can be very helpful. In* **figs 04–07** *we can see how the two positive shapes join together and transform into a single unit as they approach.* **Fig 08** *shows how using negative metaballs causes convex shapes, to further sculpt your model.*

central point. Another way to build an object is to join two shapes together and perform what is known as a *Boolean operation* **(figs 01–03)**. There are three of these operations: union, which creates a single, unified object; intersection, which leaves only the shape where the two shapes cross over; and subtraction, which removes the form of one of the shapes from the other one. This should make sense to anyone familiar with the Pathfinder effects in Illustrator.

One of the easiest ways of creating organic shapes is with a metaball modeller **(figs 04–08)**, which is also similar to working with lumps of clay. You can add or remove metaball primitives, the basic building blocks, and manoeuvre them into new shapes, which can later be taken into the vertex modeller for fine-tuning.

These are by no means all the ways of working with 3D shapes, and each program has its own approach to these and other functions. Moving from 2D to 3D is going to be confusing to start with, no matter which program you choose to work with – even with the help of a manual. However, by carefully planning your models and keeping them simple, you should be constructing whole scenes in no time.

▼ *The body of the robot is built using the vertex editor, as are all the other parts. It is made from two cube primitives that are joined using a Boolean operation, and the points moved to create the torso shape (**fig 09**). The arms and legs were made from joining a sphere and cylinder (**fig 10**) and a claw was made with a sphere as the joint (**fig 11**). A cylinder was subjected to two Boolean operations, then duplicated and flipped to make the grabber (**fig 12**). A flattened sphere was used for the head with two spheres for the "eyes" (**fig 13**). The foot was made of an elongated cylinder, with a sphere for an ankle. The various pieces, each one named, were placed in position on the right-hand side of the torso then duplicated, given new names, and placed on the left-hand side. The program's preset metallic shaders were used to give it some texture and a very basic mechanical man was created. Whether it would function under the laws of physics is another matter.*

OVER TO YOU

OTY/01

Download a demo version of one of the simpler, intuitive programs such as Carrara or Amorphium, and familiarise yourself with the 3D working environment.

OTY/02

Start by experimenting with abstract shapes and ways of manipulating them, using the basic tools mentioned above, before trying anything too complex.

FIG12 FIG13

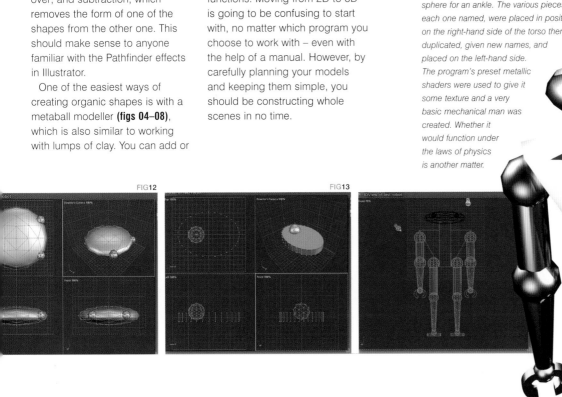

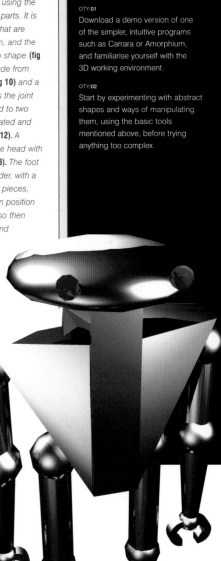

FIG01 FIG02 FIG03 FIG04 FIG05 FIG06 FIG07 FIG08 FIG

ShadersandTextures

UNIT/58

MAKING YOUR MODELS LOOK REAL

Once you've built your model it's going to look like freshly moulded plastic, with no features of its own. To make it look more realistic we have to use shaders and textures on the object's surfaces.

Shaders control a surface's overall appearance, such as colour, bump (texture) and the different ways it reacts to light. Each program has its own method for handling this function, but, as with modelling, the basic theory is the same.

Most shading is divided into seven distinct areas: colour, highlight and shininess, bump, reflection, transparency, refraction and glow. These can be applied individually or mixed together to create the desired effect.

Colour adds colour to the surface. Highlight and shininess controls the way light is reflected off an object's surface. Highlight controls the intensity, and shininess dictates the size of the highlight. Bump (or bump mapping) adds texture. A bump map creates an illusion of texture by changing the angle at which the light reflects off the surface. This can be represented as bumps or pits. Reflection controls how much another object is reflected in its surface. This is different from shininess, which only reflects light. Transparency determines how much light passes through a surface instead of being reflected off it. Refraction bends the light as it passes through a transparent surface. Glow adds a separate luminosity to an object, different from that of the main light sources.

PRACTICE MAKES PERFECT

Most programs come with preset shaders for common surfaces such as metals, glass and wood. Open them in the program's

▼ *Each 3D application has its own approach to achieving any particular function. Cararra Studio's quirky interface may not suit everyone, but for the novice it is quite logical and powerful as well.*

▼ *With its very graphical interface, Amorphium has the simplest approach to laying colour and texture on an object – paint it on with a brush. All sorts of multicoloured, textured effects are possible using a natural and intuitive method.*

The values for each attribute are set here. This is a very basic shader for a robot.

FIG18

A miniature preview of how the shader will appear when lit.

The shader editing palette in Cararra Studio, showing all the options for creating your own surfaces.

A preview of the area that is to be shaded.

A standard colour picker for selecting the right shade.

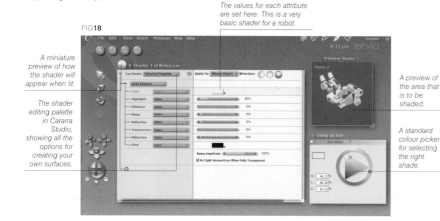

FIG19

FIG10 FIG011 FIG12 FIG13 FIG14 FIG15 FIG16 FIG17

FIG20

△ In these two shots, from Rustboy by Brian Taylor, we can see the dramatic effect shaders and lighting can have on a scene. The top picture is the flat model produced by the software while you are working on it. The picture below is a fully rendered scene, with all the shaders, textures and lighting added to give it depth, atmosphere and believability.

shader editor and, once you understand how they are made, you can try creating your own.

When you have made the shader you want, simply select the relevant object in your model and apply it to the surface. For 2D artists, Amorphium has one of the most intuitive ways of adding textures – you simply paint them on with a brush **(see fig 02)**. Pixologic ZBrush is similar, but takes it one step further by letting you paint and model a 3D character at the same time.

PHOTO REALISM

Depending on the effect, the shaders you create may not be realistic enough. You'll have to use texture maps – images that are placed on a surface. These images are usually created in an external 2D program such as Photoshop or Painter. More often than not these textures are photographs inserted into a simple polygon shape. Not only will a photograph render faster, but it will also look a lot more convincing. There are thousands of texture maps available on the Internet, but if you have a still camera, film or digital, why not shoot some textures of your own?

Try to shoot in diffused light whenever possible. Harsh sunlight causes strong shadows that limit your range of possibilities. If you are after a specific type of lighting go ahead and take the shot, but for generic use keep the lighting

neutral. Always keep the camera parallel to the surface you are shooting or you'll have to correct it in Photoshop and it won't look as real. A tripod, even a small one, is handy for this. Take pictures of the clutter of the world, too – stickers, graffiti, signposts, flyers. These will add realism to your scenes.

Shaders and textures are a vital part of the 3D process, as they provide a realistic look to your work. They can also save a lot of modelling and rendering time, but don't use texture maps just to avoid having to build models, because it will show.

△ **Figs 01–17** show assorted textures. Brick walls **(figs 01–03)** are always useful for urban scenes. Notice how the harsh lighting in **fig 02** casts a strong shadow, making it of very limited use for an object or scene. Small areas of wall can be 'tiled' (the picture is repeated like bathroom tiles) to cover a much larger surface. Some preparation and careful checking is needed to ensure that seams are invisible. **Figs 05–07** show photos of graffiti that add realism to city street buildings. Corrugated iron for roofs and fences **(fig 08)** . Elephant hide **(fig 09)**. **Fig 10** is an interesting texture of aged wood, but too detailed to be of use except for a small object. **Figs 11–12** show some quarried stone. Leather **(fig 13)**. Brushed steel and metal **(figs 14–16)** and wooden boards **(fig 17)**.

FIG21

▶ This highly stylised 40-second ad for Save the Children was made by EYE Animation in London. The characters were designed by Jo Simpson who also co-directed it with Pat Gavin. To give the 3D models an artistic feel Gavin created his own textures in Painter that were mapped to the models.

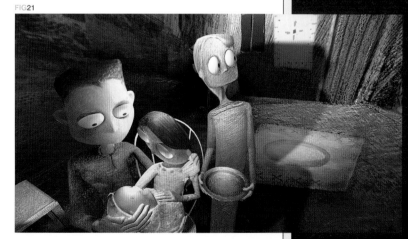

PropsandScene-Building

WORKING ON A VIRTUAL BACK LOT

Putting together your 3D animation is going to be just as long a task as creating a 2D line animation. although you don't have to create every frame of action, you do have to build every object that appears in the film. And that means everything. The more realistic you want it, the more you have to build.

There are places where you can buy, or download for free, ready-made 3D objects, but if you want to make a film with your own unique style, these options are best avoided.

Look around you. How many objects can you see? There is so much clutter that makes up the world, and you have to include a lot of it to make your 3D universe appear realistic. Next time you watch *Toy Story* or *Monsters, Inc.*, check out the detail that Pixar puts in its backgrounds and settings

and you'll be amazed at the incredible attention to detail. And every one of those items had to be built.

The good news is that once the objects have been built, you don't have to build them again. You can create your own virtual props house. The bad news is that you have to build not only interiors but exteriors as well. Fortunately there is landscape-generation software that can help with this (see page 134), but every single tree and rock has to be created.

WORK TO A PLAN

As with all animation, the more planning you do, the easier the job is. If you are shooting in a city street, decide how much of it you are actually going to see and from what angle. The image of a classic Western film set with shopfronts and nothing behind them except some wooden supports is familiar to us all. You can do the same. If you can't see it, you don't have to build it. You can also use mattes, which are 2D images used as backgrounds (see **fig 02**). If they

are in the distance, you can construct them as basic blocks and use texture maps to give them the detail they need. Alternatively you can paint them as 2D images from the start, or use photographs. Using a VR panoramic software (such as REALVIZ Stitcher) you can make your backgrounds cover a whole 360 degrees. For further realism you can simulate camera techniques and make them appear out of focus by blurring the picture in Photoshop.

In 2D animation, it is important to put a lot of detail in the background images, because they are the ones that remain on screen the longest. 3D backgrounds need to be equally detailed, but not so much that rendering of the scene

FIG01

◄ *The approach to building your scenery will depend on how you are going to use the shot. If it is a distant scene-setting shot, such as this one from Rustboy, the geometry of the objects can be kept quite simple and the details created using texture maps (page 122). The landscapes can also be made from a 2D picture, which may be easier to produce than creating a huge 3D environment.*

FIG02

◀ *Using matte (2D) backgrounds can enhance the mood or style of a 3D animation. The painted style of the Save the Children Stolen ad by EYE Animation was based on Jo Simpson's original illustrations, so keeping 2D made sense. The important thing to consider is maintaining correct perspective when using tracking shots or fly-throughs.*

FIG04

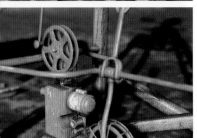

▲ *3D animation and film special effects are both produced using the same software and techniques. Special effects, generally, have to emulate the real world, or make a fantasy or futuristic world seem believable. To create the tower block for a short film, Simon Valderama used a picture of a real building and a technique known as photogrammetry to create a 3D CGI version.*

FIG03

◀ *The spartan desert setting of the trailer for The Taos Talking Film Festival did not require much in the way of buildings – just a simple adobe-style shelter. The windmill-powered film projector, however, required a much greater attention to technical detail to make it look as if it really worked.*

gets bogged down, which is why you should try to keep everything as simple as you can.

GROUP THERAPY

When building up your scene, it's a good idea to group similar objects together. This makes it a lot easier to keep track of them, especially because they are mostly going to be static. Your scene can even be made from groups of groups. Objects that are going to be animated should be grouped together using the hierarchical parenting system. For example, a torso would be a parent object and the arms would be the child, and the hands would be the child of the arm. In this hierarchical system, the child is affected by any movements the parent makes, but children can move without directly influencing the parent.

Finally, the other factor to consider when building your scenes is how they are lit. Lighting is covered on the next page.

OVER TO YOU

OTY/01
If you have a still camera, film or digital, start taking lots of pictures of scenes, interiors and exteriors. Study them to get an idea of the things that make up our world. Look for the things we usually overlook. In urban settings it could be posters or graffiti. For interiors study the way daily clutter lies around; we don't live in show homes, so neither should animated characters.

OTY/02
Create an archive of scenes and props you create. Burn them to CD rather than cluttering up your hard drive. Use a program such as Extensis Portfolio to keep a visual record of them and where they are stored.

OTY/03
Download free models from sites such as www.3dcafe.com as a starting point for creating new props.

FIG03

Lighting

ILLUMINATING YOUR SCENES

Rather than wax lyrical about the importance of light in our lives, these pages discuss the obvious: no light, no image. In 3D, the light used while modelling is an ambient light that is dull, flat and even. This is not the light that should be used at the rendering stage.

FIG02

FIG01

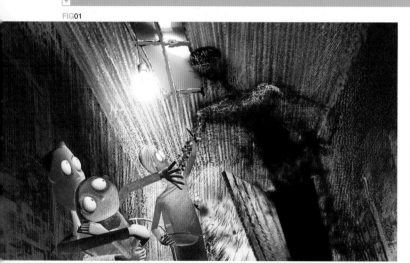

 In this scene from the Save the Children's anti-poverty campaign, by EYE Animation, the lighting plays a very important part. Not only does it illuminate the scene, using a single point light from the bulb, but also the dark, shadowy figure, representing poverty, steals the light.

One of the secrets of working in 3D is close observation of the world around you. This has already been mentioned in relation to building your scene, and it is just as valid for lighting. Study the light throughout your day. See how it changes from the clear gold of morning to the warm, glowing red of dusk. Look for the sources of light around you – daylight through windows, artificial lights overhead. Look at the shadows; these will give you the most clues about the light – its direction and intensity. Once you start looking at the way the world around you is illuminated, you'll have a better idea of how important, and difficult, it is to light your 3D scene.

LIGHT AND SHADE

Apart from being used to bring a natural luminance to your scenes, lighting has another important role to play: it gives form to your objects. It is for this reason that you should not use the default ambient light. The placing of lights can dramatically alter the appearance of your objects. Who hasn't, as a child, placed a torch under his or her chin to scare friends? This single, strategically placed light completely changes the appearance of your face. Unless you are specifically aiming for this effect, using a single light source is best avoided. Using two, or even better, three lights is the ideal. The first light is your key, or main, light. This supplies the strongest light. Your second light is the fill light. This takes the harshness from shadows. On location film sets large reflectors are used for this. The third light is a backlight. This is a low-key light

These three shots from Rustboy show what a difference lighting makes to a scene. The top shot is without any texture, the second with shaders and textures and the last with the lighting added to create a completely different mood.

FIG08

FIG04 FIG05 FIG06

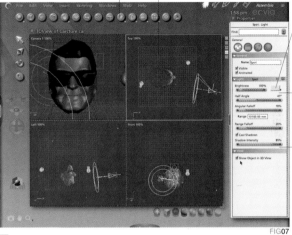

In Carrara Studio, new lights are added by clicking on the light icon and selecting the type of light you want, whether it's a spot, a bulb or even sunlight.

Once chosen, you click in one of the windows to activate and position it.

The intensity and colour of the light is controlled here.

Each type of light has other options. The spotlight's Falloff (the way the light's beam dissipates) is adjusted with these sliders.

Each program will have its own approach and methodology for lighting a scene, but once you understand the principals it is easier.

FIG07

When positioning lights, or any other object, it is a good idea to work in a four-screen mode so you can see exactly where everything is going in relation to other objects.

In **fig 03**, the model has a flat-on white spotlight. It's a bit harsh, like being confronted by a paparazzo's camera flash. To make the lighting more interesting, the spotlight was moved to the left (or the right-hand side of the model) and some pale blue added to it **(fig 04)**. Tungsten spotlights give a blue cast when photographed with daylight film – different but still lacking something. A bulb was added on the model's left **(fig 05)** to give a more diffused light and remove the deep shadows cast by the spotlight. To this was added some orange-yellow colour (to emulate incandescent – household – light). This light on its own is rather dull but when combined with the spotlight it gives an altogether different effect **(fig 06)**.

that helps bring the object out of the background.

This three-light rig is a guideline for interior settings. Just as when you're building your sets you try to keep the polygon count – the number of surfaces that need to

be rendered – as low as possible, you should try to work with as few lighting sources as possible. Observation of the world should be your guide.

LET THE SUN SHINE

Once you move into the outside world you have to deal with the original source of all light, the sun. Most 3D software comes with a preset sunlight or what may be called a distant, infinite or directional light. Don't try using other types of lighting for sunlight, because you will create all sorts of problems for yourself. By editing the distant light's parameters for intensity, angle, shadow and colour, you can make it simulate the sun at different times of the day and the year, and even its position relative to the equator.

For outdoor scenes, you also need to make sure all your objects are created with the proper

surfaces, because they will be influenced by the reflected light. This indirect lighting relies on the software's renderer, as do other lighting effects such as caustics (the effect of light shining through glass or reflecting off mirrors or water), which are usually found only in the high-end software but are also available in Carrara Studio. The best way to get as much realism as you can from your lighting is by experimenting with what your software has to offer, and by observing your environment.

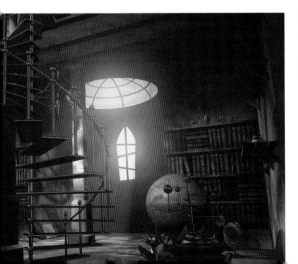

The atmosphere in this study, from Rustboy, is established by the way the light is diffused throughout the room. Emulating sunlight shining through dirty glass, a soft hazy feeling is achieved by the light bouncing around the room.

OVER TO YOU

OTY/01
Read some books on stage and film lighting, or go to your local theatre and talk to the lighting technician. Studio photographers will be able to give you some tips as well.

OTY/02
If you have a digital camera, or any other type for that matter, take photographs of lighting you find interesting. Don't use a flash because that completely defeats the purpose. Just as was suggested for textures, make yourself a scrapbook or a digital archive of light in different environments. If you already have an idea for your film, find lighting and situations that are similar and photograph those. After all, photography is nothing more than making pictures with light.

FIG01

Animating**Objects**

UNIT/61

ADDING MOVEMENT TO THE MESH

This is the part you've been waiting for. You've built your character(s) and scenery and want to get them moving. Each 3D program has its own way of tackling a set of tasks, and this is true for the animation part as well. The basics are the same; it's just the approach that differs.

The fundamentals of animation that are covered elsewhere in this book apply equally to CGI animation. The main reasons that 3D has been left until the end of the book are that first, it is the most difficult to set up, and second, it uses all the information and techniques that have been covered to date. It uses the model-making and 3D environment of stop-motion mixed with the limitless possibilities of cel animation – the best of both worlds – and the computer does most of the hard animation work.

KEY FRAMES

Most 3D animation uses a key frame and timeline system, similar to the ones we have seen with After Effects and Flash. This means that you set your character and/or object in an extreme position of the action, move it into the next pose and set it on the timeline, and let the software

calculate the in-betweens. One of the main differences between CGI and frame-based animation is that CGI is measured using time only and does not rely on frame rate. This means you can make your film without concerning yourself about frame rate and resolution issues until you are ready to render. Ideally you should know before then, but having that flexibility is useful.

Character animation is what everyone is most interested in and 3D software packages are geared towards this, with the more expensive ones better adapted to the job. Page 136 outlines the easiest route for novices, using Curious Labs' Poser. If you want to create your own unique characters, you'll need to look at one of the 'pro' packages, especially when it comes to dealing with facial animation and lip-synching. One way of dealing with this is by using a morpher.

A morpher changes the shape of one object to that of another. Morphing has been widely used in cinema to change one person's features to another, such as when a person becomes a werewolf or a vampire. These effects can be pixel-based, but in 3D the morpher tracks the changes between vertices. The two objects must have the same number of vertices for it to work. You could create for yourself a library of facial expressions and use the morpher to change from one expression to another. Alternatively, you could build a face using 'bones'.

PICKING A BONE

Bones are the foundation of 3D character animation. They are wireframe objects that become invisible after rendering and are used for moving vertex objects. A skeleton is produced by connecting the bones together in a jointed hierarchy, which is then

attached to the vertex (or mesh) model in a function known as *skinning* **(fig 02)**. To animate the skinned object you move the bones of the skeleton into the required position and the vertex object adjusts its shape to the new position. To create an animated face using bones **(fig 03)** would require an excellent knowledge of anatomy, and lots of practice and trial and error for it to look realistic – try using morphs instead.

While familiarising yourself with animating with bones you may want to practise with a simple, low-polygon character until you get the feel for the movement. You can also use the same method to create an animatic, to check the pacing of your film before you go ahead and build all the objects.

INVERSE KINEMATICS

One expression you are going to come across frequently is *Inverse*

Kinematics. Inverse Kinematics are used to help create realistic movement in bones by influencing the parent–child hierarchy. Normally a 'child' cannot influence the movement of a 'parent' but with Inverse Kinematics it does. For example, in a leg the thigh bone's connected to the knee bone and the knee bone's connected to the ankle bone. Without Inverse Kinematics, moving the ankle would not affect the other bones, as it would in real life.

MOTION PATHS

Motion paths are another aid to your animation. These are particularly useful for inanimate objects such as bouncing balls, although any object can be attached to one of these paths. You can also add physical properties to objects so that they obey the laws of physics in their movements. And there's a whole range of effects such as explode and shatter. Your software manual will outline these for you.

If you understand the principles of animation and how to use key frames and a timeline, the animation part of 3D should be fairly easy for you, once you know your way around your software.

Just one other object is animated: that is the camera, and it is covered on the next page.

FIG02

The bones, and other objects, are shown in a hierarchical table. Naming each bone as you build the skeleton makes your work a lot easier, so you can see exactly what you are working with.

The skeleton is made up of bones joined together, as in nature. The best place to start building your skeleton is the base of the spine.

FIG03

The bones control the hair's movement. In this model the hair is very simple, and not strand-based like the more sophisticated animations seen in Monsters, Inc. or Final Fantasy.

▲ Once you have designed and built your 3D character you need to add bones to the mesh to make it move. The principle is the same in most 3D programs. This model was built and animated in CINEMA 4D. Once the skeleton has been built, it is attached to the mesh using the relevant command in your software to create a skinned object.

◀ Facial expressions as well as hair and clothes are also controlled by bones.

Bones for the mouth and lips allow for lip-synching.

▶ This simple, low-polygon mesh creature, made with Carrara Studio, has a basic skeleton built to match the creature's joints. When building a skeleton it is best to work with wireframes in a four window mode, or at least constantly move between cameras to ensure the bones are accurately placed.

OVER TO YOU

OTY/01

Working with bones and skeletons, while simple in principle, is quite complex. Getting everything to move naturally will require reading your manual and practising with the various constraint options. Take the time to do this before you venture into making a proper animation.

OTY/02

Familiarise yourself with the timeline and key frame functions of your software. These are the basis of animating your models.

OTY/03

Work with a single character and practise before working on complex scenes. Your software CD may contain some models you can use for this purpose. If not, the Internet is a good source. (See the links on page 154.)

FIG04

CameraTechniques

WORKING AS A VIRTUAL CINEMATOGRAPHER

In 3D software, everything in its universe is considered an object. This includes lights and cameras, and because they are objects they can be animated. Being able to move and position the camera is vital to making your animation dynamic and realistic – realistic in the copying-a-film-camera sense, that is. In fact, you are able to produce camera effects that would be practically impossible in the real world.

▼ Zooming, when used judicially, can be very effective. In this example from Duck Soup Studio's The Snowman, the extreme close-up **(fig 02)** enhances the menacing feeling from the alien.

FIG01

FIG02

TELL US THE SECRETS TO YOUR ENTIRE PLANETARY DEFENSE SYSTEM.

To reproduce the 'Bullet Time' sequence from *The Matrix* in 3D is relatively easy as there is no problem with suspending characters in space, just animating the camera to encircle them. Try it as an exercise but don't use it in your film.

The secret of good cinematography, just like the secret of good lighting, is that, if you don't notice it, it's successful. You want the viewer to be drawn into the story and on-screen action and not to be overly distracted by the camera's movements.

Apart from the default camera views that are used for modelling (top, bottom, left, right, front, back and a reference view) you can add your own cameras, which become the objects you move around. Features vary between software programs, but you want the software's camera to imitate a real one as much as possible. Different focal length lenses (usually expressed in terms relating to 35mm cameras) and adjustable

depth of field (the amount of the image that is in focus, so that you can have blurred backgrounds) are two key features **(fig 03)**. These types of camera are known as 'Conical'. The camera should also give you a production frame, which is similar to a field guide without the grid, so you know precisely what area you are shooting.

A basic understanding of cinematography will be a great help when you are shooting your film, even if it amounts to no more

than knowing the difference between a pan, a dolly shot and a tracking shot. A pan is when the camera is at a fixed point and follows the object or the action. A dolly is when the object is fixed and the camera moves around it. Tracking is when the camera moves through a scene towards an object (see page 80).

TRACKING ON A PATH

To make a tracking shot, you need to create a motion path and attach

the camera to it. You can also get a camera to follow an object using a 'point at' command, so that as the object moves, the camera moves with it.

Because you can have more than one camera at a time, you can easily try different camera positions and angles. It is the equivalent of a television multicamera setup that you can direct by switching from one camera view to another. Although you will render from only one

camera, it is great to be able to experiment. One of the great advantages of 3D CGI animation is this possibility of trying different ways of shooting before committing to the final render – and, if really necessary, the chance to 'reshoot' from a different angle.

VIRTUAL LENS DEFECTS

Another trick to create a sense of reality is to include lens flare or glow-around lights. In the real world, lens flare is caused by very bright light reflecting off the elements of a lens, creating a line of glowing hexagonal shapes from the aperture diaphragm of the lens. The fact that it happens at all is actually a fault in the lens design and construction, but it is accepted and is used to stress a light's intensity. It is often used in desert scenes to convey the impression of heat. All these effects are included to imitate the limitations of optical technology. You should make use of them, because we are so familiar with them that anything shot without them would look too perfect – and therefore unreal. If you want to take it to the next level, once your film has been rendered you can use filters in Premiere or After Effects that emulate different film stock and can even add dust and scratches!

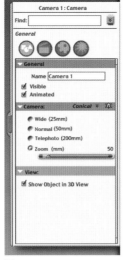

FIG03

▲ Carrara Studio offers a range of lens focal lengths, with measurements relating to 35mm photography.

FIG04

Viewing window of the 'Director's Camera', the program's default camera.

A motion path to which the camera is fixed.

◀ ▼ Attaching a camera to a motion path lets the camera move in a fixed, predetermined way. This path can be anything from a straight line to an arc through the x, y and z planes, which free the camera from limitations placed on it by real-world physics. Setting the camera's position with key frames will dictate the speed of its movement.

Window showing the main camera's view. The grey rectangles are the production frame, the area which will appear in the final render. In the inner rectangle are the safe viewing areas.

The main 'shooting' camera.

▼ Adding effects, such as lens flare, can be as easy as choosing from a menu of presets in the lighting effects **(fig 06)**. A standard lightbulb can take on the intensity of the desert sun with the right settings. Lens flare adds reality to shots by simulating the way light refracts as it passes through the lens **(fig 07)**. We are so used to seeing this in films that it would seem wrong without it being there.

FIG05

The camera at the end of the shot.

The scene as viewed by the camera.

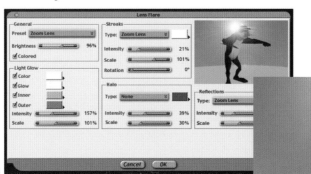

FIG06

FIG07

OVER TO YOU

OTY/01

If you are unfamiliar with the basics of lenses and optics, read an introductory book on still photography.

OTY/02

Read some books on cinematography and film direction, not necessarily related to animation. Watch some live-action films in the intended genre of your animation. Study the camera work – the use of lenses, angles and movement. If you watch a DVD, check out which members of the crew are doing the commentaries; directors and cinematographers sometimes talk about their craft and explain why they composed the shots in a certain way.

Rendering

BRINGING IT ALL TOGETHER

Rendering is probably the least interesting and most technical, and ultimately the most important, part of the CGI animation process. This is where all the polygons, shaders, lights, effects and camera work come together in the final animation. In fact, most of what has been covered over the last few pages cannot exist without the rendering engine.

FIG02

Rendering is going to test your computer's power and stability in a way that no other process is likely to. The computer has to make thousands of complex mathematical calculations to create each single image, and

your animation is going to contain hundreds or thousands of these images. Modern desktop computers are infinitely more powerful than those of even five years ago, and although this should have sped up the render processing time, artists and animators are using this power to create even more complex images, meaning that rendering is still a lengthy process.

Professional animation studios set aside computers just for the purpose of rendering. These computers are all networked together to form what is known as a render farm. The machines share the task of rendering the sequences, by each working on a different frame at a time, until the job is done. It is still the same amount of work; it just takes less overall time, using the elementary mathematical logic of 'If it takes one man one day to dig a hole, how long will it take ten men?'

You are very unlikely to have the luxury of a render farm, or even the

software that can use one, so you'll have to look at ways of reducing the rendering workload and making it more efficient. Several methods have been covered in the previous pages, such as reducing the polygon count for scenery objects and using pre-rendered images for backgrounds. Where possible, you should activate the backface culling option for your objects. This function tells the renderer to ignore any surface it can't see. Some programs use smart backfaces, which can tell the renderer if the surface in question is reflecting light that affects other nearby objects and therefore needs to be included.

One thing to consider when you are setting up your rendering is the film's destination. If it's going to be used for video or broadcast, you will have to enable field rendering so that it can give the frames the necessary interlacing.

Rendering a single image or an animation is essentially the same time-consuming process. All the information about the lighting and textures is already decided. What's left is choosing the size and method of rendering. In an animation, hundreds of small images are rendered, the size depending on your destination format – film, PAL or NTSC video. This shot from Rustboy *(see page 142) was rendered as a still for use in printed material at 4000 x 2440 pixels, where for video it would be around 640 x 480 pixels (depending on format).*

FIG01

For animation, toon or cel renderers are becoming more commonplace. These are usually a secondary render that change the overall appearance of the object. Like all renders, experiment to get the image to look the way you envisaged. These two images were created and rendered in Animation:Master. (See page 138 for more on toon renderers.)

FIG03

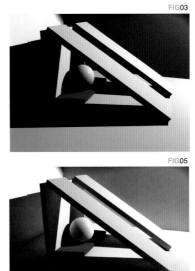

FIG04

FIG05

FIG06

◀ *Using Global Illumination when you render a scene makes the light behave more naturally, as it reflects off every surface.* **Fig 03** *shows some simple objects, with a single light source, rendered using a standard Ray Tracer. Notice how intense the shadows are and the detail is obliterated.* **Fig 04** *shows the render settings in Carrara Studio that were used for this scene. Global Illumination (***fig 05)** *makes the shadows softer, revealing the detail of the underlying objects. Note how the ball reflects the light that is shining off the upright block. This is done by activating the Indirect Lighting option (***fig 06)**.

FIG07

FIG08

▲ *Caustics simulate what happens when light is concentrated as it either refracts as it passes through a lens or when it is reflected off a shiny object, such as a mirror or water. Caustics can only be rendered with Global Illumination and rely on Photon Maps to achieve the effect realistically.* **Fig 07** *shows the way the light reacts when reflected off a shiny metal ring, and how it reacts differently to convex and concave surfaces. The light passing through the glass ball in* **fig 08** *becomes a focused point of light in the centre of the muted shadow. These effects seriously increase the render time due to the increased calculations, but the results are well worth the wait. Again, experimentation is needed before you achieve the optimum effect.*

OVER TO YOU

OTY 01

If you are serious about making 3D animations, you'll be better off initially if you invest the money in some extra hardware, rather than buying one of these expensive rendering programs. Buy a second computer, with dual processor if possible, 3D graphics card, as much RAM as you can fit or afford and a big hard drive. That way you can leave one scene to render while you work on another one. If you are stuck with working with one machine, you'll still need to have lots of RAM and disk space. The only advantage of having one machine is that it leaves you free to do other things, like talk to your friends, go to the cinema, read a book, do some drawing or go out and photograph textures – anything other than staring at a monitor.

If you are using the final film for any other purpose, including further compositing, do not switch it on.

The lighting effects, such as caustics and global illumination (also known as photon maps), and camera effects, such as depth of field, all put a heavy load on your renderer, so you need to decide how vital they are to your scene. You can also reduce the amount of anti-aliasing; it will lower the overall image quality but also the rendering time.

These are all ways of reducing the time your computer is locked up with rendering, but you also want your animation to look its best. Relative to the time you spent building the film in the first place, rendering is a small percentage of the total time. Use whatever tricks you can to reduce rendering at the building stage, so that you can concentrate on getting the most from your lighting and other effects. Make sure your software has a decent rendering

engine that will handle at least all of the effects mentioned, as, amazingly for its price, Carrara Studio does – and it even has a toon (or cel) renderer (page 138).

At the professional level, these features either come built-in as standard with a package or are accessed using an external renderer and plug-ins. The most widely known and used is Mental Ray. For feature films, one of the most highly respected is RenderMan from Pixar, the same company that makes the animations. Apart from Pixar's own animations, it is also used by George Lucas' Industrial Light and Magic.

It is not possible to cover all the aspects of rendering in the space available, just as it has not been possible to go into detail on other aspects of 3D but, as with any of the other animation disciplines, doing it is the best way to learn.

FIG01

FIG02

FIG03

Bryce Scenery

COMPUTER-GENERATED LANDSCAPES

Most people, when they think of computer-generated landscapes, think of Bryce. The program has changed publishers many times over the years and, like Poser, has developed a cultlike following throughout the world. It may not be the best or the most flexible, but it is capable of creating stunning 3D landscapes that can be used for your animations, if that's what you're after.

▲ Creating detailed and realistic scenery in Bryce is achievable with a lot of work, but the results are worth the effort as this vista, by Patrick Tuten, proves **(fig 01)**. Rugged, barren landscapes are easier to achieve than those covered in lush vegetation, yet they are just as essential, depending on your story. Don Tatro's Stupid Hero is trying to rescue no one in the middle of nowhere **(fig 02)**. Having a good range of 3D tools, Bryce allows the creation of complex architectural scenes. Utilising the water and sky creation features to good effect, Joerg Maurer was able to create a mood of silence and foreboding **(fig 03)**.

Before you decide to buy Bryce, look at some of the web sites listed on page 154 to familiarise yourself with the style of images it creates, to see if it fits in with the overall design of your animation. Animations created in Bryce are usually limited to fly-throughs. Apart from terrain editors, Bryce also has a range of standard 3D primitive objects that can be used for constructing buildings in your landscapes. If you do decide to use Bryce, the best approach is to create the landscape, and then export the object into your animation program. You could create an animated scene in Bryce, then composite other parts into it using After Effects, but getting the lighting to match could be more trouble than it's worth.

When you open Bryce for the first time, the interface will look familiar if you have used Carrara Studio, Poser or even KPTfilters for Photoshop, with its central work window and the various tools and controllers situated around it.

BUILDING A WORLD

A new work area contains a default sky and a flat plain onto which you start building your world by adding a piece of default terrain. This can be enlarged or reduced, and moved around along any axis until you have an elevation that suits you. Now you can edit it to achieve the effect you want. Luckily there are plenty of visual guides to give you a hand. Sculpting the terrain is very interesting, and until you familiarise yourself with the huge

FIG04

This gives you a small preview of your scene while you work.

The tool palette where all the different elements are created and edited.

Camera controls. Click-dragging the mouse over the arrows and trackball moves you around your scene.

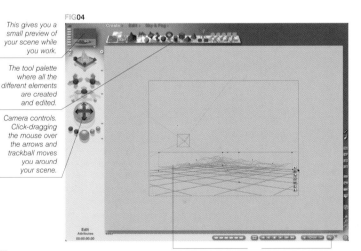

▲ The Bryce interface was created by the legendary Kai Krause and, at the time, was a complete departure from what people expected of a GUI, including Mac users.

The working window where you create your scenes by adding surfaces, terrains, water and sky as well as other 3D shapes and models.

The animation controls work with a key frame system similar to other 3D animation programs.

FIG05

135

BRYCESCENERY

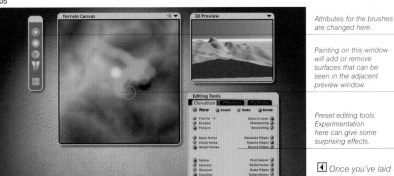

Attributes for the brushes are changed here.

Painting on this window will add or remove surfaces that can be seen in the adjacent preview window.

Preset editing tools. Experimentation here can give some surprising effects.

◄ Once you've laid out your basic scenery you will want to start making it look more natural and evolved. The terrain editor lets you erode the landscape to build up mountains and hills. This can be done using some of the preset tools or by painting it with the mouse or a stylus.

FIG06

▲ The Materials Lab is where you add the textures to your terrain. There are a good range of presets. You can even develop your own.

FIG07

▲ This is a horticulturist's dream – trees that grow exactly as you want them to. You can control exactly how they look and even mix and match tree shapes and foliage to create mutant jungles.

array of tools and options at your disposal, experimentation is the name of the game.

If you want to add some vegetation, just click on the tree icon in the 'create' palette and a tree appears. Choose from the long list of different tree types, then edit how much foliage it has, its height, trunk texture and so on **(fig 07)**. The trees look surprisingly realistic, although putting a sycamore tree in a desert scene might be stretching the bounds of credibility. What you don't get is good grass. This is definitely the preserve of high-end 3D programs with fur plug-ins, although it can be achieved in any 3D program with a particle emitter. The scene in *Shrek* where Shrek and Donkey are walking through a meadow, is an excellent example of what can be achieved with CGI.

Bryce has water, sky, cloud and fog editors as well, with a number of editable presets, so you can add all the details you need to complete a total environment.

People starting to work with 3D can make very usable landscapes on their first try with Bryce. Its animation tools are designed for

creating fly-throughs, so if you want to use the landscapes for anything else, you are probably better off exporting them into your principal 3D animation program. You could also try rendering the scene as a still image and using it as a background matte. Whether this suits your needs will depend on the style of your film, but it is a way of reducing the final rendering time.

CREATORS, BUY OTHER NAMES
Bryce is by no means the only landscape generator. Most of the professional 3D applications come with terrain editors, either built-in or as plug-ins. Some of the lower-priced programs, such as Carrara

Studio, also have environment editors, but they are usually no match for specialist applications.

Other choices worth considering are Vista PRO, Natural Scene Designer and Vue d'Esprit **(fig 08)**. Vue d'Esprit has an optional plug-in that lets you import Poser character animations (see next page for more on Poser). One other program worth looking at is MojoWorld, which creates whole planets, using fractals, through which you can navigate. It creates fantastic scenery, but it is not so easy to integrate with other programs. A comprehensive list is given on page 154.

FIG08

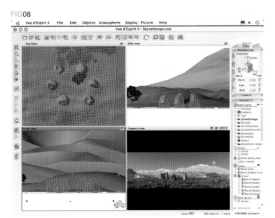

◄ Vue d'Esprit is an alternative to Bryce with a more conventional 3D interface. It too produces realistic landscapes, but with the added advantage of being able to import Poser animations, with an additional plug-in.

OVER TO YOU

OTY/01

Download a demo version of Bryce, or one of the other landscape generators, and fiddle away. They are excellent tools but won't create stylised scenery.

FIG01

FIG02

FIG03

◄ Poser is ideal for creating fantasy/sci-fi/martial arts animations because the models are very realistic and highly editable. It is possible to use one male and/or female base model for all the characters in your film, and to perform all the stunts. DAZ made this short martial arts film to demonstrate the possibilities using Poser and its own models.

Poser Characters

UNIT/65

ANIMATING PEOPLE THE EASY WAY

Creating human, or animal, characters for 3D animation is a lot of hard work, even when you know how; for novices it is practically impossible. Enter Poser.

▼ The characters in these frames for an in-development animation were created in Poser, then rendered using the cel shader in LightWave.

FIG05

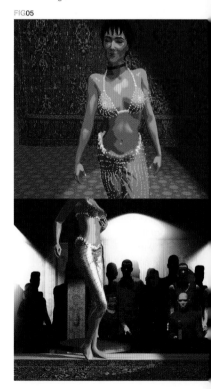

Poser is a character-generation program. It creates anatomically correct 3D humans and animals that can be customised and animated. Originally developed as a digital equivalent of an artist's wooden mannequin, it has grown into one of the primary tools for making 3D digital characters.

The program contains sets of default figures that can be altered

▼ Another DAZ animation highlighting the quality and variety of the animation possible using Poser.

FIG04

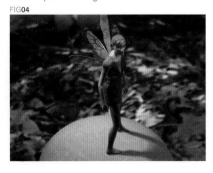

and clothed to suit your animation. There is a huge, worldwide community of users and developers who supply additional high-quality, photo-realistic figures and props. Although there is a risk of too much uniformity, anyone with the imagination and patience to experiment can create truly unique characters, as seen in the pictures on this page.

Because Poser is primarily a character-animation program, creating a whole scene is not really practical, but the animated characters can be placed into worlds created in LightWave, CINEMA 4D or 3D Studio Max.

Using Poser is very easy. You load in a figure, either one of the default figures supplied with the program, or one created by a third-party company such as DAZ Productions. The figure's physical attributes can be altered to make it fatter, thinner, shorter, more muscular, bald, anything you want.

They can also be exaggerated and distorted to create humanoid aliens. The latest version even has strand-based hair with growth and styling controls.

WALK LIKE A MAN

Once you have your character looking the way you want, you can start animating. Walking is the simplest motion, because Poser comes with a built-in Walk Designer. First, create a path for the figure to walk along (Figure -> Create Walk Path). Now open the Walk Designer, which can be found under the Window menu (see **fig 06**).

Of course, you'll want your character to do more than just walk. Poser uses the common key frame animation principle. You pose the figure in a position and click 'Add Keyframe', then move it to the other extreme of the movement and click on 'Add Keyframe' again – after calculating the number of frames you want the

FIG06

◀ *Creating a unique walking style for your Poser model is just a matter of adjusting the sliders on the right-hand side of the window. Combine different walk styles and Tweaks until you have the desired idiosyncracies for your character. Save it as a walk style (.pwk) file and apply it to the figure. You have started animating.*

▶ *Mimic takes a recording of the voice-over artist, analyses it, and creates a pose file that is attached to the character. It even adds facial movements such as blinking. This program saves so much time that it should recoup its cost in a single day.*

FIG07

NOTE: *Most of the information here refers to Poser 4 Pro Pack because most of the figures available on the Internet were created for that version. The latest version of Poser offers a higher level of sophistication in character creation and animation, but at the time of writing, there were still some compatibility issues with third-party products.*

▼ *These shots from a drug education video called 12D were created using Poser 4 Pro Pak and LightWave. This is a very popular combination with Poser animators, as LightWave is very powerful, versatile, yet easy to use and relatively affordable 3D software.*

action to move across. The software will calculate all the in-between frames.

Poser offers an incredible amount of control over the way you move each part of the body. You can do it visually or numerically with the scroll wheels on the right-hand side of the screen. It can take a lot of practice for you to move your figure smoothly and naturally from pose to pose, as it sometimes twists and turns in unexpected ways. Poser does have Inverse Kinematics to help overcome some of these problems. The program comes with a selection of ready-made poses and there are thousands more available on Poser-dedicated web sites, if you are struggling in the beginning. Eventually, you will want to direct your characters to move how you want them to, but while you are learning, there is no harm in using the resources available.

TALKING HEADS

Apart from complete body movements, Poser is very good at details such as hands and faces and is ideal for creating 'talking heads'. A complete set of phonemes is included with the program for creating lip-synched animation. This would usually be done manually, using a dope sheet, but if you intend to use a lot of lip-synched dialogue the best solution is a program such as MIMIC (see **fig 07**).

Poser also has the usual array of lighting and camera options that you find in 3D programs, which can be animated to create interesting movie effects ('Bullet Time', anyone?). When you've finished your animation, you have a number of rendering and export options, including sketched and cartoon styles, although many professional animators prefer to render in high-end 3D software.

Poser is not the only program available, although its history, international acceptance and price give it an advantage. Credo's Life Forms is another established motion editor for 3D models, and Discreet's Character Studio is a complete high-end solution for use with 3D Studio Max. DAZ Studio, a new animation and rendering program from DAZ Productions, which supplies Poser figures and MIMIC, is worth looking at.

If you want to incorporate human figures into your animation, using one of these programs is going to be the easiest, and probably the best, way of doing it.

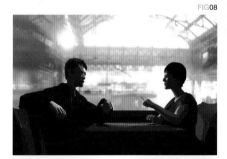

FIG08

OVER TO YOU

OTY/01
Try using Poser to make an animated film as the basis for rotoscoping (page 64). The figures won't need clothing or sophisticated renders, just enough to show the movement.

OTY/02
Study some of the preset animations included with Poser to see how they work before attempting anything too sophisticated on your own. Getting the Poser figures to move naturally is trickier than it first seems.

3Dinto2D

USING 3D SOFTWARE TO CREATE 2D ANIMATION

With computers a fixed part of nearly every animation style and process, it is only natural to see some cross-fertilisation. This is most evident where 3D is used to create 2D animation. Just as all traditional animation is stop-action, as mentioned before, so, in reality, is all animation 2D.

3D animation uses a computer-generated 3D environment to create a 2D picture. Likewise, line animation uses 2D to create the illusion of three dimensions. The marriage of the two processes is a logical progression.

The use of 3D CGI has been employed in Disney animation for many years, most noticeably in the ballroom scene in *Beauty and the Beast*. As computer technology developed, the unification of styles and technologies became seamless with the Deep Canvas backgrounds in Disney's *Tarzan* and *Atlantis*.

While software developers were pushing to create photo-realistic rendering systems for special effects, they were also developing flat colour toon shading. Inkworks is a plug-in for Maya that integrates with the Animo 2D system, and ToonShader is a USAnimations Maya plug-in.

Other programs, such as LightWave, come with toon shading incorporated. Even low-priced consumer programs such as Carrara Studio **(see fig 03)** and Poser come with toon rendering, so it is within the reach of everyone.

MAN AND MACHINE

Using 2D/3D usually works best on inanimate objects such as buildings and other props, or mechanical items such as cars or robots **(fig 01)**. Warner Brothers used it to great effect in *The Iron Giant*, and also in *Osmosis Jones* for the robotlike character, Drix. With human and animal characters, which tend to be highly stylised in line animation, 3D software does not have the free expressiveness of an artist's pencil.

One of the advantages of using 3D software with 2D animation is the amount of time saved in the production cycle. Any prop that is created is stored on the computer and can be used at any time without having to be redrawn. It can be moved around and viewed from any angle without the need for studied drawings. It could be argued that this diminishes the animation artist's skills. It may mean less opportunity for young animators to work their way up through the studio system, but if

FIG02

▲ *Secret Weapon, from California, is a games development and production company. In its spare time it makes animated films such as Gear Hero. The battle of machine against machine was created with 3D Studio Max and rendered with toon renderer to give it its hybrid look.*

FIG01

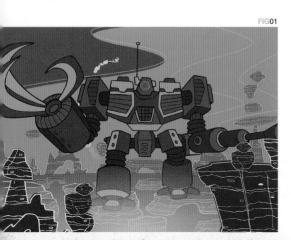

◀ *Robots seem to be the most commonly created 3D characters for 2D animation. The giant Kill'o'bot was integrated into Atomic Cartoons' Atomic Betty, a series made up from a fusion of 3D, Flash and traditional animation techniques.*

FIG03

139

3DINTO2D

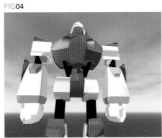

Set the colour for the lines and the shadows, and highlights.

These sliders control the intensity of the effects.

The thickness of the linework is adjusted here.

If you don't want outlines on your shadows or highlights set the slider to zero.

▲ Toon or cel shaders are becoming more common place in 3D software. From top-of-the-range pro packages to affordable consumer software such as Animation: Master and Carrara Studio. In Carrara Studio, the Toon shader is a post-render filter. This means that it will render the scene according to your settings then re-render it with the options set in the filter. Experimentation is the only way to get it looking how you want. Luckily Carrara has a very fast render preview so you don't have to render the image before seeing the results.

Clicking on the camera icon in the bottom left-hand corner and dragging over a selected area will give a preview of how the effect will look in the final render. You can quickly fine tune the effect to appear as you want it to before committing to the lengthy rendering process.

FIG04

FIG05

▲ A normal ray traced render of a robot.

▲ The same image with the Toon filter applied. Outlines are only applied to the edges of the shapes so that some subtlety of shading is maintained.

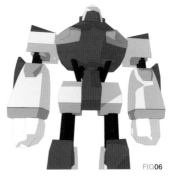

◄ The same 3D file converted to vectors for use in Flash or Toon Boom Studio, at a fraction of the file size.

FIG06

they develop both traditional and digital skills, their opportunities will be wider.

FINE TOONING

If it is your intention to create an entire 'toon' animation, or just props and elements, using a 3D application, it will influence the way you work with it. Your objects aren't going to need complex textures; in fact the simpler you keep them, the easier it will be to render them. Although it is still important to light the scenes properly, a bright, global illumination will help maintain the toon feel. How you light it will depend entirely upon the content

and style of the animation. An anime- (Japanese-animation-) style, sci-fi film will probably use subdued light, whereas a children's cartoon is more likely to have vibrant light and colours. Make these design decisions at the planning stage.

It is the use of lighting and colour in both the 2D and 3D parts of your animation that will ultimately determine how successfully you can blend them – and getting it all to stay in register. The integration of the 2D and 3D elements is usually carried out using specially designed software such as Animo. You can also composite the different elements together with After Effects. Another alternative is to save your 3D film as a Flash .swf file and add the other elements using Flash or Toon Boom Studio.

Whatever your style of drawn animation, try adding a little depth with toon-shaded 3D.

▶ Carrara Studio also has an optional plug-in, called Vector Style, that will render scenes into Flash movies or single-image Illustrator files. Although it has a good range of options, the single colour cartoon shading is very close to the style we are used to seeing. Again, experiment with the settings before committing to the final render.

FIG07

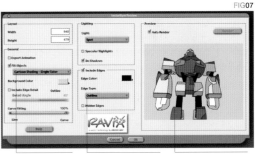

Select the degree of shading you want in your animation here.

Choose your outline options here.

The preview window shows you how the final image will look. If you set it to Auto Render, it will automatically update the preview every time you change one of the attributes.

OVER TO YOU

OTY/01

Start by creating simple objects and practise applying toon shades.

OTY/02

Experiment with your 3D objects to try to get a hand-drawn feel to them to match other elements in the animation.

FIG01

Games

UNIT/67

BUILDING INTERACTIVE WORLDS

One area where 3D animation enters into a world of its own is in video games. Just as the power of the computers and software that create the animations continues to increase, so does that of the consoles. Now we have games that are incredibly realistic in appearance, with game play that is more sophisticated too. In fact, a lot of games are becoming more like interactive, animated films than straightforward games.

FIG02

FIG03

🔺 *2D role playing games (RPG) are reasonably easy to make, compared to 3D games, but they still require a large amount of planning and a good story line. 'Genocide' is one such game in development that uses anime-style characters and cut scenes created in SoftImageXSI.*

Animators' skills can be used in several areas in the videogame production cycle beyond the game's actual concept stage. These areas are character design and modelling, character rigging and Full-Motion Video, sometimes known as *cut-scenes*.

As with all forms of animation, games need characters and they have to be designed by artists. These will usually start off as pencil drawings, to fit the style of the game, and develop from there. There are levels to be designed as well, which involve creating all the relevant scenery – similar to background artists' work in films. The characters are then made into 3D models. The skill here is to create them using as few polygons as possible without sacrificing the realism of the model. This is done by creating the characters from scratch with the minimum number of polygons, then adding highly detailed, but low resolution, textures **(figs 06–08)**. Plenty of movement in the characters,

coupled with the viewer's immersion in the action of the gameplay, creates an illusion of high-quality rendering.

An animator's understanding of movement is necessary when it comes to the game's action sequences. With the current generation of high-spec consoles, skeletal structures are more frequently used for animating characters. Where realistic action is vital, for instance in sports games, MoCap (Motion Capture) is employed.

🔽 *The III Clan took the very popular Quake game engine and, instead of making a game, created humourous animated shorts, such as the award-winning* Hardly Workin'. *It used a process called Machinima, that uses the game's rendering engine rather than creating the animation frame-by-frame.*

FIG04

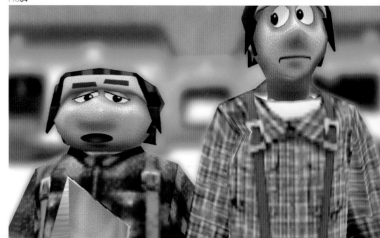

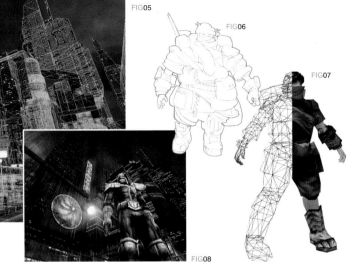

FIG05

FIG06

FIG07

◀ *For its new PC/PS2 game, 'Judge Dredd: Dredd vs Death', developers Rebellion built a replica of Mega City One (***fig 05***), using mesh models in Discreet 3DS Max, and finished it with their own game engine software, Asura. Wherever possible, characters for the Judge Dredd game were taken from the 2000 A.D. comic books. All characters were first sketched (***fig 06***); polygon models were then built using Discreet 3DS Max and Character Studio (***fig 07***) and textures added using Photoshop and Pixologic ZBrush (***fig 08***). The average character was around 2,000 polygons. The game is a first-person shooter so we only get to see Dredd in the cut scenes.*

FIG08

GAME OVER

The processes outlined so far have leaned heavily towards the technical, and are closely linked with the games' programmers, who are responsible for initiating where and when actions occur. The one area that can be considered pure animation is the cut-scenes. These are the noninteractive film sequences used as introductions to the game or to segue from one level to the next. They are made at a much higher resolution than the rest of the game because they are straight playbacks of pre-rendered animation rather than something that has to be rendered on-the-fly by the computer or console. The animator can show a lot more detail and concentrate on high-quality lighting and anatomically correct movements, elements that are sometimes overlooked in the game play.

If you already have the rudiments of 2D and 3D animation techniques, coupled with artistic imagination and skills, you just need to learn the right software packages and a little about the underlying science and technology of games engines to start working

◀ *Just as with any animation, story plays an important part in games, even shoot 'em ups. 'Black and White', from Lionhead Studios, is a role-playing game where you play the ultimate role – God. You can even control the weather.*

FIG09

in this sector. Most games are created using the same high-end software that is used to make 3D animations, mostly 3D Studio Max and LightWave, although Maya and SOFTIMAGE are used as well.

From a practical point of view, creating animations for the games industry could initially be a better career choice than straight filmmaking. It may not be as satisfying from a creative point of view, but it is a large and wealthy market that could sustain you while you develop your ideas and the skills necessary to make your 'big project'.

▼ *Secret Weapon created the 'Supabikes' game project using Discreet 3DS Max, with a toon renderer to achieve an anime look.*

FIG10

OVER TO YOU

OTY/01
Find out about the technology that drives games.

OTY/02
Learn one of the industry-standard 3D animation programs.

OTY/03
Devise some original games characters and practise creating low poly-count (3,000 and under) versions.

OTY/04
If you have an idea for an animated film, try rethinking it as an interactive, multi-threaded story where different decisions take the story in other directions to alternative conclusions.

OTY/05
Different-style games require different engines. For FPS (first person shooter), the Quake engine is widely used and can be downloaded from www.idsoftware.com. If you prefer RPG (role playing game), Coldstone is an excellent and very reasonably priced shareware option for Macintosh that is easy to use and surprisingly powerful (see www.ambrosiasw.com/games/coldstone).

CaseStudy

UNIT/68

RUSTBOY BY BRIAN TAYLOR

You would think that creating your own CGI animation would require a room full of high-powered workstations and servers and software programs that cost more than a small car.

FIG01

FIG02

FIG03

Well, artist and animator Brian Taylor has surprised a lot of people and generated a lot of industry excitement with his short animated film, *Rustboy*, which is being made on a standard desktop Macintosh, with Infini-D, an inexpensive and now defunct piece of 3D software.

Rustboy started out as an idea, and then became some concepts on paper. From there a 3D model was created on the computer and a story was developed, followed by hours and hours of designing and building sets and props, while Brian Taylor learned more about 3D animation.

HOME ALONE

When Taylor started working on the project, it was just a hobby and a way to develop his 3D and

▶ *The original drawing for the castle's entrance* (**fig 01**). *The computer-generated 3D model* (**fig 02**). *The final rendition with textures and lighting added* (**fig 03**). *Having a clear vision of what he wanted and the talent to put it down on paper meant that Taylor was able to conceptualise and build the sets with very little deviation.*

▶ *The hero of the story Rustboy rendered with and without the texture map.*

FIG04

animation skills. As the work progressed he created a web site as a diary for anyone who was interested in following the growth of his creation and, as can happen on the Internet, a buzz started about these fantastic images of a mechanical boy. It wasn't long before studios such as Pixar were phoning him to compliment him on his work. Thanks to private funding, *Rustboy* is now Taylor's full-time job. He is still working alone, and still using a desktop Mac and Infini-D (along with Photoshop, Premiere and Carrara Studio) to finish the 25-minute film.

For anyone starting in animation, this is a great example of what can happen if you have a good idea for a character and a story, have the persistence and talent to make it work and make intelligent use of the Internet to get the work seen.

FIG05

FIG06

The layout of a scene in Infini-D, showing the camera and light sources in the wireframe windows along with a rendered preview.

FIG07

The attention to detail given to every scene is all the more impressive given the comparatively rudimentary equipment used. Really, anyone who says he or she can't make a 3D animation because he or she doesn't have the right software or a powerful enough computer, no longer has any excuse. Talent and determination are the deciding factors in producing high-quality work, not the tools with which it is done.

Another example of the intricate detail given to objects and to the lighting in every scene. Choosing a low camera angle adds further impact to the shot.

FIG08

The scene of Rust Boy plunging into the ocean, with the refracted light behind him and the air bubbles surrounding him as he sinks, is another excellent piece of animation, regardless of the equipment used.

Editing

PUTTING IT ALL TOGETHER

Editing means joining all the disparate bits of your film – video, voice-over, music – together to make a unified whole. Unfortunately, it's not that simple. You've poured your heart and soul into making this animation, so you won't want to stick it together like self-assembly furniture.

FIG01

▲ If you want to use iMovie on your Mac to edit your animation, it has to be in a DV format. If you've shot it using a DV camcorder, you can work directly from the camera, but if your files are any other movie format they will have to be converted. QuickTime Pro does this easily by choosing export and the Movie to DV Stream option shown. Even if you are already working in DV, it is worth the low price to upgrade from the standard to the Pro version.

■ iMovie is more than capable of putting your film together with titles, credits and simple effects.

Editing an animation is different from editing a live-action film. Every scene and every frame has been carefully planned and painstakingly created. You don't have the luxury of extra takes or different camera angles, although there is nothing to stop you from doing a two-camera shot for stop-action animation.

The job of the animation editor is to take all the footage and join it together, following the dope sheet as faithfully as possible, so that each change of camera angle or change of scene happens smoothly and seamlessly. This can be done by adding in fades, where the picture goes to black or white, or with dissolves, where one scene fades out and overlaps the other scene fading in (fig 06).

Because an animation is so tightly planned, it is quite rare for scenes to be deleted, but if the director decides that it needs changing to improve the pacing, then the editor has the unenviable task of removing the offending parts while maintaining the integrity of the remaining film.

SYNCHRONISING SOUND

The hardest part of the editor's job is to synchronise all the different sound tracks. The sound mixing

Thumbnails of imported clips are stored here.

Clip thumbnails are shown in sequence with any transitions.

Transitions are added from this window. Choose the transition and time, then drag-and-drop it between two clips.

FIG02

Preview monitor.

The video timeline, where the clips are dropped for editing and 'splicing' together. Each clip is named and its running time displayed. Transitions are shown here too.

iMovie has only a limited number of audio channels, but they should be enough for most simple animations.

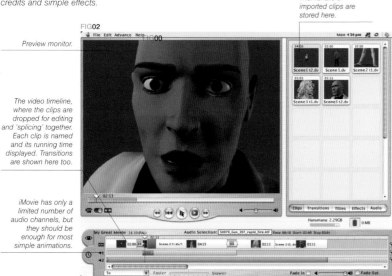

FIG03

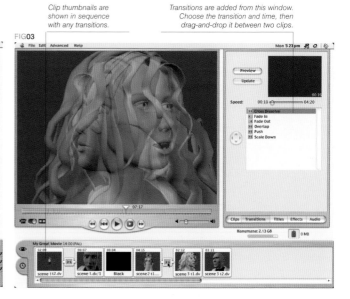

on a large production is handled by an audio engineer, who ensures the proper fidelity of the voice-overs. As these are often recorded at different times and locations, they have to be tweaked until they all have a similar resonance. The audio engineer also ensures the correct volume levels and balance between voices, music and sound effects. This final mixing is done in conjunction with the visuals.

The use of desktop editing systems, such as Premiere **(fig 04)**, make the editor's job much easier. You have at your disposal multiple video and audio tracks and a choice of special effects and filters. But don't be lured into using them unless required – a carefully crafted animation can be spoiled with unnecessary special effects.

CHOOSING SOFTWARE
Your choice of editing software will depend upon your budget and usage – from the free iMovie for Macs to professional systems such as Avid and Media 100. Windows users have a good choice, whereas the Mac market is dominated by Apple's Final Cut. If you have been working with Photoshop and After Effects, Premiere is a natural choice, as they work together. A recent Macintosh will have Apple's iMovie DV editing software already installed **(fig 01)**. If you have shot your animation with a DV camera, just plug it into your FireWire-equipped Mac and start editing. The Mac version of Toon Boom Studio can export directly to iMovie or to a DV stream for editing in any other DV editing software.

When choosing your editing software, keep in mind what you intend to do with the finished film and make sure the software will output it in a format you can use.

OVER TO YOU

OTY/01
Pick an editing package that suits your needs and budget. The more complex the animation, the more sophisticated the software will need to be.

OTY/02
If your computer takes plug-in video cards and convertors, these often come bundled with editing software, which makes them very good value.

OTY/03
Watch some short films, animated or otherwise, to see how scenes are cut together.

OTY/04
Keep your dope sheet handy when you are editing, as this should be your main guide.

OTY/05
Getting all the sound and visuals to synch together is harder than it first appears. Practice and persistence are essential. Keep working at it and don't settle for substandard results, especially with the sound.

FIG04

All video and sound clips are imported into the Project window and stored in Bins (folders), where they can be easily accessed and previewed.

Using the Video A/B option makes it easier to control transitions and other aspects of the editing process. Clips are dropped from the Bin onto one of the channels. Clips can be cut by simply dragging the edge of the clip to the required length, or by doing it visually, using the Monitor.

The audio controls in Premiere are very good and should be able to handle all your needs, providing the sound is of good quality to start with. You can have multiple audio tracks for mixing sound effects, dialogue and musical score. These can be edited visually or by using the Audio Mixer.

The Monitor, for previewing your film as you edit it.

Transitions between clips can be fine tuned here, then dropped onto the Timeline.

Using this option you can pan the sound (make it move between the two speakers) by adding and adjusting points on the line.

The volume of the sound can be adjusted by adding points and moving them up and down as desired.

▲ *Premiere is one of the main cross-platform editing programs, with a host of professional features and integration with Adobe's other software.*

◀ *The Audio Mixer does the same job as moving the points in the audio timeline, but it is designed to resemble a traditional mixing desk for those who prefer, or have experience, working that way.*

▶ *Transitions, such as this cross dissolve, help make moving from one clip to another a lot smoother. Use transitions sparingly and with subtlety. If done well, they should be unnoticeable.*

FIG05

FIG06

FIG01

FIG02

FIG03

↑ In this short animated trailer for the Taos Talking Picture Festival, Igor Choromanski integrated the credits into the film's storyline. Using a woodblock typeface, reminiscent of advertising and 'wanted' posters from the old West, the titles are projected onto a wall **(fig 02)**, followed by the scrolling credits **(fig 03)**.

MusicandFinalCredits

UNIT/70

CREDIT WHERE CREDIT'S DUE

The role of music is so intertwined with the rest of the creative process that it is something you should always bear in mind at every stage of the animation process. It is covered briefly on page 86, with the other parts of the sound track, so this is a reiteration and consolidation of music's place in your film.

If you are commissioning an original score, you need to bring the composer in at the storyboard stage so that he or she can start getting a feel for the animation and assess the mood and tempo required. In fact, the whole pacing of the film can be dictated by the music. A lot of animation directors like to work to the musical score, relying on the composer's sense of rhythm to create the movement rather than forcing the composer to follow the metre of the film.

If you are multitalented and can write music as well as animate, it won't matter where in the process you create the music. Leaving it until the animation is finished and edited allows you the freedom not only to alter the film as you go (a lot more practical with digital systems) but also to synchronise the music exactly to the film. You, or the composer, will be able to write and perform to the cue points, the peaks and troughs of the action and emotion. Digital sound recording and video editing systems make it easy to control.

ROLL CREDITS

One other finishing touch to your film are the titles and credits. Titling is covered on page 66. As for the credits, you can decide at which end of the film you want to put them. If you're the whole studio, the credits are going to be very short and could easily be incorporated into the title. If you have other people involved, you need to put their names and jobs somewhere, and that is probably better left until the end. You may also have some people who have

FIG04

Rolling Title Tool for creating text box.

FIG05

Rolling Title Options

Direction
- ● Move Up
- ○ Move Down
- ○ Move Left
- ○ Move Right

☐ **Enable Special Timing**
Special Timing (frames)
Pre Roll Ramp Up Ramp Down Post Roll

[Cancel] [OK]

Select direction of scrolling here.

Fine tune the scrolling by entering frame numbers in the relevant boxes.

◀ If you are using Premiere to do your final editing, you can use its titling function to add credits and titles. Open the titling window **(fig 04)** – File –> New –> Title – and select the Rolling Title Tool. Draw a text box and insert the text – this is best copy-and-pasted from a prepared word processor file. Change the typeface, size and colour as desired. The options are fairly limited but still workable. From the menu bar choose Title –> Rolling Title Options **(fig 05)**. The important thing to remember is that the text box must be full for scrolling to work, so either make the window small or use carriage returns at the end. The titles can be added to the editing timeline with the length of time allocated determining the speed.

FIG06

👤	Kvin kLara	arboj acxetis
🎩	Ses telefonoj	stulte helfis
	Multaj domoj	trinkis kvar
🐦	bieroj	Tri malrapida
💻	hundoj veturas	La malpura vojo batos multaj tre malrapida arboj.
📷	Tri malklara	telefonoj skribas
✂	du flava	domoj kaj
👁	La malbona	arbo trinkis
🎵	Denvero	Ses belega
🎗	Libroj	malvarme skribas
🥧	La alta	birdoj sed

FIG07

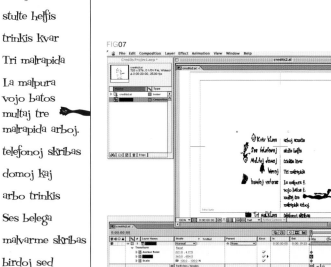

◀ *If your animation has been comped in After Effects, you can use it to make your credit and title sequences with a lot more creative control. Set up your titles using a program with better typographic controls, such as Illustrator or FreeHand (fig 06). Select a typeface that captures the feeling and style of your animation. The resulting file can be imported into After Effects and made to scroll using the Transform options in the Timeline (fig 07). For more adventurous titles use multilayered Photoshop images.*

FIG08

▲ *Putting your animation together in Flash still requires a similar approach to After Effects and Premiere. The same text file (fig 08) can be used in Flash, using a motion tween in the Timeline (see page 108). Creating sophisticated text and titling effects in Flash can be very time consuming, so a program like Wildform SWfx can make the job a lot easier with its library of hundreds of preset effects. The finished swf files can be placed directly into Flash and most video-editing programs.*

supported you while you were locked in your room. Or maybe you managed to persuade the local takeaway to supply you with free pizza for a mention in the film; that can be done here. The all-important copyright notice and any other legalities and disclaimers should go right at the end – don't forget them.

Whatever you do, try to make it interesting and original. Pixar's outtakes were a brilliant idea – not that outtakes are original, but showing animated characters making mistakes was a masterstroke in helping to 'suspend disbelief'. Another idea is a payoff scene or gag when the credits have finished. These are just suggestions, but whatever you do you should maintain the mood of the film. Your editing software should be able to create credits if they're something simple.

BOXING CLEVER

Apart from deciding which medium to put your finished piece onto (see page 148), you will need to design a cover and label for said medium. Keep the design in line with the mood and design of the film (fig 09). Have a look at film packaging in your local video shop to get an idea of how commercial companies approach it. You don't have to imitate that style, which is aimed at making it stand out on a shelf, but still try to make it eye-catching, even if you are printing all the covers and labels yourself on your inkjet printer.

All that's left to do now is make some copies and send them out for people to see. More on how to do this is covered on the following pages.

▶ *Keep the cover design of the packaging in which you present your finished piece simple and graphically strong. Place one or two scenes from the film on the back cover with a brief synopsis of the story and your contact details.*

OVER TO YOU

OTY/01
Practise writing copy about your film. Write a synopsis in 50, 100 and 200 words. Try to make it intriguing without giving too much away. Try to avoid cliches and too many superlatives, no matter how good you think the synopsis is.

OTY/02
When you watch a film, whether in the cinema or at home, watch the credits. Study all the different layouts and approaches. See who gets first billing and what is the most common order.

OTY/03
Don't forget the copyright notice at the end of the credits. This should cover the animation, the screenplay, the music and any other original material that has been created.

FIG09

DistributionMedia

HOW TO GET YOUR WORK SEEN

Once you've put the final finishing touches to your film or films, you will want to show them off. You'll want to reach a much wider audience than your friends and family, and preferably one with financial backing.

FIG02

Apart from using the Internet, (see page 114), you will have to put your film onto some sort of medium to send it to your potential viewers. You have three choices: videotape, DVD or CD-ROM. The decision about which to use will be dictated by its intended recipient.

CHOOSING A MEDIUM

Until recently, when sending out a showreel, the preferred medium was VHS videotape, but with the rapid growth of the DVD market, DVD is going to be your better choice, for a lot of reasons other than just its popularity.

Not only have the price of domestic DVD players dropped to less than that of VCRs, but DVD writers have also become very affordable, and many computers come with them as standard, such as the SuperDrive-equipped Macs, which come with iDVD software for authoring the discs. As an animator/filmmaker, you will probably have chosen a DVD-R-equipped machine. Because you've been working digitally on your animated epic for months, it makes sense to keep its digital quality for playback by putting it on a DVD.

If you think using a DVD disc, capable of holding hours of digital video, is a little excessive for your short film, you could make a VideoCD (VCD) – a format that compresses a film to fit on one, or sometimes two, standard CDs. It will play on most DVD players and

FIG03

computers. The quality is about the same as VHS tape, but more convenient to distribute.

Another alternative is to save your animation as a QuickTime movie that can be played back on almost any computer. QuickTime is a free video player for computers, and now comes as a standard installation with most new systems. If you are sending a QuickTime CD it should be saved as a .mov file and, more importantly, you should make sure that the CD can be

▼ QuickTime is a standard, cross-platform movie and media format developed by Apple Computers. Using this format, your showreel can be viewed on most computers. QuickTime movies can be shown over the Internet, but writing them to a CD is a much easier solution for getting your work seen by computer-bound studio people.

valderama.mov

FIG01

▲ Once you've decided whether to use videotape, DVD or CD for your showreel, you need to create an overall, consistent package. Sending a video/DVD and a CD-ROM is always a good idea **(fig 03)**. *Include a letter and business card with the package* **(fig 02)**. *Keep the letter short and let the showreel do the talking for you.*

◁ *Always keep a supply of showreels handy. The cost of duplicating videos and CDs is always cheaper the more you have done. On the other hand, don't get too many made and end up throwing them away.*

read by both Mac and Windows. A Macintosh can read an ISO9660-formatted CD, but Windows will not read a Mac-formatted disc without additional software.

What you really want is feedback from other animators, so sending a showreel of your work to an animation studio is going to be your main priority (see page 150). Unfortunately, one film does not a showreel make.

MAKING A SHOWREEL

If you have a variety of animations in different styles that you can use, then DVD is the best solution for making that captivating showreel because of its nonlinear nature. Initially, your showreel should be a series of short highlights, edited together and accompanied by some original music if possible, much like a cinema trailer. Avoid using commercially released music for this (see page 86). Try to keep the highlights down to two minutes or less; remember most television commercials are 30 seconds long, just to give you an idea of how much information can be fitted into a short space of time. Making this 'trailer' will be a good way of honing your editing skills.

Once you have grabbed their attention with the trailer, lead them to the full-length films. This should be optional, which is why DVD is an ideal medium. Make the interface for the DVD as interesting as you can, and your software will allow. The navigation system in DVDs will allow viewers to select whatever takes their interest. One idea is to make a page that explains a little about the film and the technique used to create it before they actually view the film – just some text over an illustrated background. When making the DVD, it is important to ensure that the navigation system works and the viewer can return to the main menu.

Another alternative is to make a CD-ROM with a self-contained projector, created in Flash, Director or any other multimedia authoring program, that can be viewed on a computer. This is an ideal option if your portfolio has a lot of vector animation in it, but that doesn't exclude you from also making it as a DVD. There are plenty of things you can do with multimedia programs, but follow the same guidelines given for DVD. Better still, try to make them identical and

send both in the same package **(figs 02–03)**. And remember to think cross-platform.

When making the showreel for linear media such as tape, you will naturally put your highlights first, then put the full films in some sort of order. Save the best till last and put the second-best first; the middle is up to you. Transferring your showreel to tape should be easy enough if your video card supports video-out and has the correct sockets. Otherwise you will have to get yourself a breakout box such as Dazzle Hollywood DV-Bridge, which will cost almost as much as a DVD writer.

So get editing now and create a killer showreel.

▼ *Try to keep your web site design consistent with the rest of the material you have sent out. If you have access to a streaming server for movies remember to make different versions for different bandwidths. Nothing drives people away faster than having to wait hours for a film to load.*

FIG05

OVER TO YOU

OTY 01
Before you send your completed showreel to prospective studios, show it to trusted friends, an experienced professional or a teacher.

OTY 02
Get a list of local animation studios from the Yellow Pages or the Animation World directory (www.awn.com). Be adventurous and look outside your area, or even your country. If you know your stuff is good, then take chances.

OTY 03
Phone the studios beforehand to see if they are interested in looking at showreels, and find out what format they prefer. Make sure you get the name of the person to send it to, and follow up with a phone call. Ask for some feedback about the work and how it is presented. Everybody has different tastes and different opinions so try not to take criticism too personally.

FIG03

Where to Now?

UNIT/72

TAKING THE NEXT STEPS

we've reached the end of the book and Hopefully you've learned something in this brief and basic introduction to animation, at least enough to stimulate you to take it further. But where?

FIG01

▲ *Animation World Network is an excellent resource for anyone interested in animation – from industry news to databases of studios, services and schools, to career opportunities.*

If you haven't started college yet, now is the best time to look at schools that teach animation. The Web is a good place to start – type in 'animation schools' and your country or county. This should give you a comprehensive list of places with animation on the curriculum, either full- or part-time.

Taking a course may be out of the question, in which case you are going to have to persevere on your own. By this stage you should have decided which style of animation best suits the way you want to express yourself and maybe even make a living.

If you want more detailed information, there are plenty of books that specialise in every aspect of the art, from huge tomes on Flash, Maya or any other software program you care to name, to some excellent books on how to draw 2D animation. There are also some excellent video-based teaching courses for learning software techniques (see page 154).

Maybe you just want to get on with it and make a short film on your own. Experience is a great teacher, and you will remember everything you learn and discover. It may take a little longer, but animation can be such an engaging process you probably won't notice the passage of time.

▶ *Software companies, such as Toon Boom Studio, have showcases for users to show work created with their software. It's an easy way of getting your work seen by a large audience with minimal effort on your part (aside from making the animation in the first place).*

FIG02

▲▶ *Attending a dedicated animation school means expert help is always on hand when you are stuck with technical or creative problems* **(fig 03)**. *Interaction with other students also helps to fuel creativity. Animation courses range from full-time degree courses to part-time vocational courses. Even attending a few hours a week can be helpful and give you access to equipment and experience you won't find anywhere else. Get the brochures from all the local courses* **(fig 04)** *and compare syllabus, prices and course times to find one that best suits you.*

FIG05

Animator Chris Nunwick put his showreel online for people to see. He also decided to use it to publicise his other talents, ones that could bring in extra work. As an animator you will have developed skills that could be used elsewhere, whether it's as a modelmaker or illustrator or camera operator, so why not advertise them?

Once you've finished your animation, you'll want to show it off. Putting it on the Internet is an easy way to find an audience, albeit a nonpaying one. If you build your own web site you'll need to get it listed on a search engine. This is the best way to generate traffic **(fig 05)**. Set up the meta tags on your homepage with a good selection of key words. Another way is to send your work to one of the many gallery sites. If you have used a specific software program to create the animation, then have a look on the company's site **(fig 02)**. Companies are usually more than happy to show good-quality work that is created with their products. Always remember to put a copyright notice somewhere on the film.

Some other alternatives are television stations, especially the local channels. They all need content, and some of them set aside time for showing high-quality short films, whether live-action or animated. There are also film festivals and competitions, which are ideal places to have your work viewed by your peers. Competitions can be an excellent incentive to produce a short film, and working to a theme and time limit is good practice if you want to enter the world of professional animators. A word of caution about competitions: Don't let them distract you from other projects that you consider important or that are paying your rent and food bills.

When it comes to looking for work, you can either wait for people who have seen your work on the Web to contact you, or start knocking on doors. Either way it is going to take a lot of persistence. An excellent resource is Animation World's web site (www.awn.com), which has not only industry news but also an online directory of animation studios **(fig 01)**.

Your work and how you present it is the key to getting your foot in the door – even more important than your CV, especially during the early stages of your career. If you are making first contact through e-mail, try to find the address of a specific person rather than a generic info@ address. You have a much greater chance of someone reading it. Try sending an animated e-card, but keep the file size as small as possible and make sure there is a link to your web site.

Using the postal service is good, and because people are neglecting it in favour of e-mail, you have a good chance of being seen. Together with your letter you will need to send a showreel. Show some imagination and ingenuity in the packaging, but don't be too clever. You also need to choose the right medium to send your showreel on (see page 148). If you want your discs returned, enclose an addressed envelope with return postage, but bear in mind that it is much better to let them keep the discs because you never know who will watch them at another time.

If you do get called in for an interview, which may happen after a lot of rejections, remember to be yourself and wear your normal clothes. The important thing for most animators, apart from talent, is passion and enthusiasm for the medium, because it's going to swallow up a big chunk of your life.

Whether you go on to further studies, decide to join a studio or go it alone, good luck in your pursuits. Above all, have fun and enjoy.

When going for an interview, dress better than you normally would, and make sure you take a spare showreel and copy of your CV to leave. First impressions count!

FIG04

FIG06

Glossary

Animatic: A filmed, taped or computer-animated version of the storyboard that runs the same length as the finished animation.

Animatronic: A puppet or character with a robotic skeleton usually controlled by a remote control.

Anime: A Japanese-style animation. Sometimes called Japanimation or Manga, it is characterised by people with large, exaggerated round eyes.

Antialiasing: The process of resampling pixels to make hard, jagged edges look soft and smooth.

Armature: Wire or ball-and-socket skeleton for stop-action puppets.

Background artist: The person who paints the background scenery of an animation.

Batch process: Setting the computer to perform a repetitive task to a large number of files; e.g., reducing all images to the same size.

Bitmap: A text character or graphic image comprised of dots or pixels in a grid. Together, these pixels make up the image.

Blue screen: A background of pure blue (or green) that can be removed with compositing software and replaced with another image. Also known as Chroma-Key.

Bones: Wireframe objects in animation software that are joined together to make a skeleton. The skeleton is attached to a character model; once this is done, the character model becomes the skin.

Broadband: A fast Internet connection. For home computer users, this is usually either DSL or cable.

Camera stand: A support for a still or video camera. This can be a tripod, a copy stand or a more sophisticated professional rig.

CD, CD-R, CD-RW: Compact Disc, Compact Disc Recordable, Compact Disc Rewritable.

Cel: A sheet of transparent cellulose acetate used as a medium for painting animation frames. It is transparent so that it can be laid over other cels and/or a painted background, then photographed.

CGI (Computer Generated Imagery): Animated graphics produced by a computer. Also referred to as CG in the context of animation.

Character designer: Artist who creates the look of the individual characters.

Claymation: A proprietary name for stop-action animation using clay models.

Clean-up: Retracing an animator's sketches into single, clearly defined lines.

CMYK: Cyan, magenta, yellow, and black – the standard inks used in four-colour printing.

Compositing (*also* Comping): Joining together the various layers and elements of an animation or special effect.

Digital ink and paint: The process of tracing and colouring an animator's drawings using a computer.

Director: Creative supervisor for an entire animation who decides everything from camera angles to the musical score.

Dope sheet: *see* Exposure sheet.

Doubles: Shooting on doubles or twos is the process of photographing two frames of a single image, either as a cel or 3D model.

DV: Digital Video.

DV Camera: Digital Video Camera.

DVD (Digital Versatile Disc): A disc capable of holding a large amount of data. Principally used for films.

Exposure sheet: A form onto which all the shooting and drawing information for an animation is entered, one frame at a time.

Field guide: A punched sheet of heavy acetate printed to indicate the sizes of all standard fields. When placed over an artwork, it indicates the area in which the action will take place.

FireWire: A high-speed connector used to download digital data at extremely high speeds from peripherals (such as DV cameras, hard drives and audio hardware) to a computer. Also known as IEEE1394 and i-Link.

Flash: A computer program by Macromedia for creating vector-based animation for the Internet. Its .swf format is the default standard.

Flip book: Simple animation made by drawing a series of images on the pages of a book and flipping the pages with one's thumb to make the characters or design move.

Frame: An individual photograph on a strip of film. When the film is projected, each film is normally seen for one twenty-fourth of a second, or at a frame rate of 24fps (frames per

second). However, the fps varies according to final format; e.g., Film – 24fps, PAL video – 25 fps, NTSC video – 29.97 or 30 fps.

Game play: The storyline and interactive parts of a computer game.

GIF (Graphics Interchange Format): A computer image format used on the World Wide Web for images with fewer than 256 colours. Good for bold graphics.

Graphics tablet: A computer peripheral that allows you to draw or write using a pen-like instrument as if you were working on paper.

Graticule: *see* Field guide.

Gray scale: Black-and-white image with full tonal range of greys.

Inking: Tracing a cleaned-up drawing onto the front of a cel for painting.

Jaggies: Hard-edged pixels that appear on computer-generated lines when they are not antialiased.

JavaScript: Platform-independent computer language developed by Sun Microsystems. Mostly used for adding interactive effects to web pages.

JPEG (Joint Photographic Experts Group): A universal format for storing digital image files so that they take up less space.

Keyframe: Frame that shows the extreme of an action or a principal movement in an animation.

Layers: Cels comprising different elements of a single frame and mounted one on top of the other. Also simulated in software programs.

Layout artist: The person who designs the composition of the shots.

Lead animator: Person in charge of the animation team. Usually draws keyframe action.

Lightbox: A glass-topped box with a powerful light source. Used by animators to trace artwork.

Line animation: Animation created with drawings.

Lip synch: The matching of characters' mouth shapes in time with recorded dialogue.

Live action: Film made using real people or actors.

Maquette: A small statue of a character used as a drawing or 3D modelling aid.

Megapixel: 1,000 pixels. Used to describe the resolution of digital cameras.

MIDI (Musical Instrument Digital Interface): An industry standard for connecting synthesizers to computers in order to sequence and record them.

MoCap (Motion Capture): A way of capturing accurate human movement for use in 3D software by attaching sensors to an actor and mapping the co-ordinates in a computer program.

Modeling paste: Modelling clay used by animators to make models for claymation.

Model making: Creating puppets and scenery for use in 3D stop-motion animation.

Model sheet: A reference sheet for the use of animators to ensure that a character has a consistent appearance throughout a film. It consists of a series of drawings showing how a character appears in relation to other characters and objects, with details of how it appears from various angles and with different expressions.

NTSC: Television and video format used in the US and Canada.

Onion-skinning: The ability to see through to underlying layers of drawings for tracing and comparing images when tweening.

OS (Operating System): The part of the computer that enables software to interface with computer hardware. Two commonly used operating systems are Microsoft Windows and MacOS. Others include UNIX, Linux, and IRIX.

PAL: Television and video format used in Europe, Australia and Asia.

Panning shot: A shot that is achieved by following an action or scene with a moving camera from a fixed position.

Peg bar: A metal or plastic device to hold hole-punched paper and cels so that they remain in register.

Phoneme: Phonetic sounds used in speech to help the animator make the correct mouth shapes (visemes) for lip synching.

Pixel (from PICture ELement): The smallest unit of a digital image. Mainly square in shape, a pixel is one of a multitude of squares of coloured light that together form a photographic image.

Pixilation: A stop-motion technique in which objects and live actors are photographed frame by frame to achieve unusual motion effects.

Plexiglas: Proprietary name for a type of transparent plastic that is lighter and more impact resistant than glass; it is used as a replacement for glass in many applications.

Plug-in: A piece of software that adds extra features or functions to another program.

Pre-production: The planning stage of a film or animation before shooting begins.

Primitives: Basic shapes used by 3D software (cube, sphere, cylinder, cone).

Puppet: Model for stop-action animation made with wire or ball-and-socket skeleton then covered in clay or latex.

QuickTime: A computer video format developed by Apple Computer.

QTVR (QuickTime Virtual Reality): A component of QuickTime, used for creating and viewing interactive 360-degree vistas on a computer and on the Web.

RAM (Random Access Memory): The area of computer memory where the computer holds data immediately before and after processing, and before the computation is 'written' (or saved) to disc.

Raytracing: Used by a rendering engine to create an image by sending virtual rays of light from the light sources so they reflect off the objects in a scene.

Registration: The exact alignment of various levels of artwork in precise relation to each other.

Render: To create a 2D image or animation from 3D information.

RGB (Red, Green, Blue): The colours used in computer and TV monitors to make all the colours we see on screen.

Rostrum camera: A motion-picture camera that can be mounted on columns and suspended directly over the artwork to be filmed.

Rotoscope: A device that projects live-action film, one frame at a time, onto a glass surface below. When drawing paper is placed over the glass, the animator can trace off the live-action images in order to get realistic movement.

Script (also _Screenplay_): The dialogue and directions of a film.

Showreel: A portfolio of moving images on videotape, DVD or CD.

Steadicam: A camera rig that is harnessed to a steadicam operator so s/he can follow actors in a scene without the camera jolting.

Stop Action or Stop Motion: Animation where a model is moved incrementally and photographed one frame at a time.

Story reel: _see_ Animatic.

Storyboard: A series of small consecutive drawings plotting key movements in an animation narrative, and accompanied by caption-like descriptions of the action and sound.

Streaming video: A sequence of moving images sent in compressed form over the Internet and displayed by the viewer as they arrive. The Internet user does not have to wait to download a large file before seeing the video.

Super8: Small film format that was popular with amateur filmmakers before the arrival of video cameras. Still has a strong cult-following. Very expensive compared to DV.

Texture map: 2D image used to give texture to a 3D object.

Timeline: Part of software that displays the events and items of an animation in terms of time or frames.

Trace back: Sometimes a part of an animation may remain unchanged from one cel to the next. It is therefore traced back onto subsequent cels.

Track (or truck): A cinematic shot where the camera moves through a scene.

Tweening: Drawing the intermediate drawings/frames that fall between the keyframes in an animation.

Vector: Lines created in computers using mathematical equations.

Vector animation: An animation that uses images created with vectors. Vector animations are resolution independent so they can be enlarged to any size without deterioration of image quality.

Vertex: A control point on a 3D object, where two lines of a wireframe model meet.

Visemes: Mouth shapes corresponding to phonemes.

Wireframe: A representation of a 3D object showing its structure made up of lines and vertices.

World Wide Web: The graphical interface of the Internet that is viewed on a computer using a software browser.

Links

INTRODUCTION
General web sites
Apple Computer – www.apple.com
Canon – www.canon.com
Dell Computers – www.dell.com
Epson – www.epson.com
Hewlett-Packard – www.hp.com
Microtek – www.microtek.com
Silicon Graphics – www.sgi.com
Sony – www.sony.com
Umax – www.umax.com
Wacom – www.wacom.com

CHAPTER 1 THE STORY
General web sites
Screentalk Magazine –
 www.screentalk.biz
Writers' Guild of America –
 www.wga.org
Zoetrope – www.zoetrope.com
Wordplay – www.wordplayer.com
www.createyourscreenplay.com
www.simplyscripts.com
www.successfulscreenplays.com

Web sites of animators' work
Cartoon Saloon –
www.cartoonsaloon.ie/content/animatio
 n/rebel.mpg, p.15
Godfather ad for HBO –
www.loopfilmworks.com, p. 27

Software
Final Draft – www.finaldraft.com

ScreenForge –
 www.apotheosispictures.com/Downl
 oad.htm
Screenplay style sheets for Macs –
 www.mindspring.com/%7Eplucky/sc
 reen.html
Screenwriter 2000 –
 www.screenplay.com

Suggested reading
Campbell, Joseph. *Hero with a
 Thousand Faces.* Princeton University
 Press: Princeton, 1972
Field, Syd. *Screenplay.* Bantam
 Doubleday Dell Publishing: New
 York, 1984
Gerrold, David. *Worlds of Wonder.*
 Writer's Digest Books: Cincinnati,
 2001
Goldman, William. *Adventures in the
 Screen Trade.* Warner Books: New
 York, 1989
Goldman, William. *Which Lie Did I Tell?*
 Vintage Books: New York, 2001
King, Stephen. *On Writing.* Pocket
 Books: New York, 2003
McKee, Robert. *Story.* Harpercollins:
 New York, 1997
Silver-Lasky, Pat. *Screenwriting for the
 21st Century.* Batsford: London,
 2003
Vogler, Christopher. *The Writer's
 Journey.* Michael Wiese Productions:
 Studio City, 1998

CHAPTER 2 STOP-ACTION
General web sites
Aardman – www.aardman.com
www.stopmotionanimation.com

Web sites of animators' work
Talking head –
www.chrisnunwick.com/inn_abr.html,
 p.30
Ikea ad –
www.headgearanimation.com/work/wor
 k2/movie1.html, p.31
Moonlighting –
www.loopfilmworks.com/film, p.31
Astral Media MFest –
www.headgearanimation.com/work/wor
 k2/movie2.html, p.38
Angry Kid by Darren Walsh –
www.angrykid.com
http://atomfilms.shockwave.com/af/ani
 mation/series/angrykid, p.43

Software
BTVPro – www.bensoftware.com
Stop Motion Pro –
 www.stopmotionpro.com
Lunchbox –
 www.animationtoolworks.com
PencilTest –
 www.slashjpl.com/software/penciltes
 t/html/

Suggested reading
Lord, Peter, and Sibley, Brian. *Cracking
 Animation.* Thames and Hudson:
 London, 1999

CHAPTER 3 SIMPLE ANIMATION
Web sites of animators' work
Flipbook –
www.chrisnunwick.com/the_other_wo
 man.html, p.51
The last minute 'little' change –
www.buzzzco.com/video/we.mov, p.56
HBO promotion –
www.loopfilmworks.com/film/loop_pop
 _vr.htm, p.57
Post-9/11 public service
 announcement –
www.loopfilmworks.com/film/loop_pop
 _liberty.htm, p.65
Our Hero –
www.headgearanimation.com/work/wor
 k5/movie2.html, p.66
The commercial artist –
www.buzzzco.com/we.html, p.67
C.O.R.E. Digital Pictures Inc.—
www.coredp.com, p.69
Angela Anaconda –
www.angelaa.com, p.68
A Warm Reception in LA –
www.buzzzco.com/video/warm.mov,
 p.70
Ruairi –
www.cartoonsaloon.ie/content/animatio
 n/ruairi.mov, p.71
Fast Food Matador –

www.buzzzco.com/matador.htm

Atomic Betty –
www.atomiccartoons.com/flash_bettyp
age.html, p.71

Software

Boris – www.borisfx.com

Creatoon – www.creatoon.com

Painter – www.procreate.com

Studio Artist – www.synthetik.com

CHAPTER 4 CEL ANIMATION

General web sites

The Animated Cartoon Factory –
www.brianlemay.com

Web sites of animators' work

Animator's desk –
www.bluesunflower.com, p.72

Dress Rehearsal –
www.cartoonsaloon.ie/content/animatio
n/dressr.swf, p.100

Chicken Limb –
www.amiplasse.com/flash.html, p.102

Software

Animation Stand –
www.animationstand.com

Animo – www.animo.com

AXA Team 2D – www.axasoftware.com

Canvas – www.deneba.com

Controller –
www.tascam.com

CorelDraw – www.corel.com

CTP – www.cratersoftware.com

Expression – www.creaturehouse.com

FlipBook – www.digicelinc.com

FreeHand – www.macromedia.com

Illustrator – www.adobe.com

Moho – www.lostmarble.com

PencilTest –
www.slashjpl.com/software/penciltes
t/html/

RETASPro – www.retas.com

ToonBoom Studio –
www.toonboomstudio.com

Toonz – www.toonz.com and
www.softimage.com

USAnimation – www.usanimation.com

Sound

Band in a Box – www.bandinabox.com

Cubase – www.steinberg.net

Deck – www.bias-inc.com

Digital Performer – www.motu.com

Groovemaker – www.groovemaker.com

Logic – www.emagic.de

ProTools – www.digidesign.com

www.findsounds.com

www.partnersinrhyme.com

www.sounddogs.com

www.sound-effects-library.com

www.sound-ideas.com

www.soundoftheweb.com

www.ultimatesoundarchive.com

www.zero-g.co.uk

Suggested reading

Blair, Preston. *Cartoon Animation*.
Walter Foster Publishing: Laguna
Hills: 1995

Galore, Janet, and Kelsey, Todd. *Flash
MX – for T.V. and Video*. John Wiley
and Sons: Hoboken, 2002

Ozawa, Tadashi. *How to Draw Anime &
Game Characters*. Books Nippan:
Los Angeles, 2001

Thomas, Frank, and Johnston. *Ollie,
Illusion of Life*. Hyperion: New York,
1995

Griffin, Hedley. *The Animator's Guide to
2D Computer Animation*. Focal
Press: Burlington, 2000

Whitaker, Harold, and Halas, John.
Timing for Animation. Focal Press:
Burlington, 2002

Williams, Richard. *The Animator's
Survival Kit*. Faber & Faber: London,
2002

CHAPTER 5 WEB ANIMATION

General web sites

Axeledge – www.mindavenue.com

Fireworks – www.macromedia.com

Flash Studio – www.macromedia.com

Flix – www.wildform.com

Plasma – www.discreet.com

Swift 3D – www.erain.com

Shockwave – www.shockwave.com

ToonBoom Studio –
www.toonboomstudio.com

VectorStyle – www.eovia.com

Web sites of animators' work

No Guts Galaxy –
www.nogutsnogalaxy.com, p.104

Renegade Cartoons –
www.renegadecartoons.com, p.104

Bon Voyage E-card –
www.cartoonsaloon.ie/content/animatio
n/ecards/bvoyage.swf, p.105

CHAPTER 6 3D CGI

General web sites

3DS Max – www.discreet.com

3D Toolkit – www.dvgarage.com

3D Training – www.3dbuzz.com

Amapi – www.eovia.com

Amorphium Pro –
www.electricimage.com

Animation: Master – www.hash.com

Blender – www.blender3d.org

Carrara Studio – www.eovia.com

Cinema 4D – www.cinema4d.com

Deep Paint 3D –
www.righthemisphere.com

El Universe – www.electricimage.com

Houdini – www.sidefx.com

LightWave – www.newtek.com

Maya – www.aliaswavefront.com

Movie 3D – www.aist.com

Pixels3D – www.pixels3d.com

Realsoft 3D – www.realsoft.com

Renderosity – www.renderosity.com

Softimage – www.softimage.com

Stitcher – www.realviz.com

Strata 3D – www.strata.com

Web sites of animators' work

Awakening –
www.bandaranimation.com/awakening.
 html, p.117

Rustboy –
www.rustboy.com, p.123

Atomic Betty –
www.atomiccartoons.com, p.138

Hardly Workin'—
www.illclan.com/movies.htm, p.140

Black and White –
www.lionhead.com, p.141

Supabikes –
www.secretweapon.org/orig03.htm

Games development

Asura game engine –
 www.rebellion.co.uk

Coldstone game engine (Mac)—
 www.ambrosiasw.com/games/coldst
 one

Quake engine (PC)—
 www.idsoftware.com

www.gamasutra.com

www.gamedev.net

www.polycount.com

Poser related

BodyStudio – www.reiss-studio.com

Character Studio – www.discreet.com

Credo Life Forms – www.lifeforms.com

DAZ Productions – www.daz3d.com

Poser – www.curiouslabs.com

Messiah:animate –
 www.projectmessiah.com

Poser Resources:

www.poserworld.com

www.the-forge.ie

www.renderosity.com

www.zs3d.com

Terrain editors

AnimaTek World Builder –
 www.digi-element.com

Bryce – www.corel.com

Leveller – www.daylongraphics.com

Mojoworld – www.pandromeda.com

Natural Scene Designer –
 www.naturalggfx.com

VistaPro – www.monkeybyte.com

Vue d'Esprit – www.e-onsoftware.com

World Construction Set –
 www.3dnature.com

Xfrog – www.xfrog.com.com

Video editing

Avid Xpress – www.avid.com

Blade – www.in-sync.com

Edition DV – www.pinnaclesys.com

Final Cut Pro – www.apple.com

iMovie – www.apple.com

MediaStudio Pro – www.ulead.com

MoviePack – www.aist.com

MovieStar – www.dazzle.com

Peak – www.bias-inc.com

Premiere – www.adobe.com

QuickTime – www.apple.com/quicktime

Speed Razor – www.in-sync.com

StrataDV – www.strata.com

Vegas Video – www.sonicfoundry.com

VideoFactory – www.sonicfoundry.com

VideoStudio – www.ulead.com

Suggested reading

Brooker, Darren. *Essential CG Lighting
 Techniques.* Focal Press: Burlington
 2002

GENERAL ANIMATION LINKS

Animation Artist –
 www.animationartist.com

Animation Blast –
 www.animationblast.com

Animation Magazine –
 www.animationmagazine.net

Animation Meat –
 www.animationmeat.com

Animation World Network –
 www.awn.com

Animato – www.sci.fi/~animato/

Complete Animation –
 www.completeanimation.com (This
 is the author's web site, which
 includes further information to
 supplement this book, including
 forums and a chance to showcase
 your first animations.)

Index

Credits

The publisher and the author would like to thank the following for their kind permission to reproduce their pictures:

(Key: l left, r right, t top, b bottom, c centre)

© 2003 2000AD / Rebellion 141tc&tr(group); Adobe Inc 5tr, 67br; 2Advanced Studios 111tl(group); © 2002 Aardman Animations Ltd 43t; Acció Studios / R.L. Espí / M.P. Lozano 78b, 79cl, 82br, 82/83t, 88(all), 95br; Adinolfi, Anthony / Bandar Animation 101br, 117cl; © Allied Visual Artists / Linker Systems 90br; Amok Studio 110cl(group); Angela Anaconda © 2002 DECODE Entertainment Inc. Copyright in Angela Anaconda and all related characters is owned by DECODE Entertainment Inc. ANGELA ANACONDA™ is a registered trademark of Honest Art, Inc. All rights reserved / C.O.R.E Digital Pictures Inc 47tr, 57tl, 68/69(all); Apple Computers Inc 8cl, 9bl; Apple Core 105cr; Atomic Cartoons 19c, 71cr, 78cr, 83br(group), 101tr, 138bl; Bambú / Ronald Grant Archive 71tl; Beaumont, Tim 3, 19tr, 83cr(group), 85tr(group); Blue Sunflower 149br; Bozzetto, Bruno 70tl(group); © 2003 Broken Saints.com; 114/115 (all); Burgess, Rupert / Glamorgan Centre for Art and Design Technology 36l; © Buzzco Associates, Inc / a film by Candy Kugel and Vincent Cafarelli 1, 5tc, 56cl, 57cr, 62bl, 66/67t(group), 70bl, 71cr; Cambridge Animation Systems 97cl&cr; Cano, Enrico 13tl; Canon Inc 9cl; Cartoon Saloon 15tr, 17bl, 24bc, 71tr, 79t, 82cr, 100tl, 105tl; © Children's Television Trust International MMI 5tr, 11tr&c&b, 14tr (group), 17c, 30br(group), 36br, 37c, 44/45(all), 47br, 64(group), 70br, 95tr; Choromanski, Igor a.k.a Ikaria 116tr, 125bl(group), 146tl(group); Cobb, Penny 12l; Cowan, Finlay 25t(group) &r, 80/81(all); Daz Productions 136t(group)&bl; Discreet 119bl; © Disney Enterprises, Inc. 16b, 116bl; © Disney Enterprises, Inc / Pixar Animation Studios 14b; © 2000 Dreamworks, Pathe and Aardman 37tl; Duck Soup Studios, Los Angeles 117bc, 130(all); Eastman Kodak 32bl; Eovia Corporation 118cr, 133(all); Ellis, Heli 46, 60bl; EYE Animation Studios 117tl, 123br, 126cl, directed by Pat Gavin and Jo Simpson 124/125t, 126cl; Fuji 32bl; Hanna Barbera / Ronald Grant Archive 18bl; Head Gear Animation / YTV 2, 31cl&bl; 38b, 66bl; Hewlett Packard 8tr; Ill Clan Productions 4l, 140br; India Book House 13br; Intro 2000 321br; Jönmark, Mårten / Edinburgh College of Art 21(all), 28/29(all), 78tl(group), 95tl(group); Lambard, Dave (written and animated by) 100bl; Lazenby, Daniel / Glamorgan Centre for Art and Design Technology 40(all); Lemay, Brian 84l; Lionhead Studios 141c; Llam l from 'Strange Frame' © 2002 G.B

Hajim 47c; Lloyd, Sobrina / Glamorgan Centre for Art and Design Technology 41(all); Loop Filmworks, Inc / HBO, USA 56/57bc, / The Sloan Group, NYC 65br(group), / Bravo Network, USA 27r(group), 31r(group); Lord, Rod 71br(group), / Chrysalis Distribution 117cr(group); Maurer, Joerg 134bl; Maxon 118bl; Model Rail 37br; Morningside Worldwide Pictures / Columbia Pictures Corp / Ronald Grant Archive 14bl; Morris, Vanessa / Glamorgan centre for Art and Design technology 6l; Nikon Cameras 58bl&br; Nishizawa, Naokazu 119cr, 132tr; Nunwick, Chris 30r(group), 51bl(group), 56tr, 129c(group), 131tc&c, 151tl; Olympus Cameras 9br; ORF/ Austrian Television / Hedley Griffin Films 96; Patmore, Chris 20bl, 86tr&bl, 87tl; Plasse, Amitai 79cr(group), 102/103(all), 113t(group); Rea Productions 104cr(group), 111tr; © 2000 Renegade Animation Inc 104/105b(group); Secret Weapon 138r(group), 141br; Stone, Nick / Hinterland Films 5tc, 136br(group), / Educari 137br(group); Tatro, Dan 134cl; © Taylor, Brian 2001–2003 6t, 113b(group), 123cl(group), 124bl, 126tr(group), 126/127bc, 132bl, 142/143(all); Quality, The 111b(group); Theory 7 110cr; Toon Boom Technologies Inc 100bc, 150bc; Tuten, Patrick 134tl; Two Animators! 82cl, 84bl, 85tl, 104tr, 106t&c&b, 107b, 112(group); UMAX 9tr; Valderama, Simon 5tr, 24/25c, 125tr, 128/129t(group), 140l(group), 148bl; Varga, George / Giantheads 101tl(group); Wacom 9tl.

All trademark and proprietary names are recognized as the property of their respective owners.

While every effort has been made by the publisher and the author to contact and duly credit all authors, artists and original copyright holders of material appearing in this book, we apologise in advance for any omissions or errors, and would be pleased to make the appropriate correction for future editions of this book.

The publisher and the author would also like to thank Nikki Gibbs at Blue Sunflower and the students of her 'Getting Animated' course for allowing them to photograph Ms. Gibbs and her students at work.